D1581972

CAROLINE SAULNIER BY RANKIN

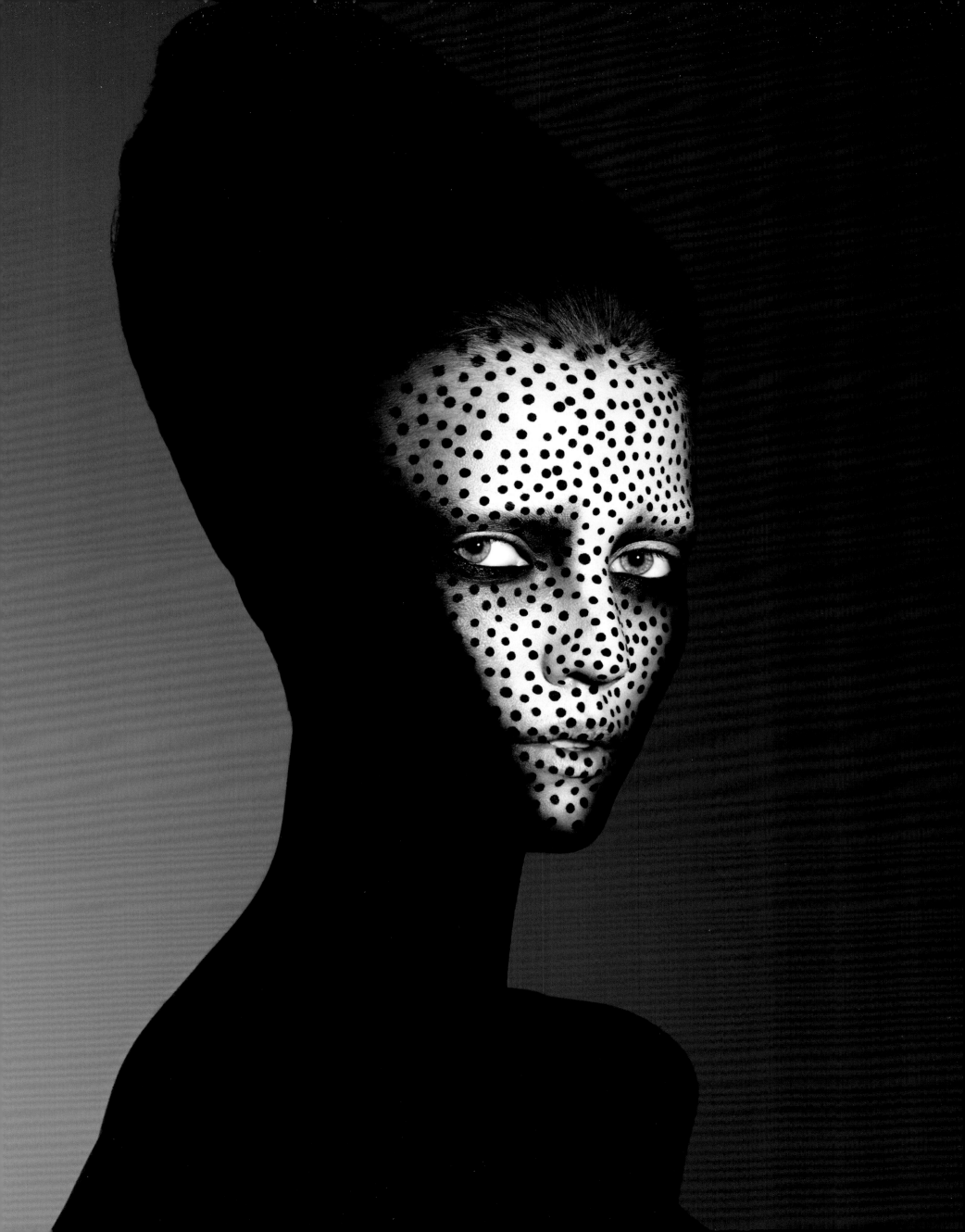

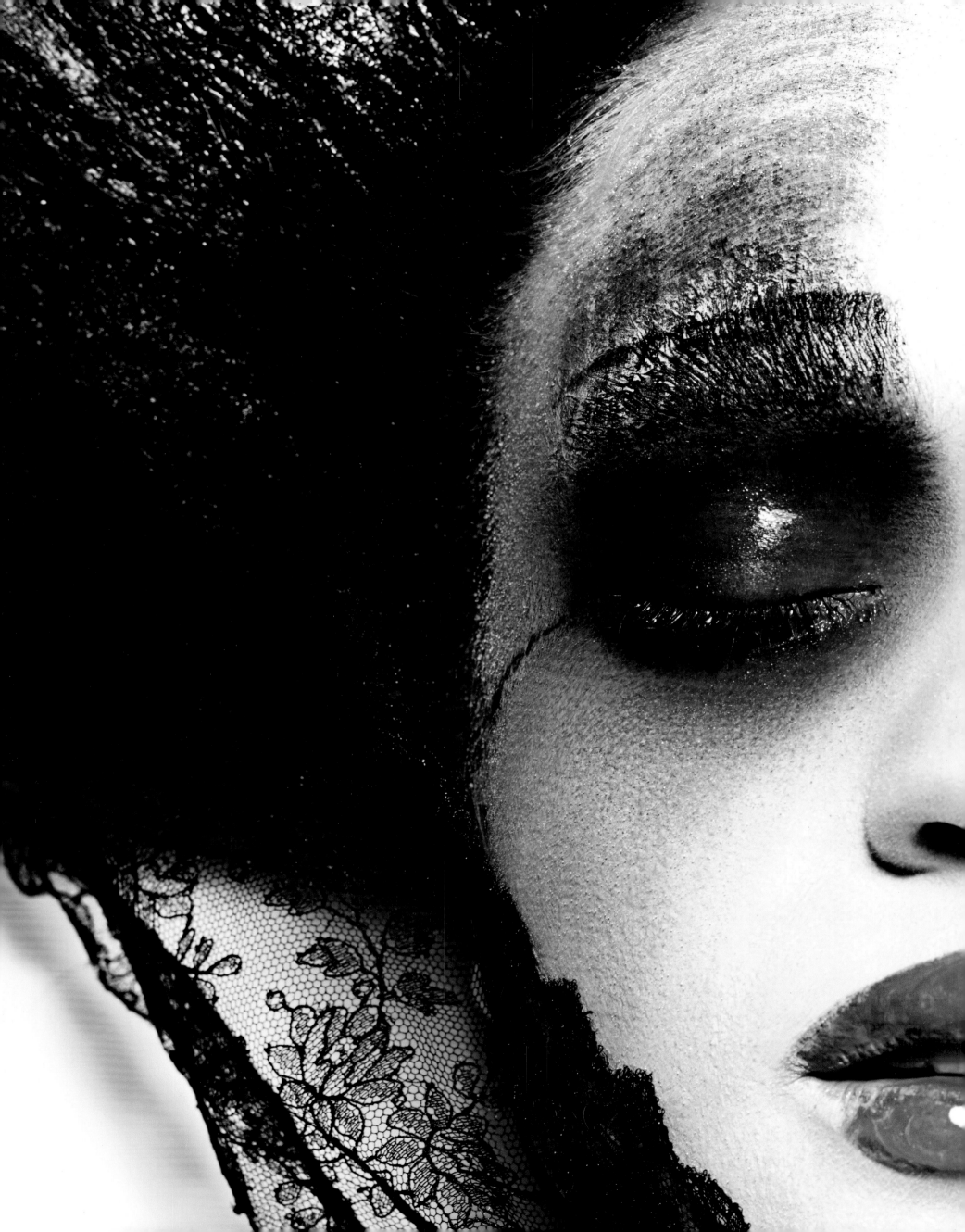

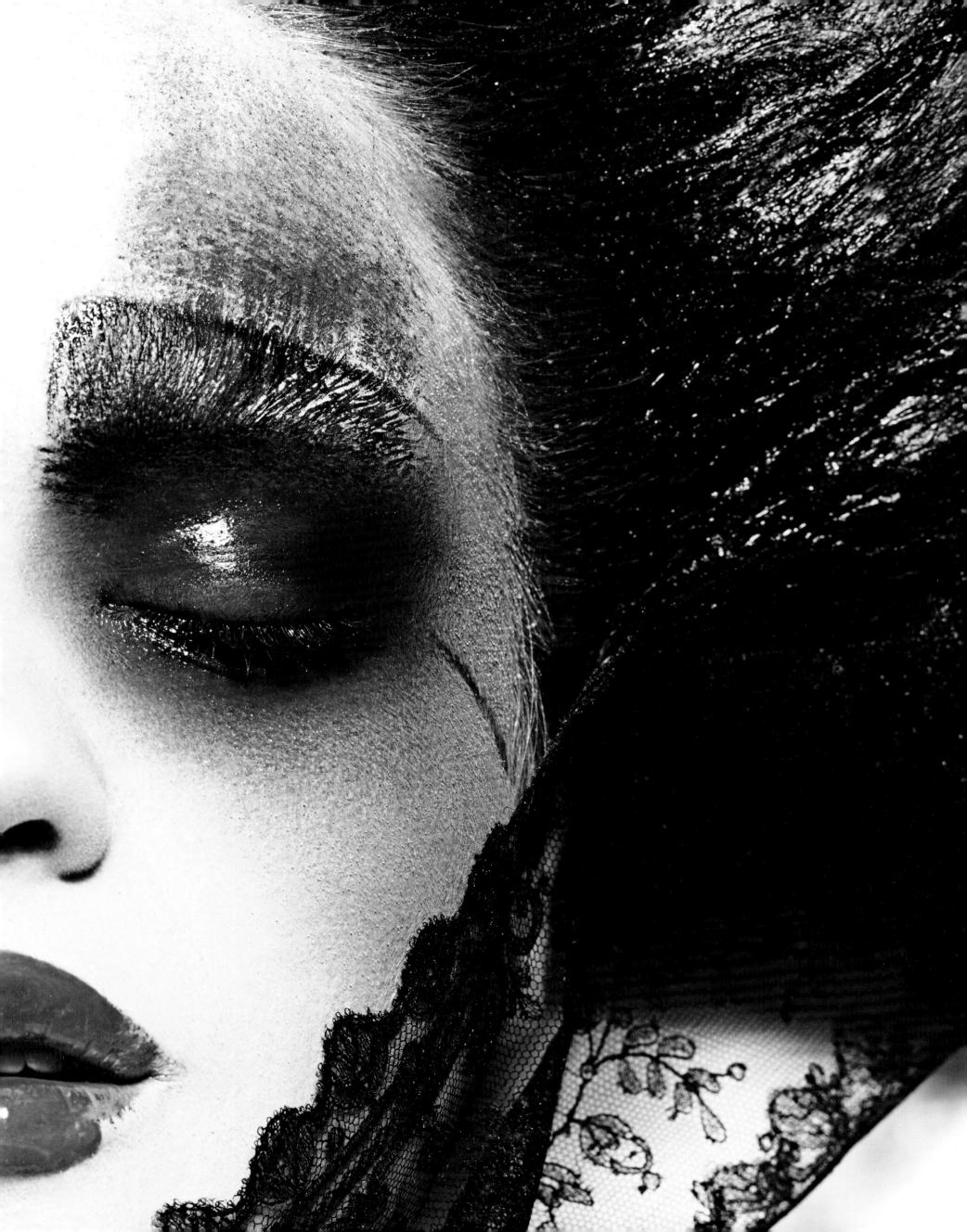

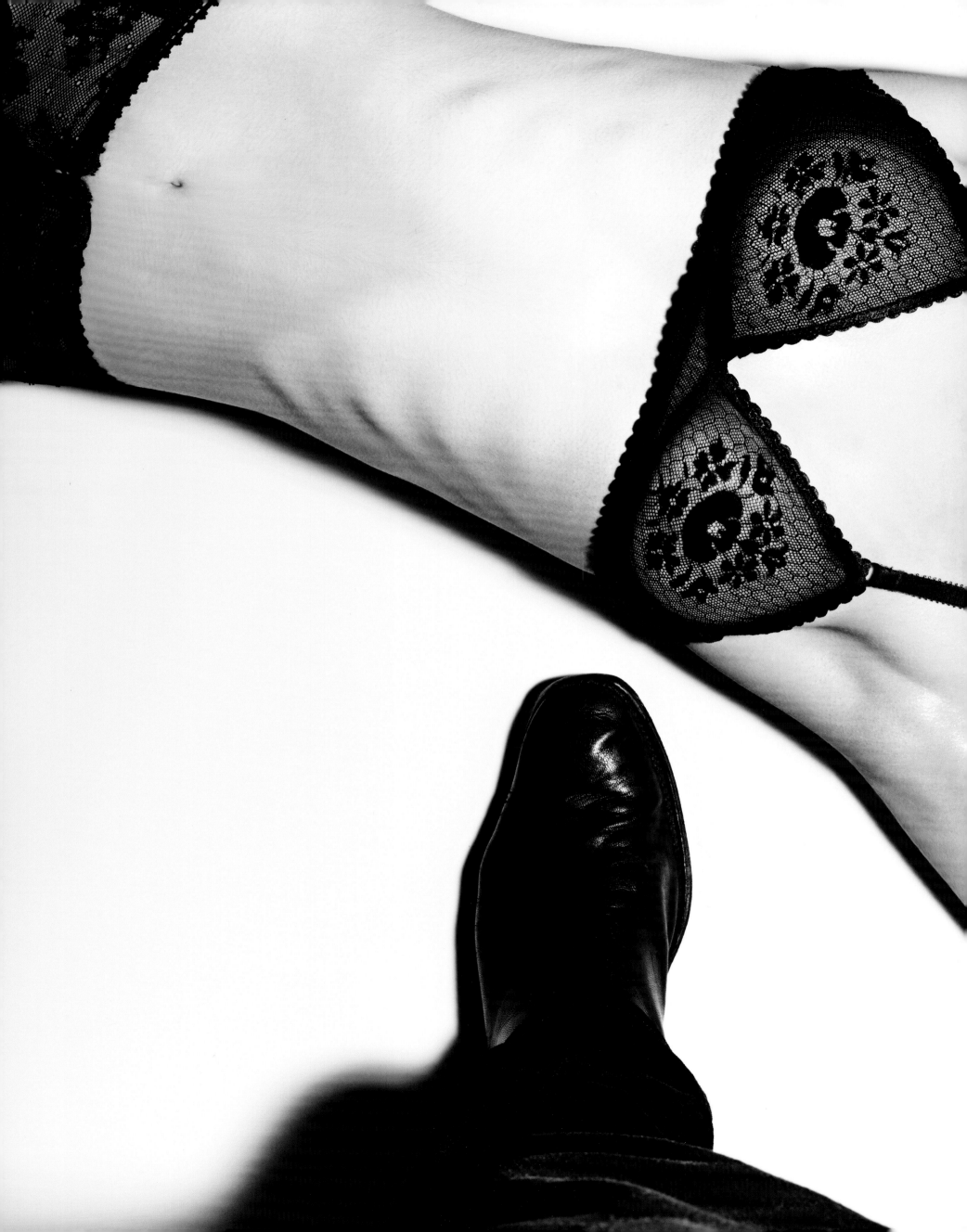

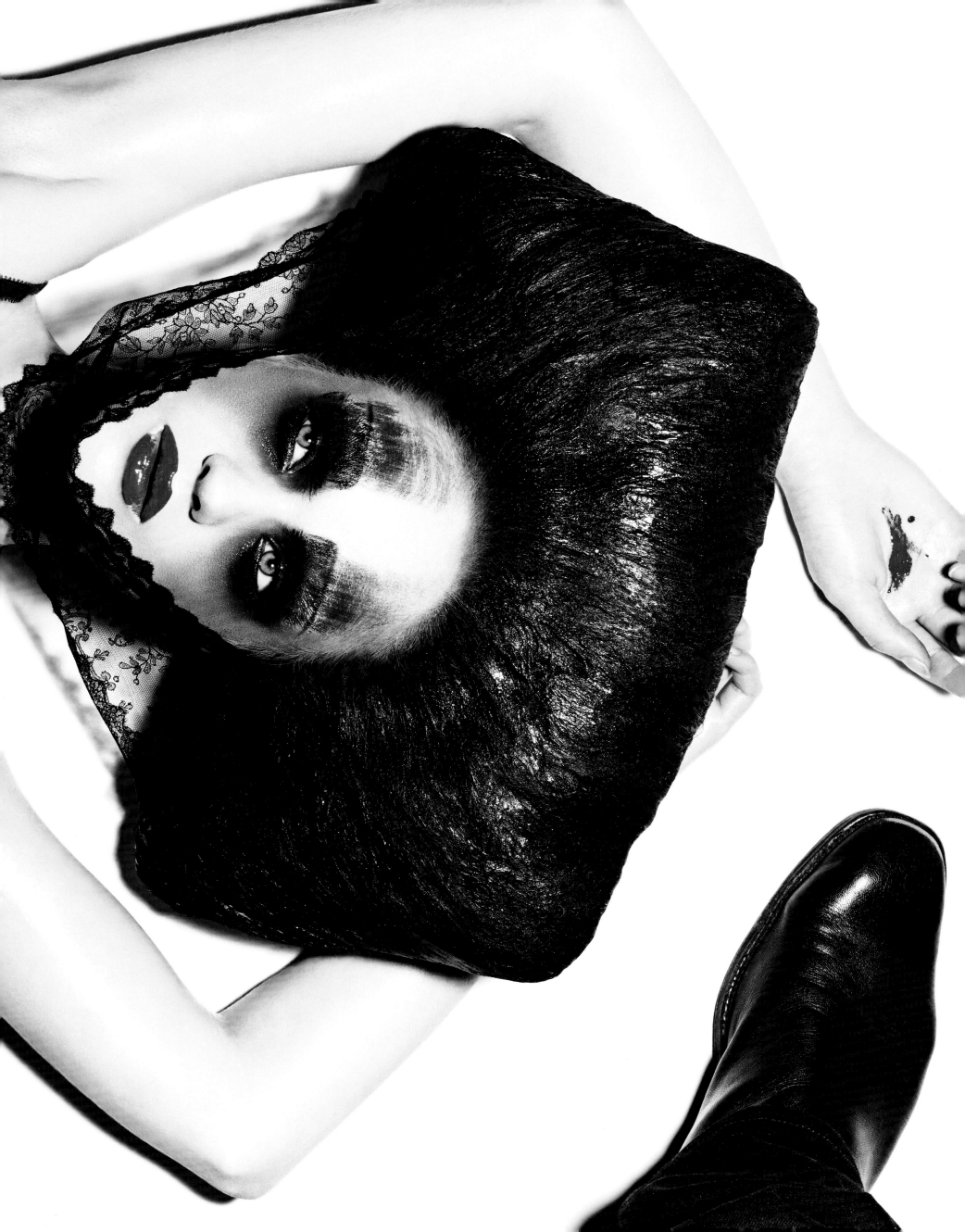

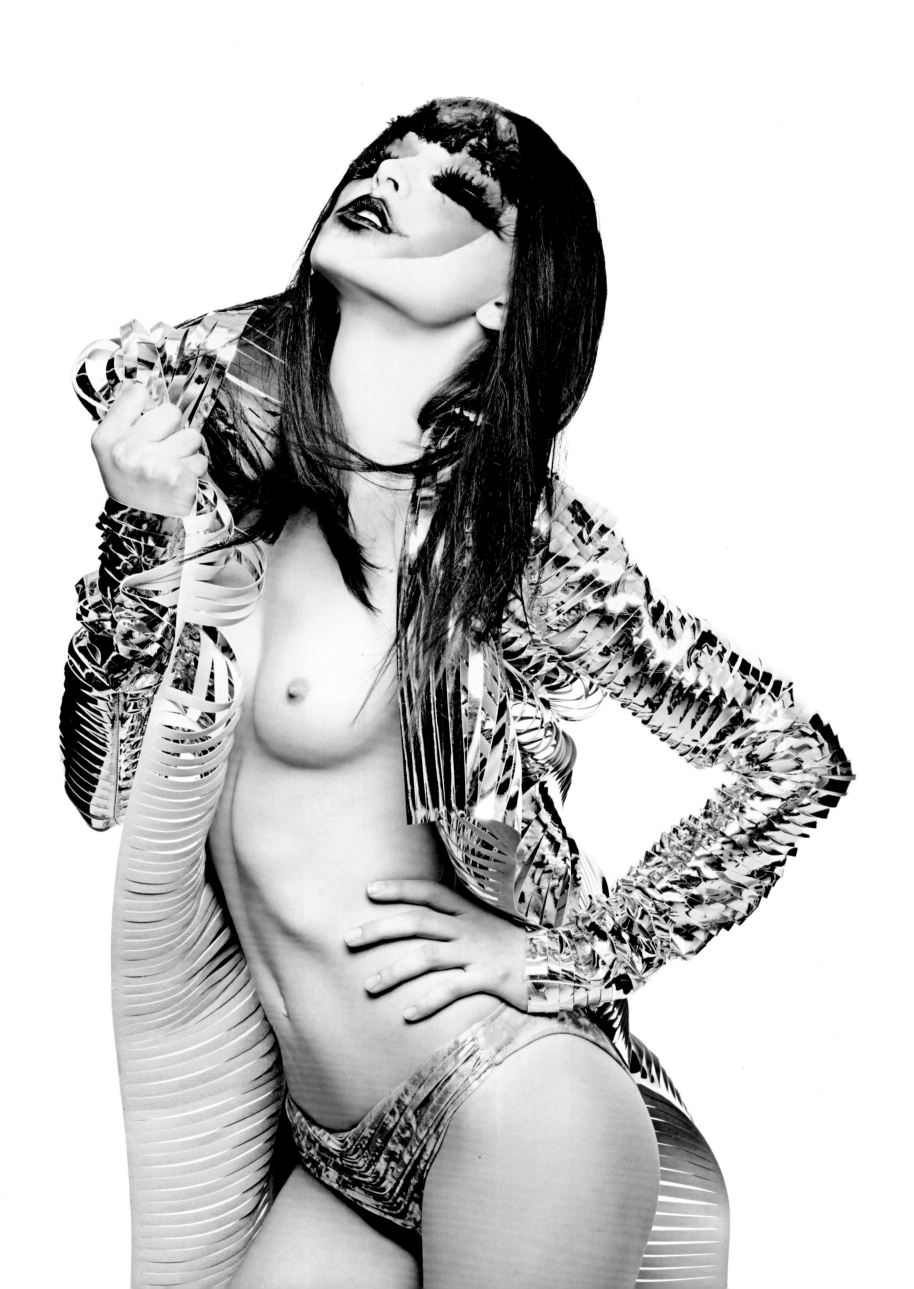

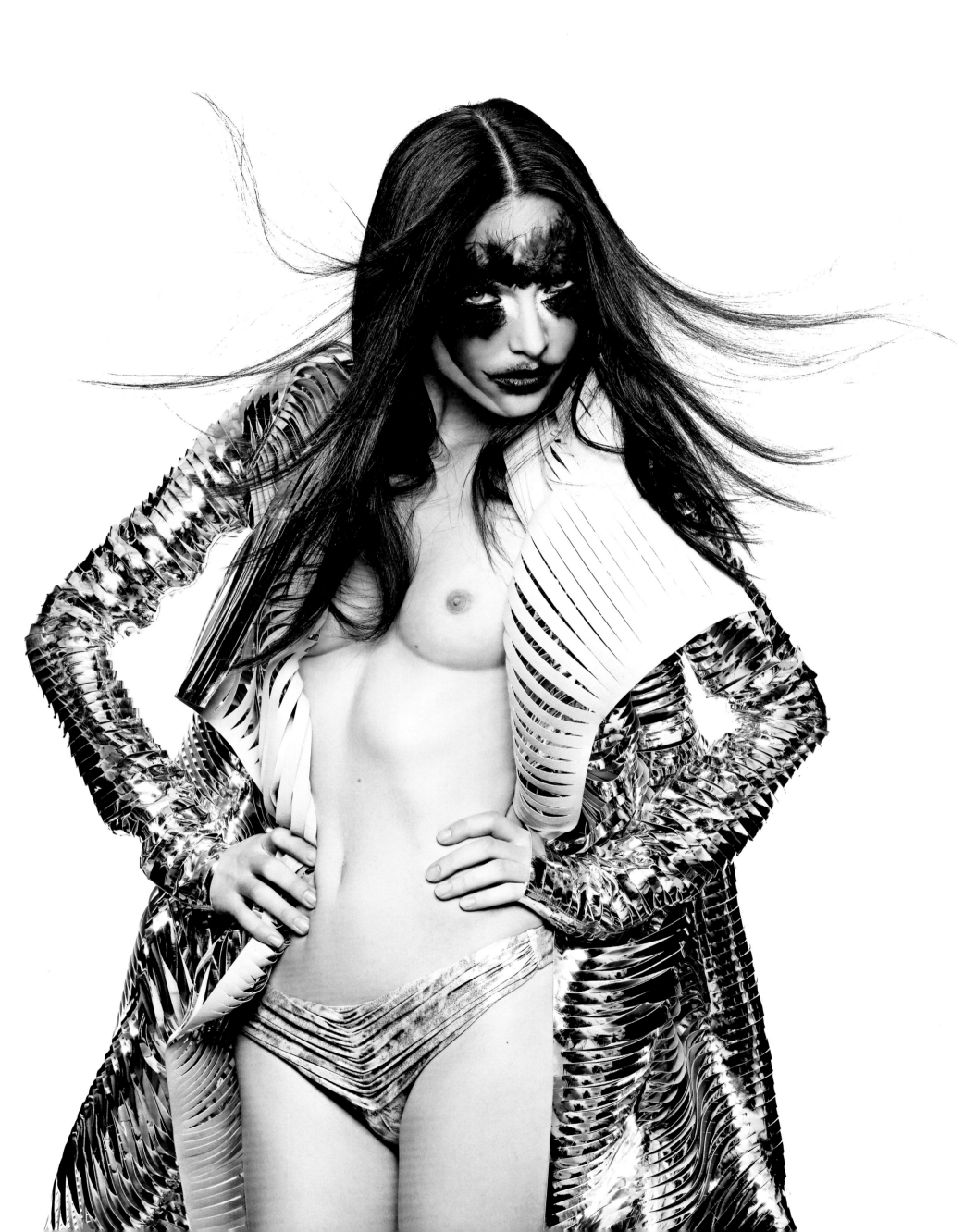

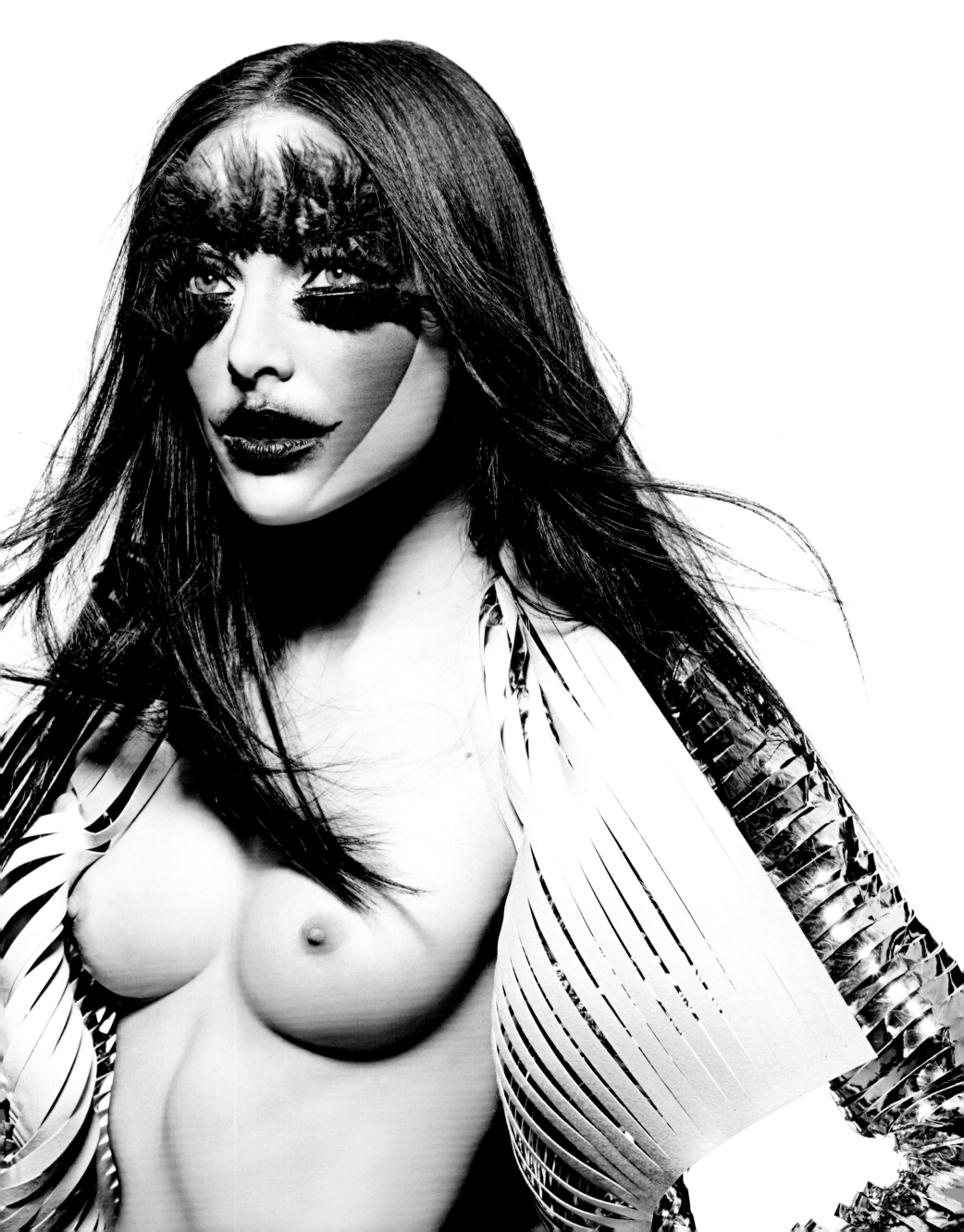

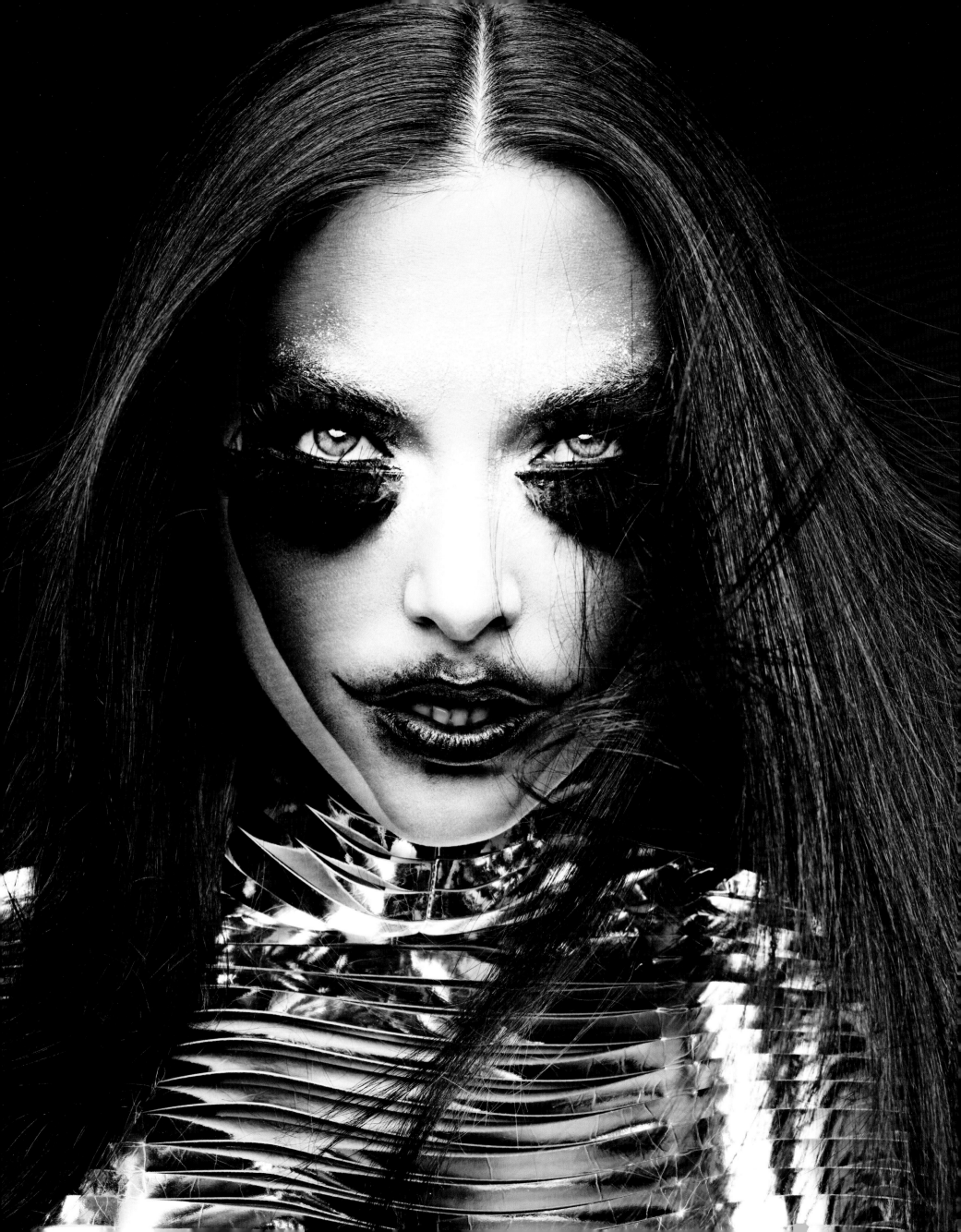

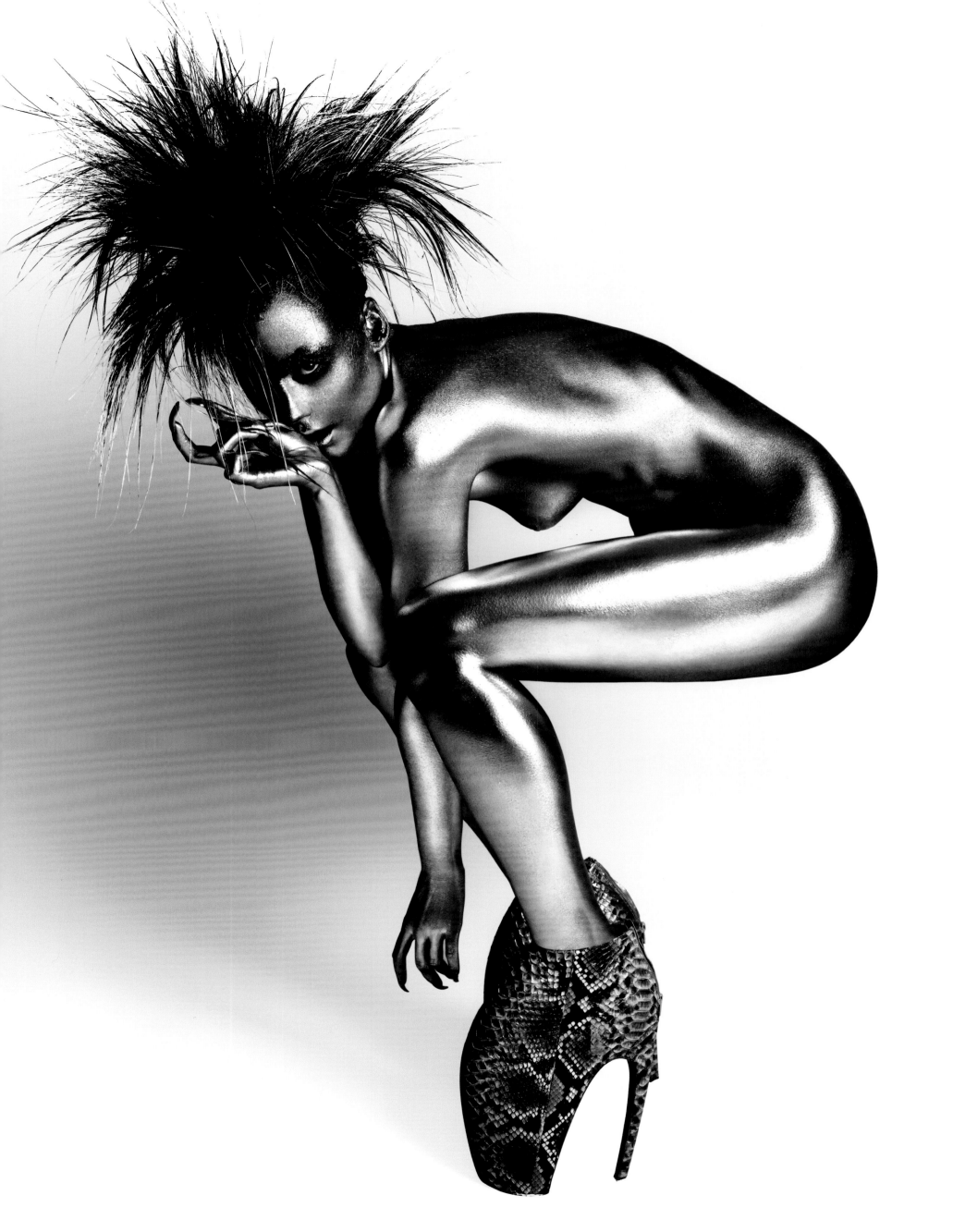

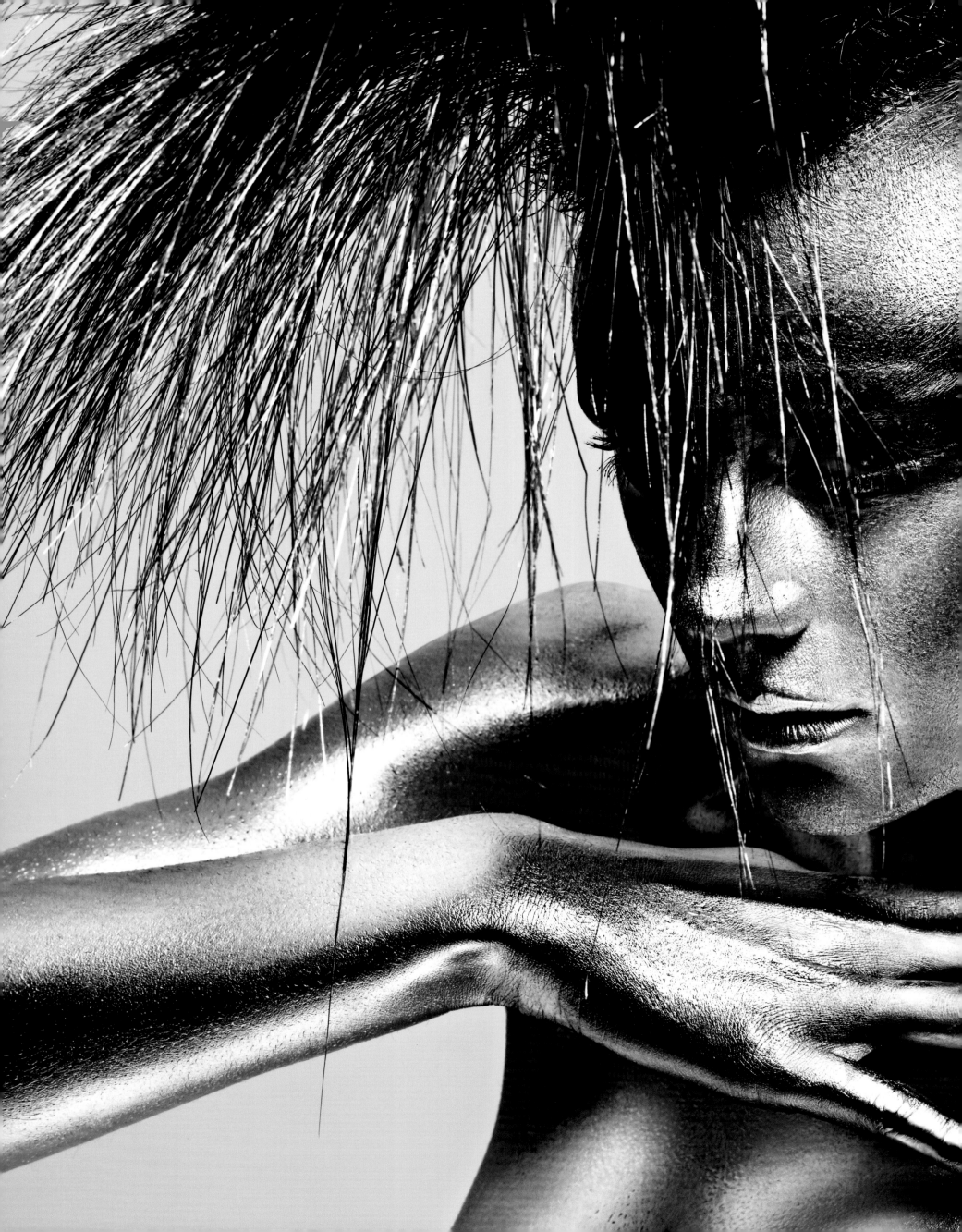

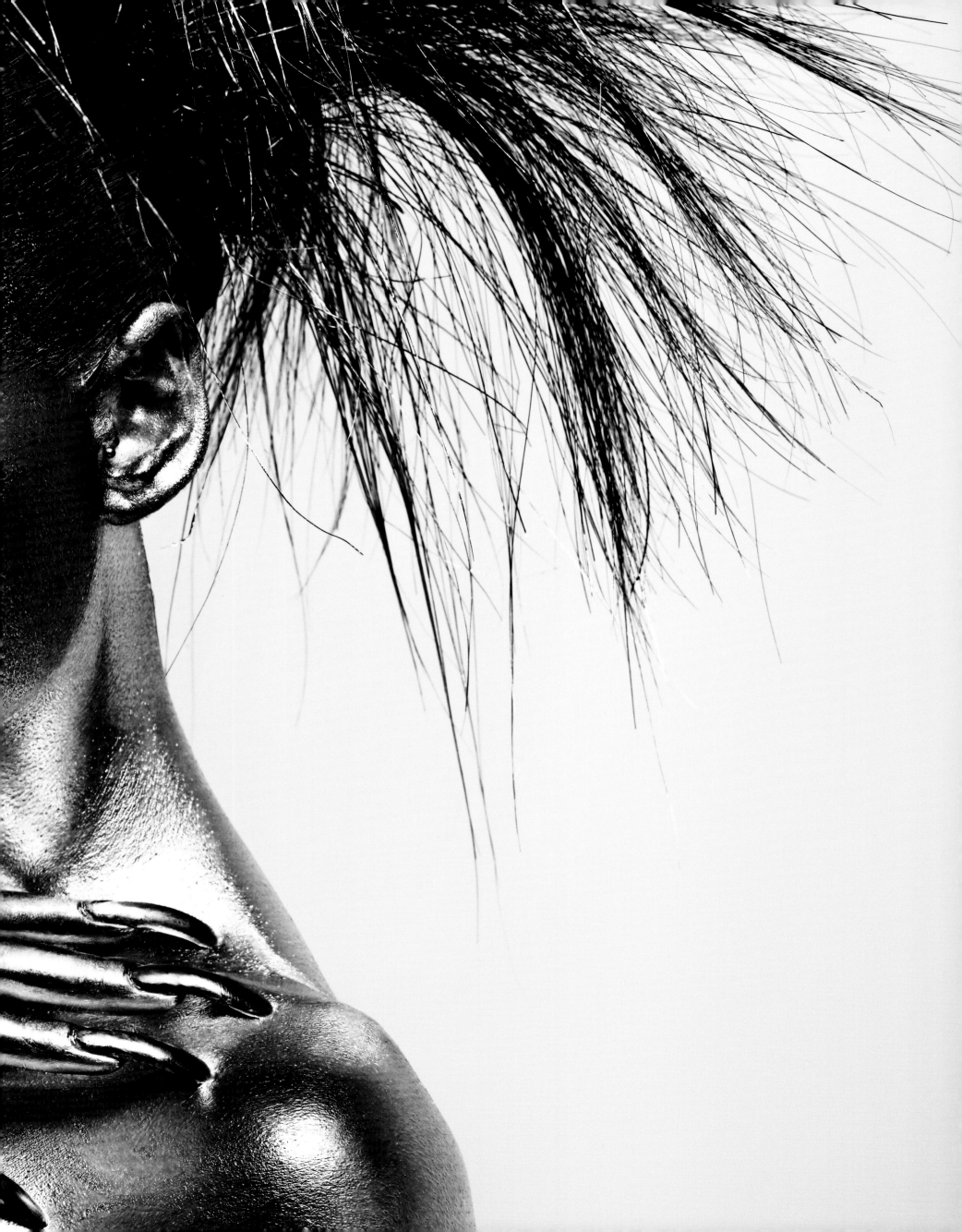

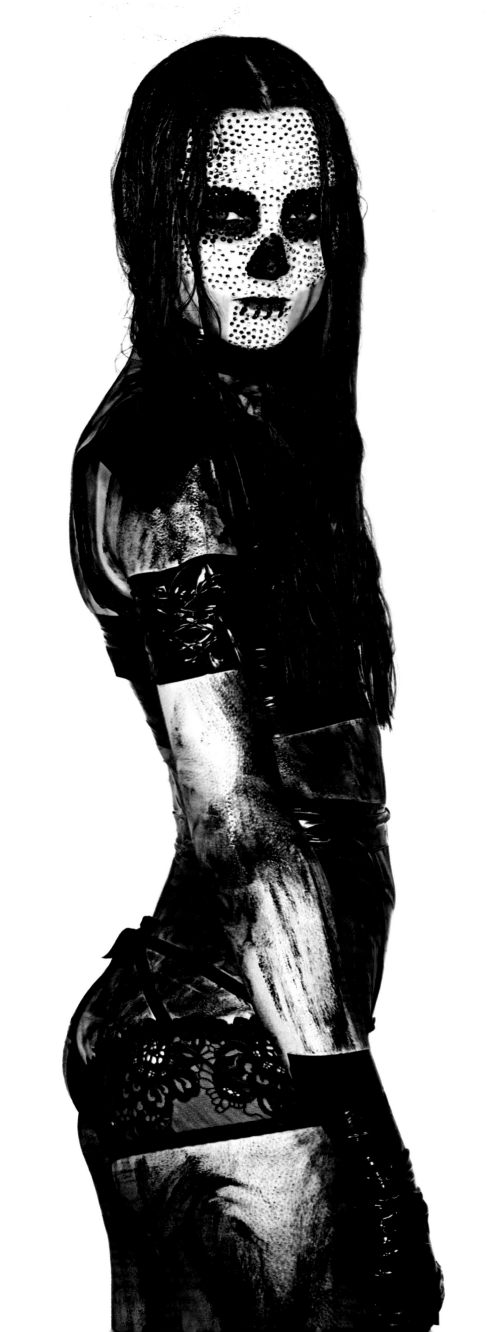

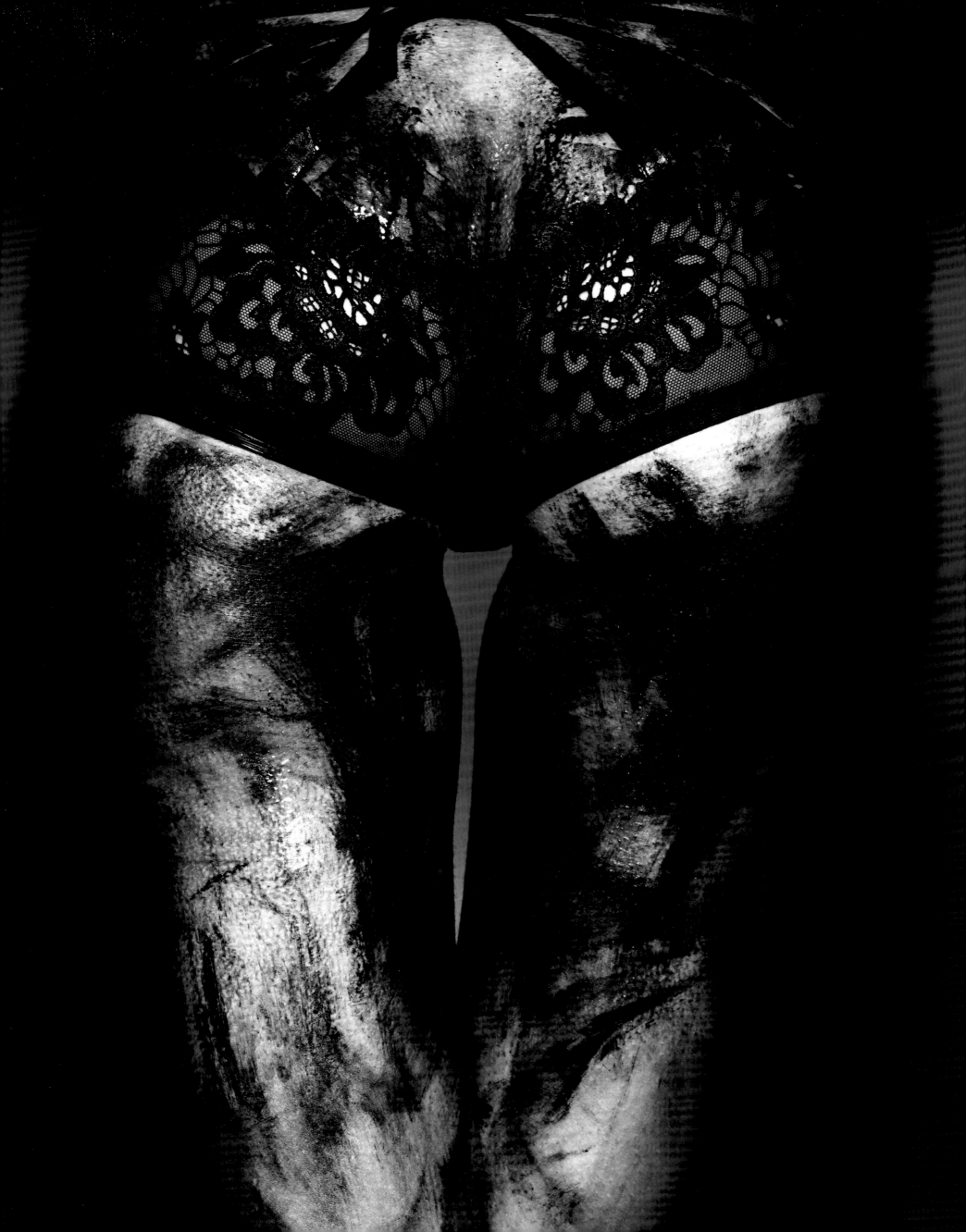

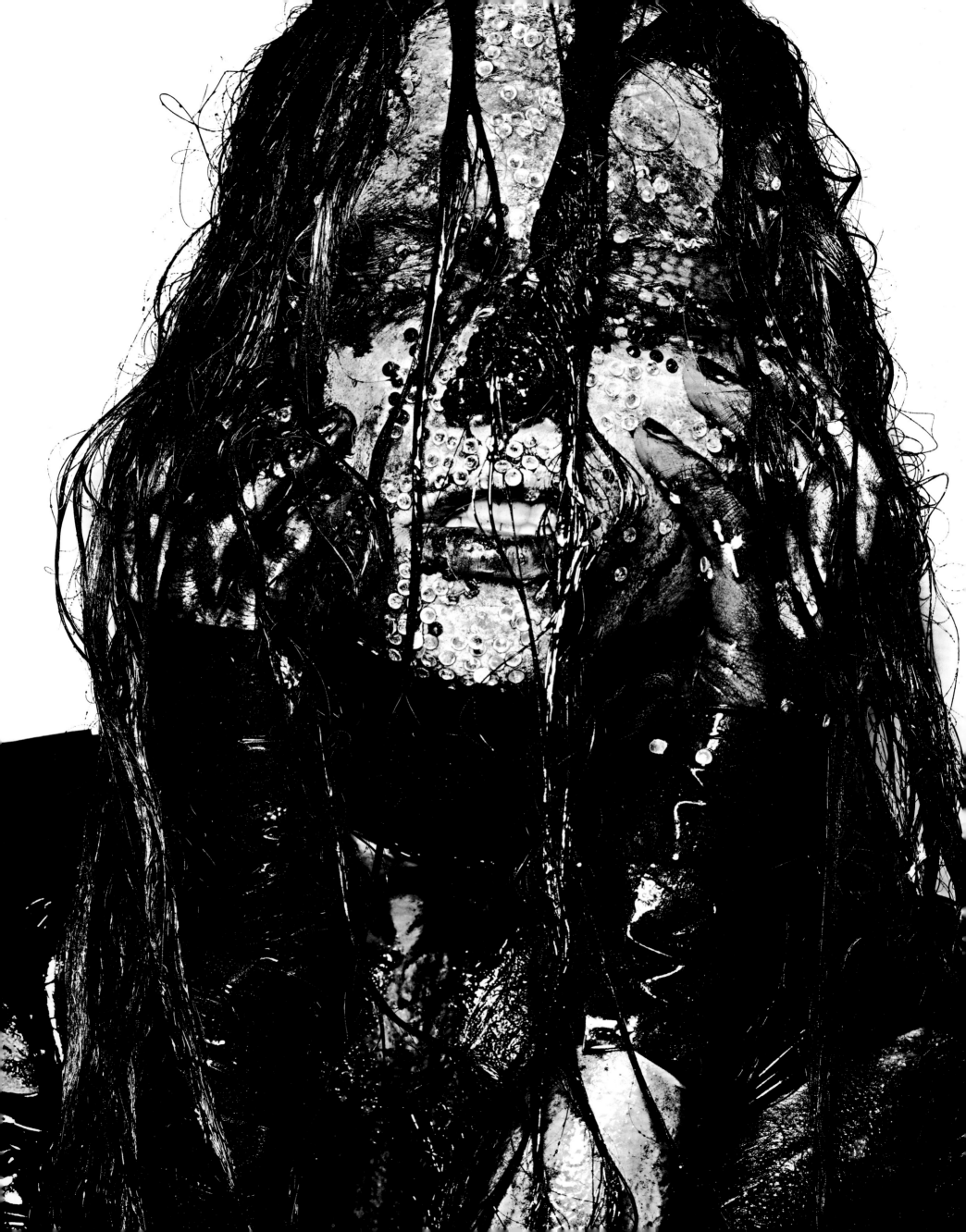

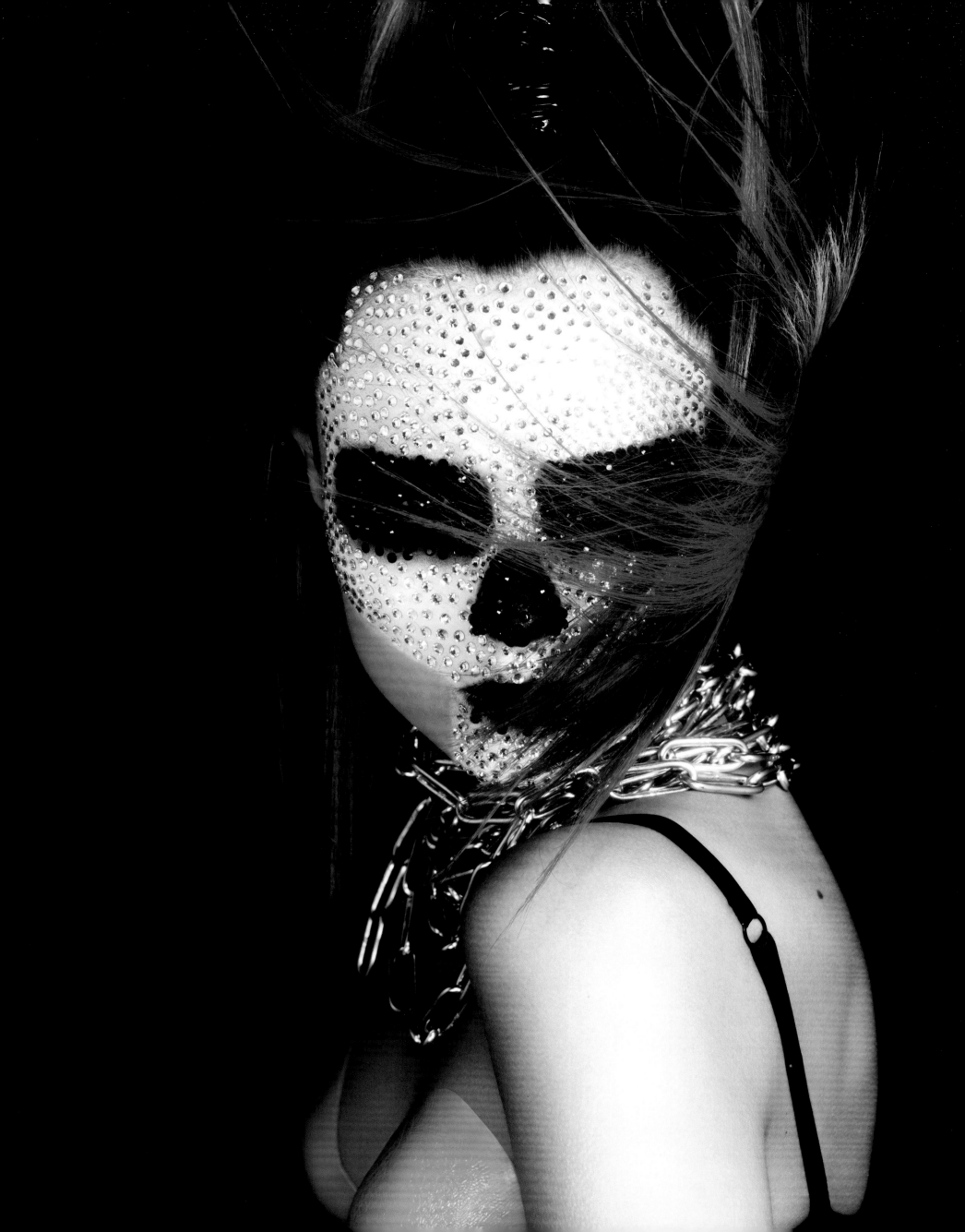

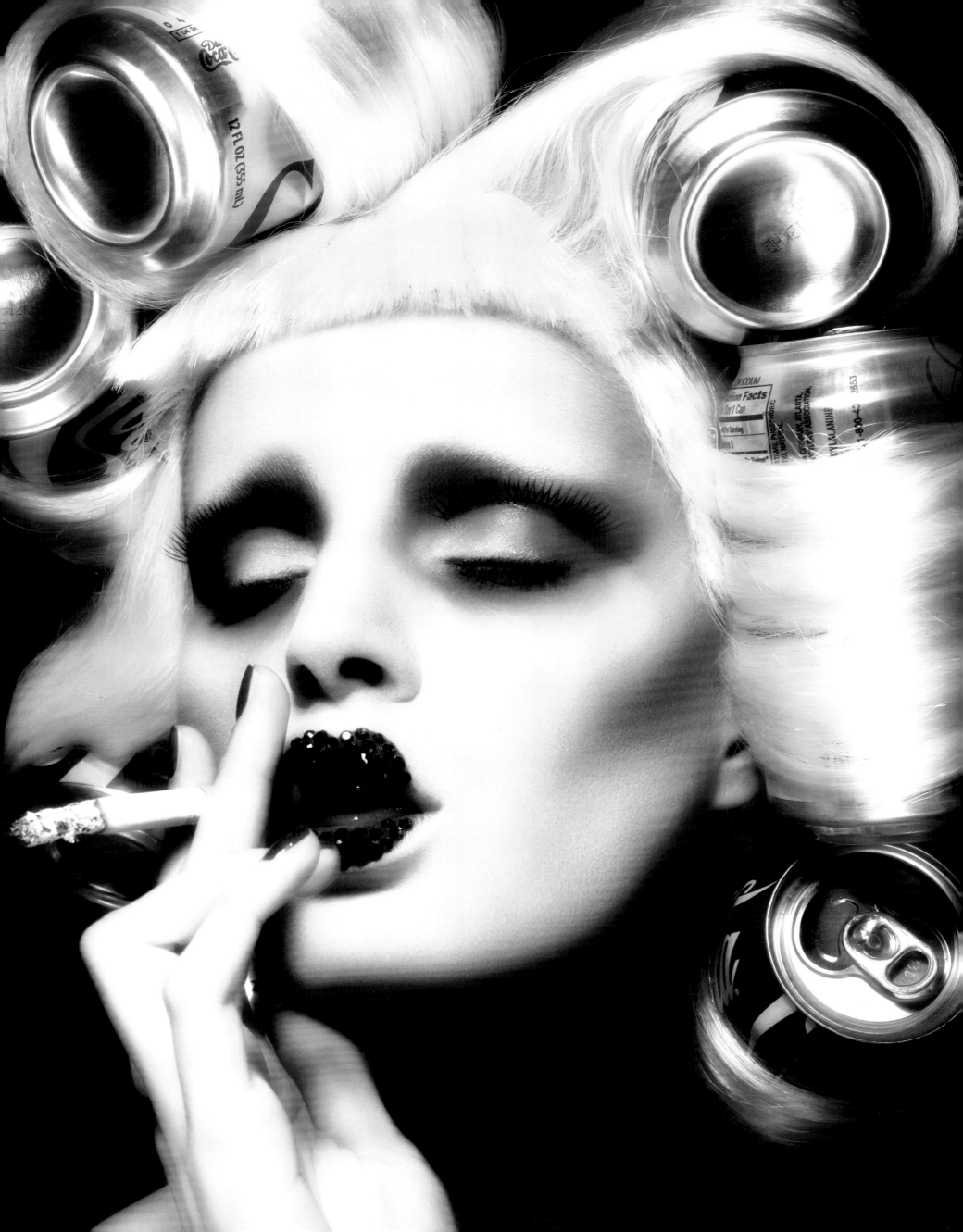

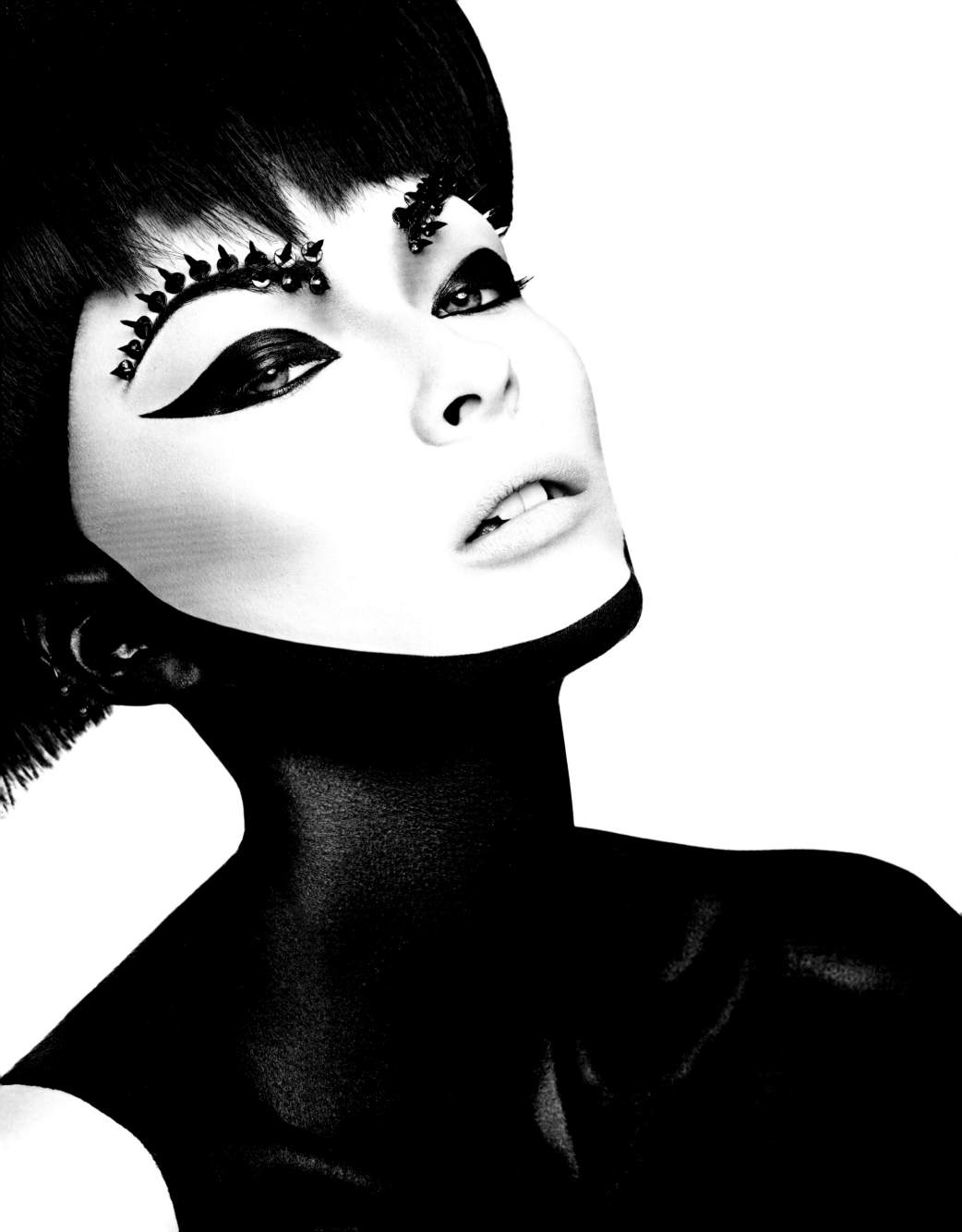

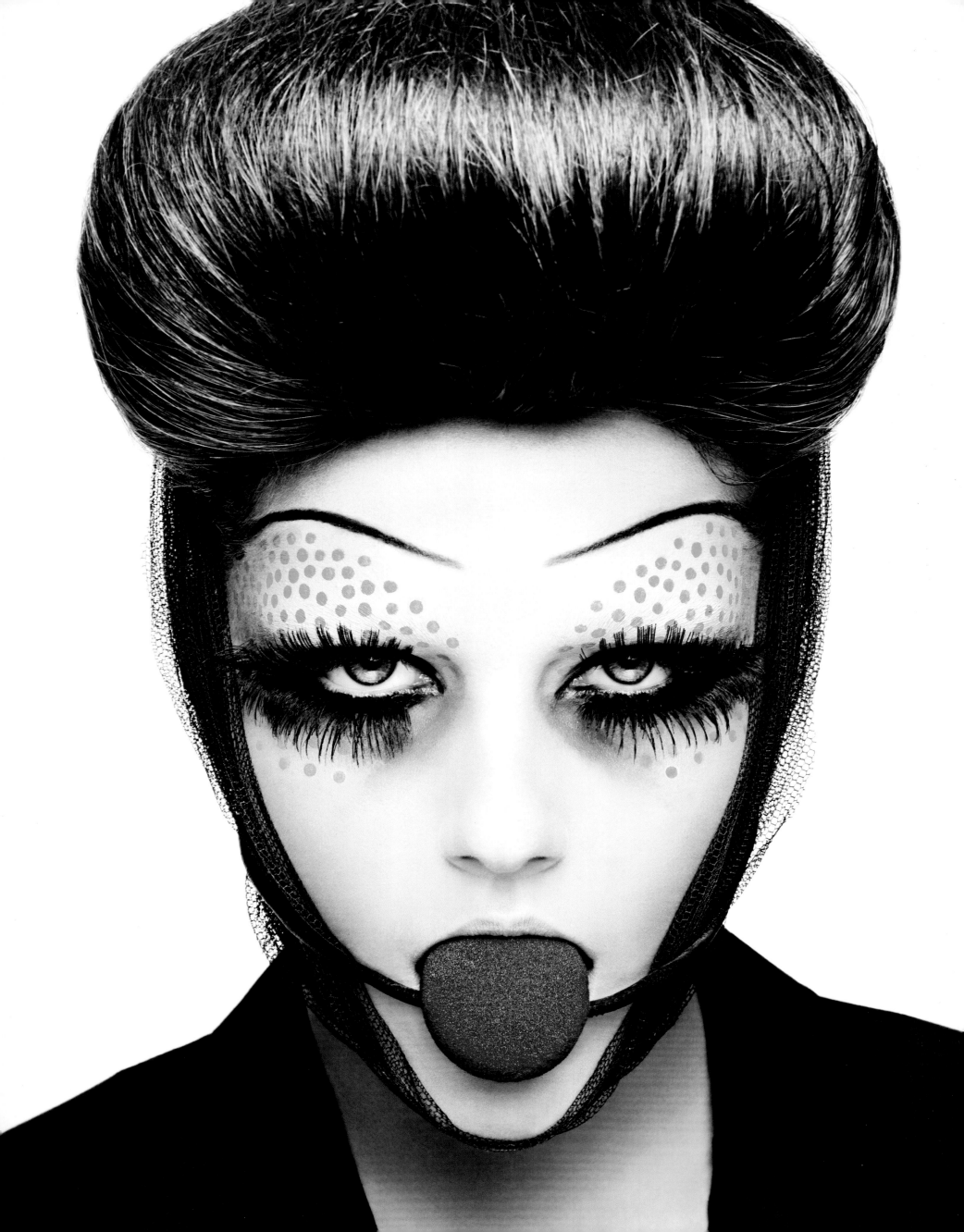

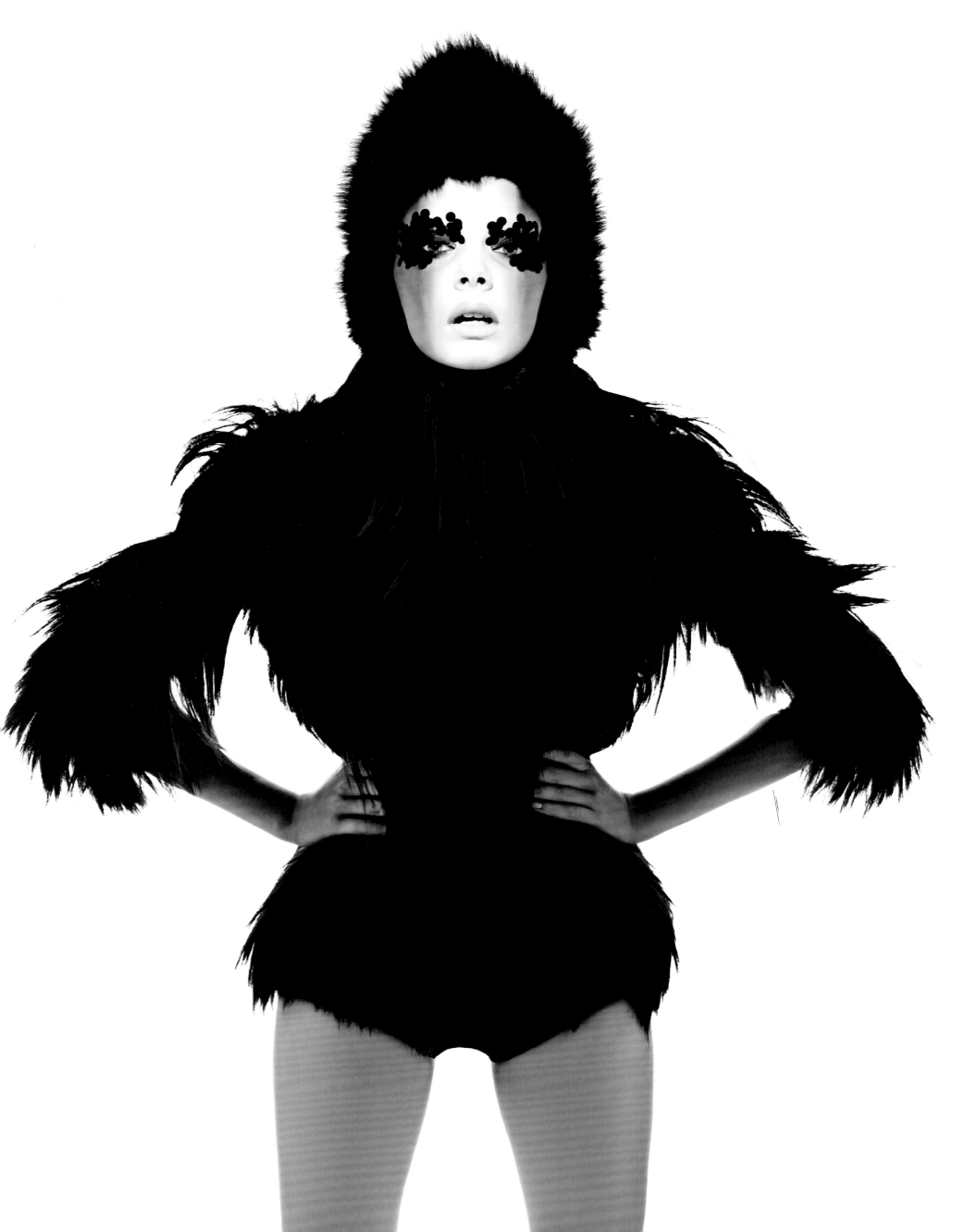

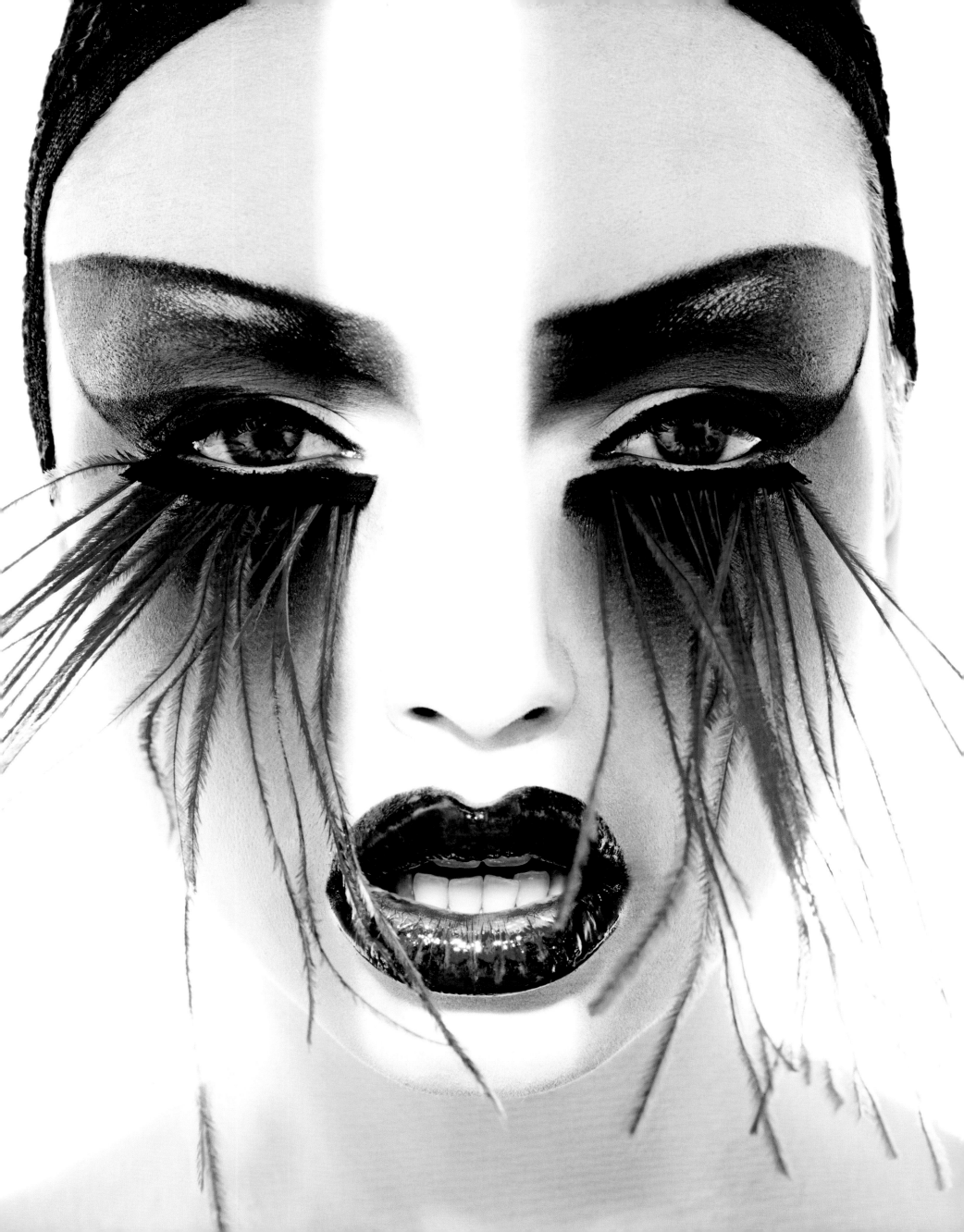

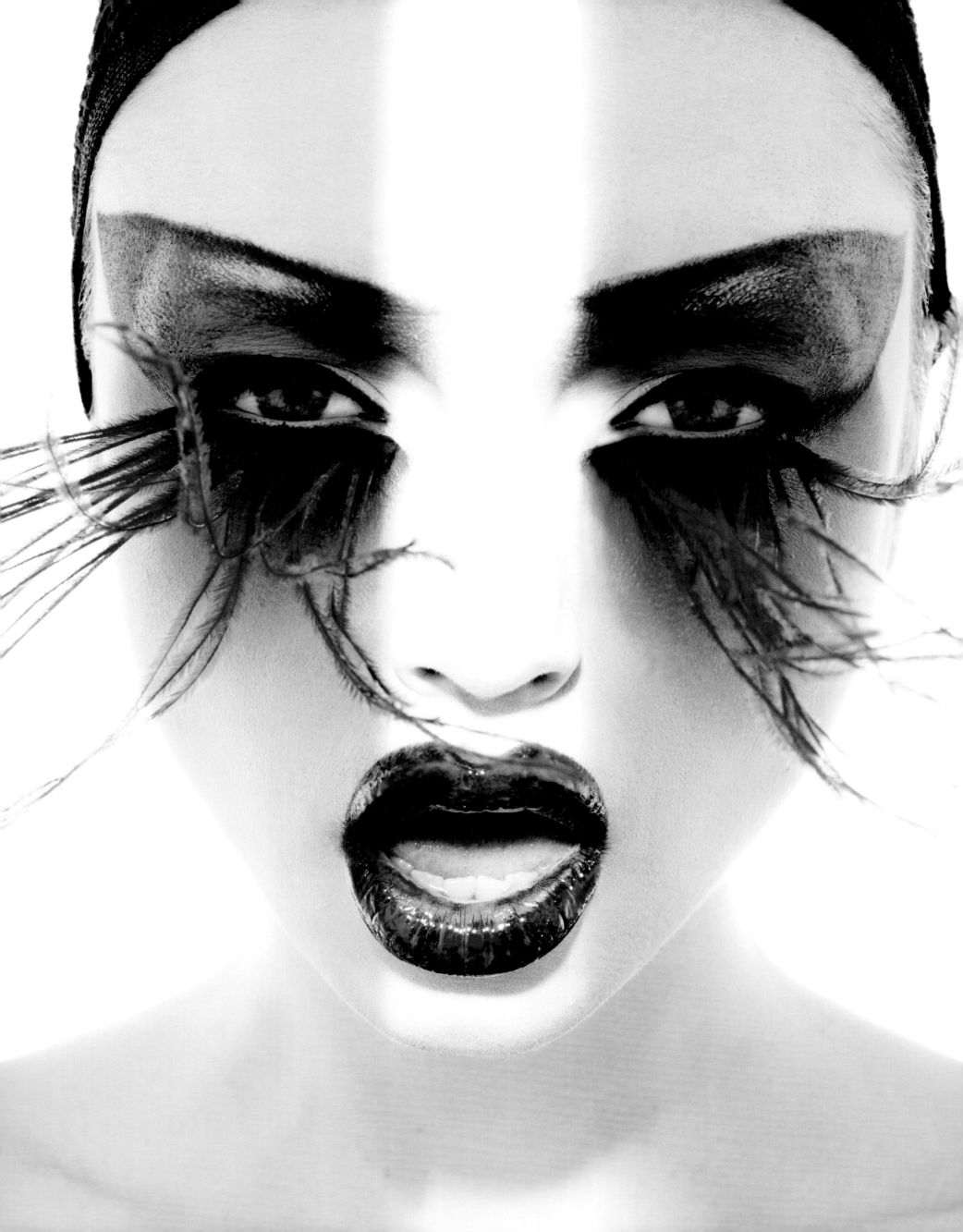

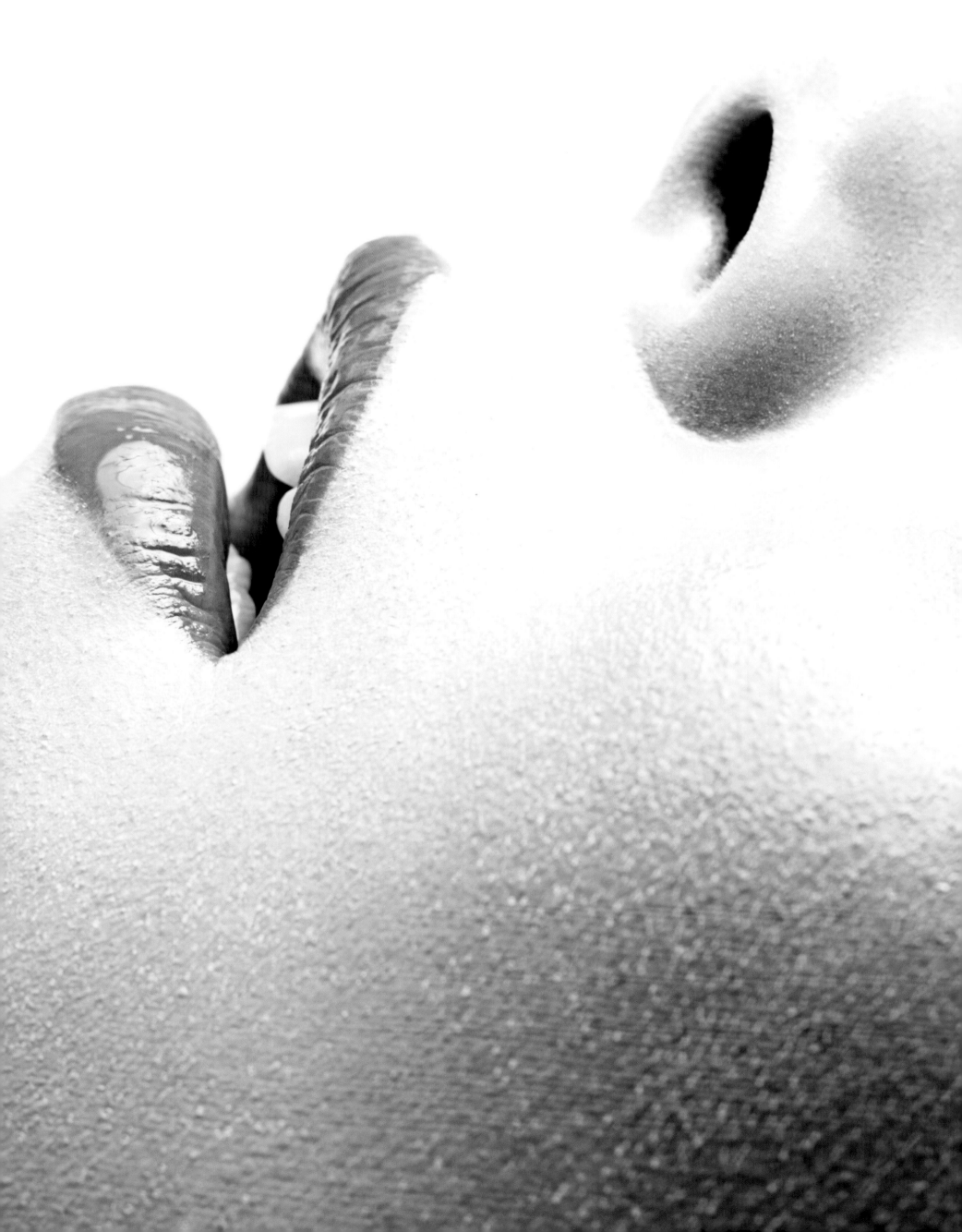

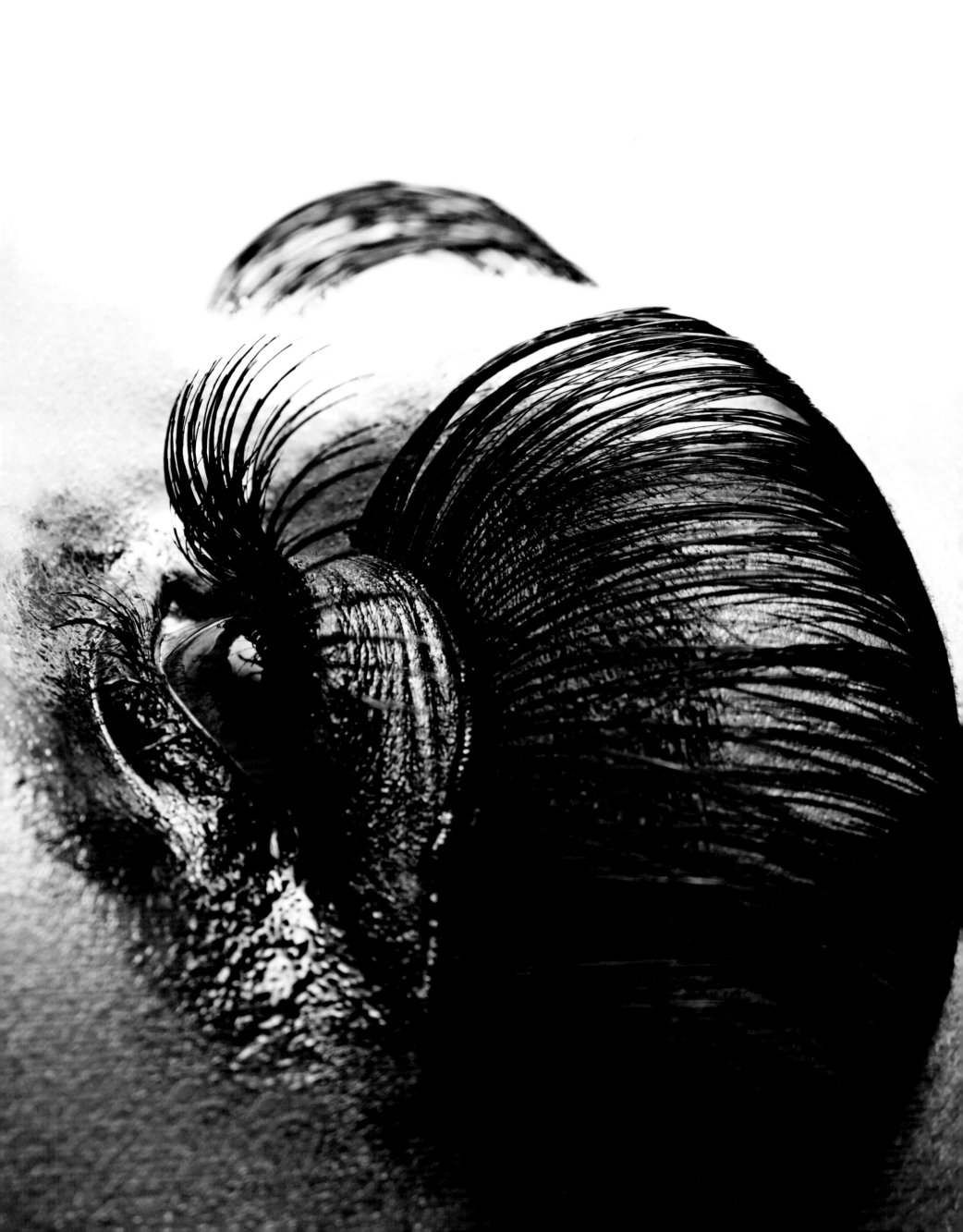

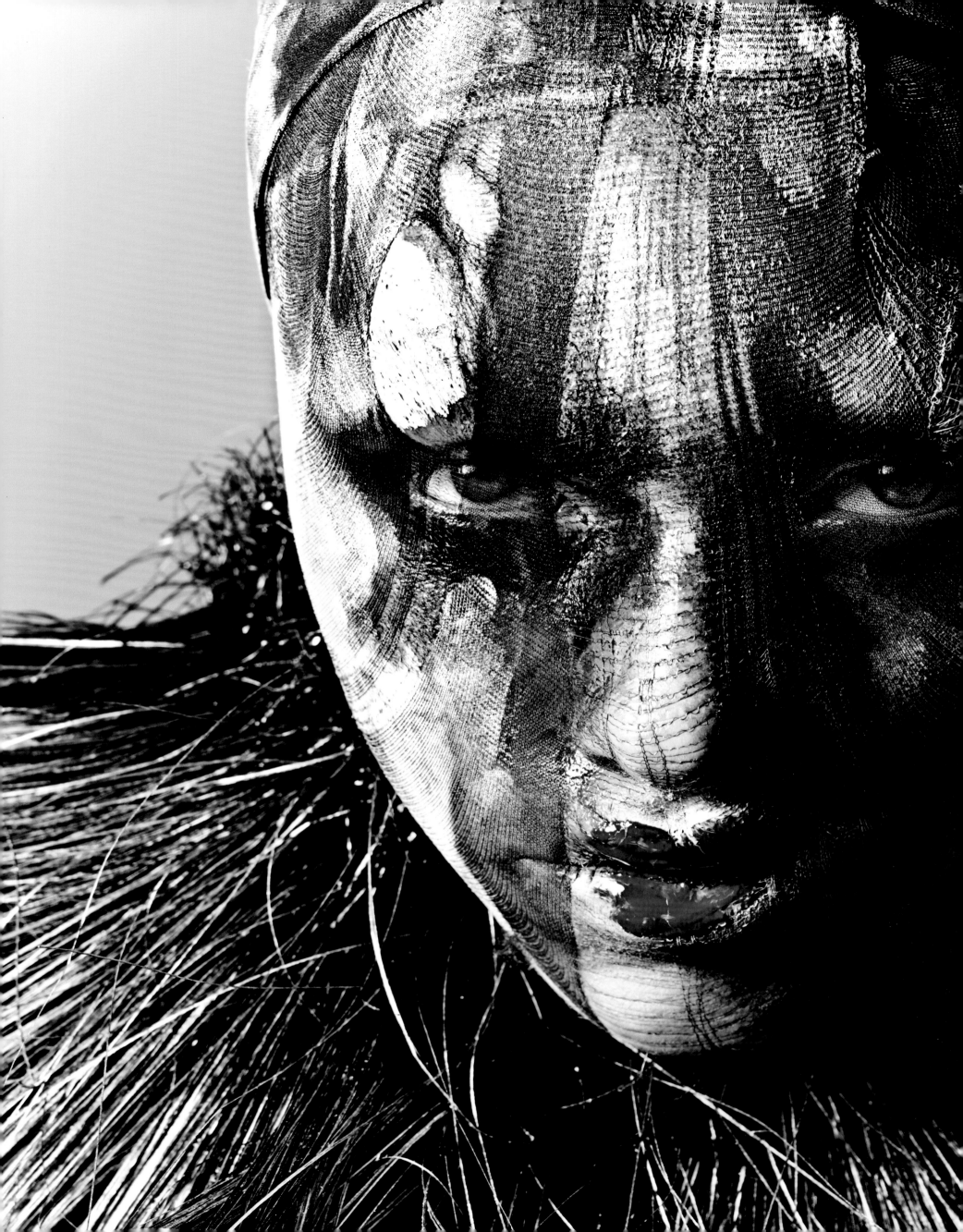

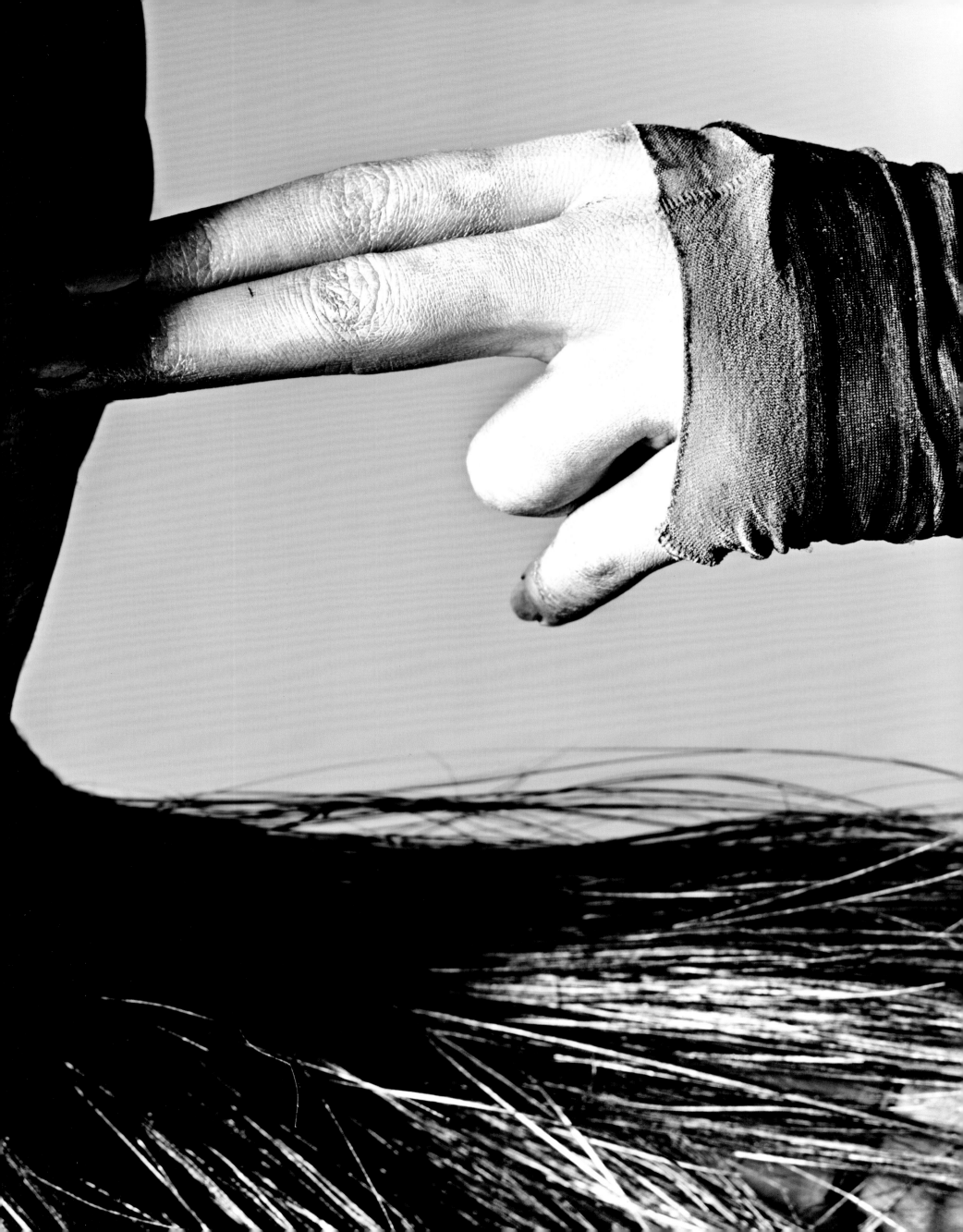

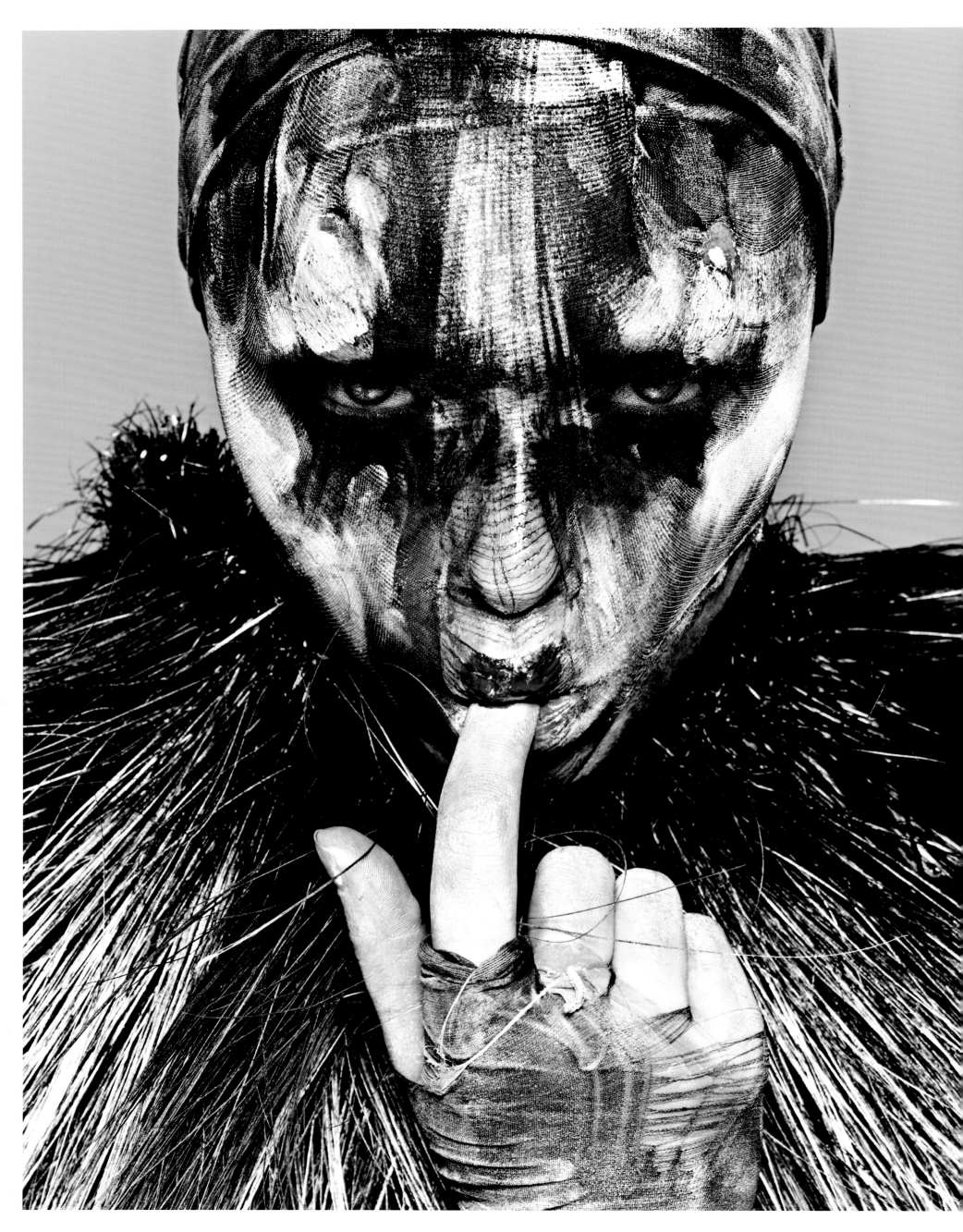

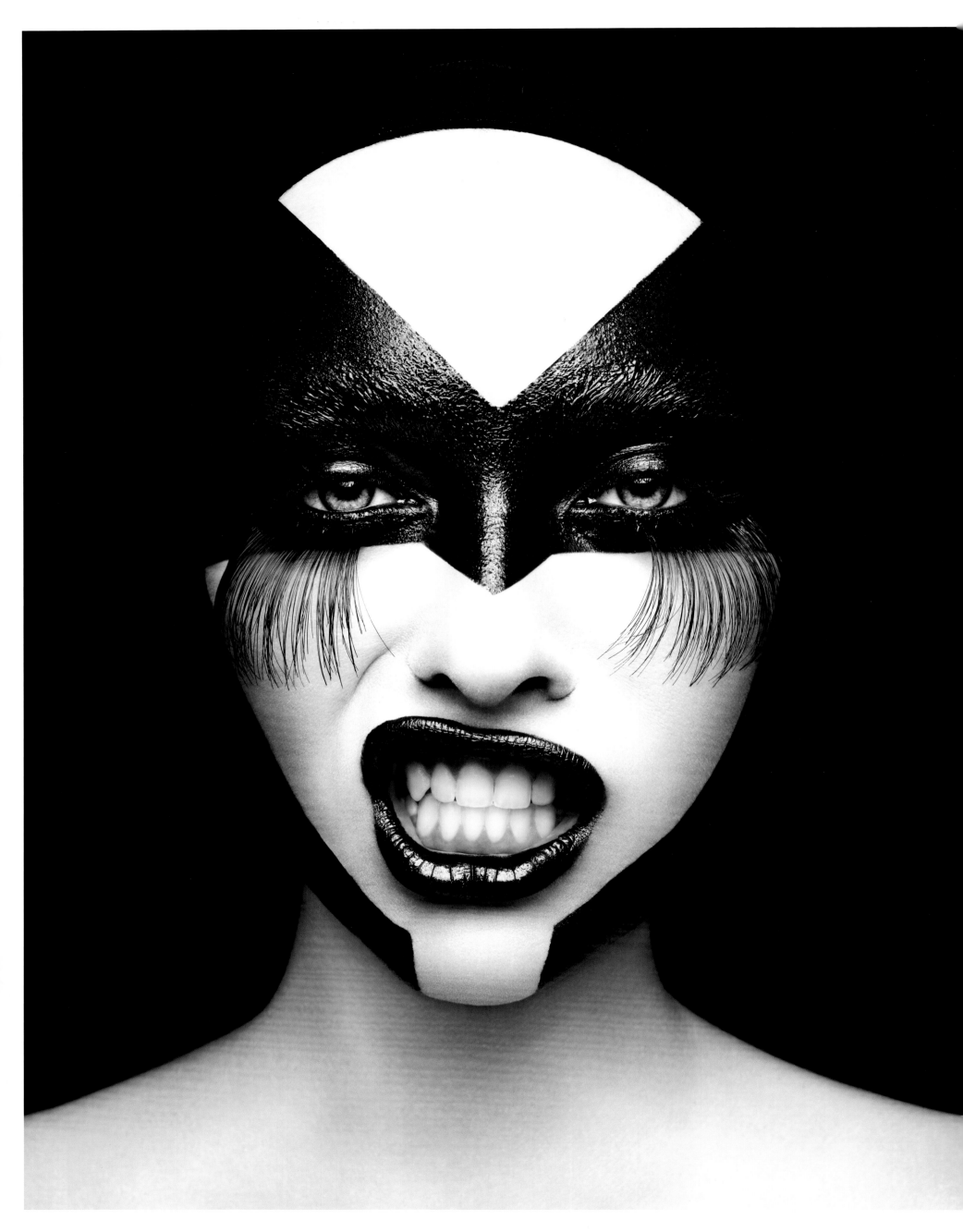

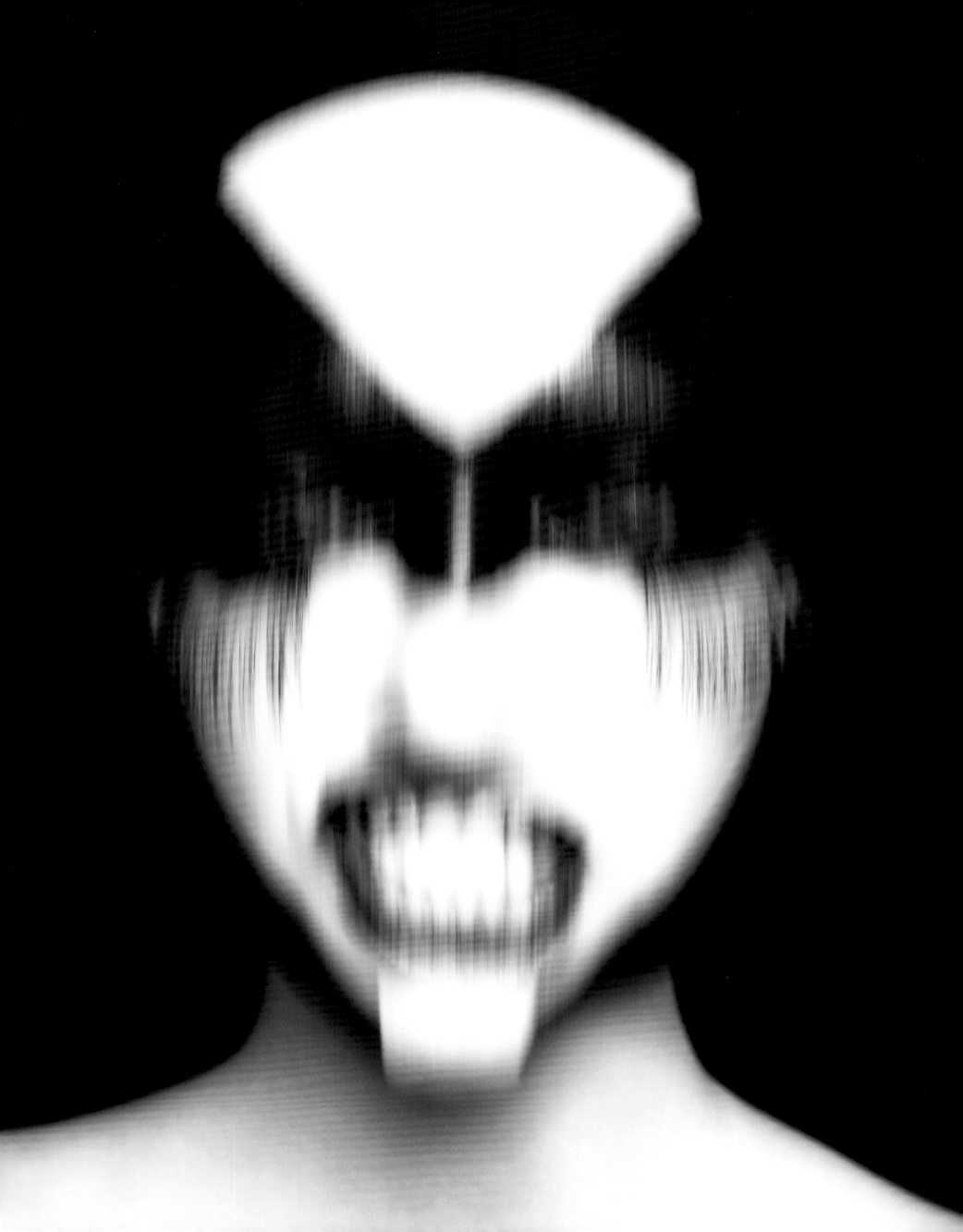

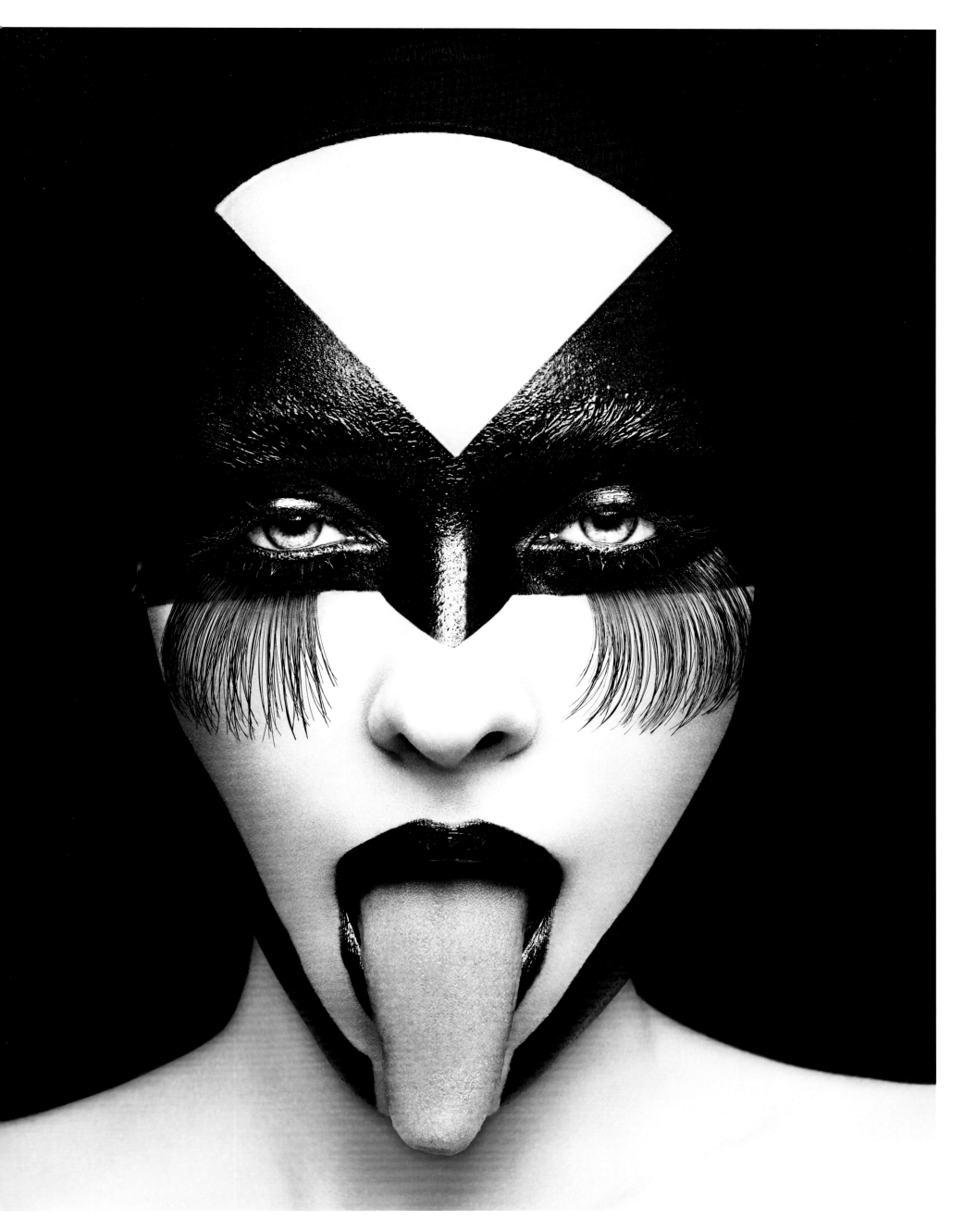

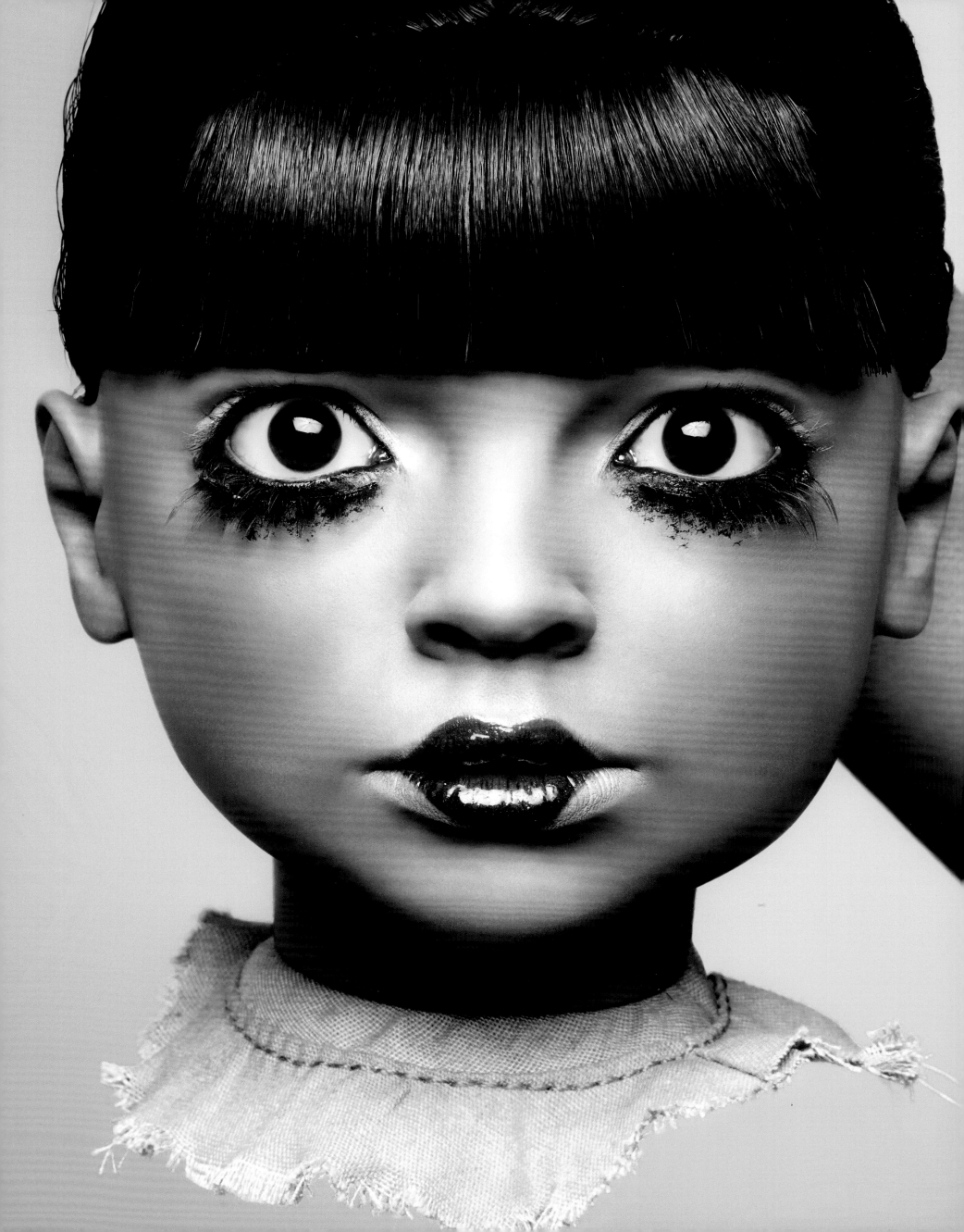

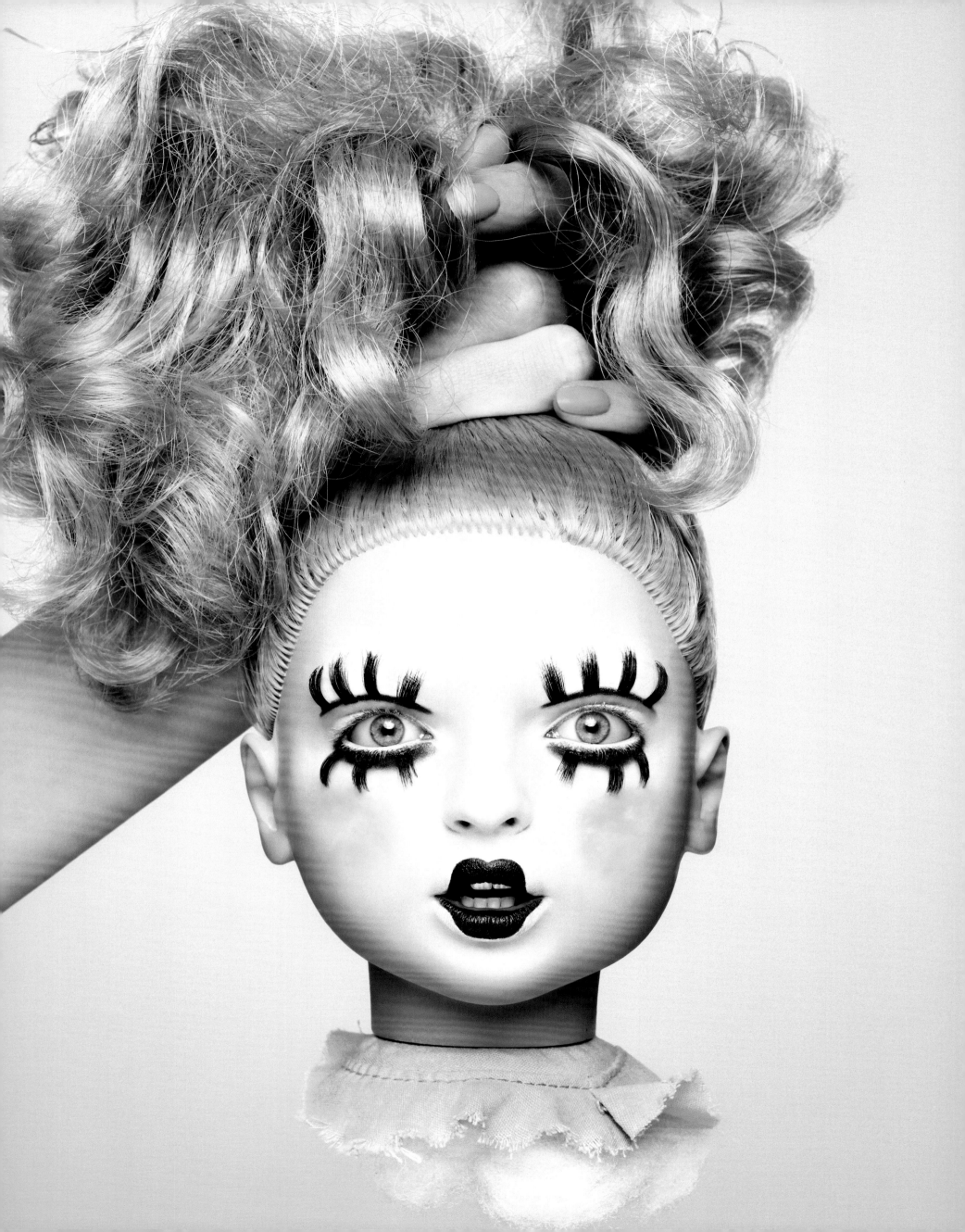

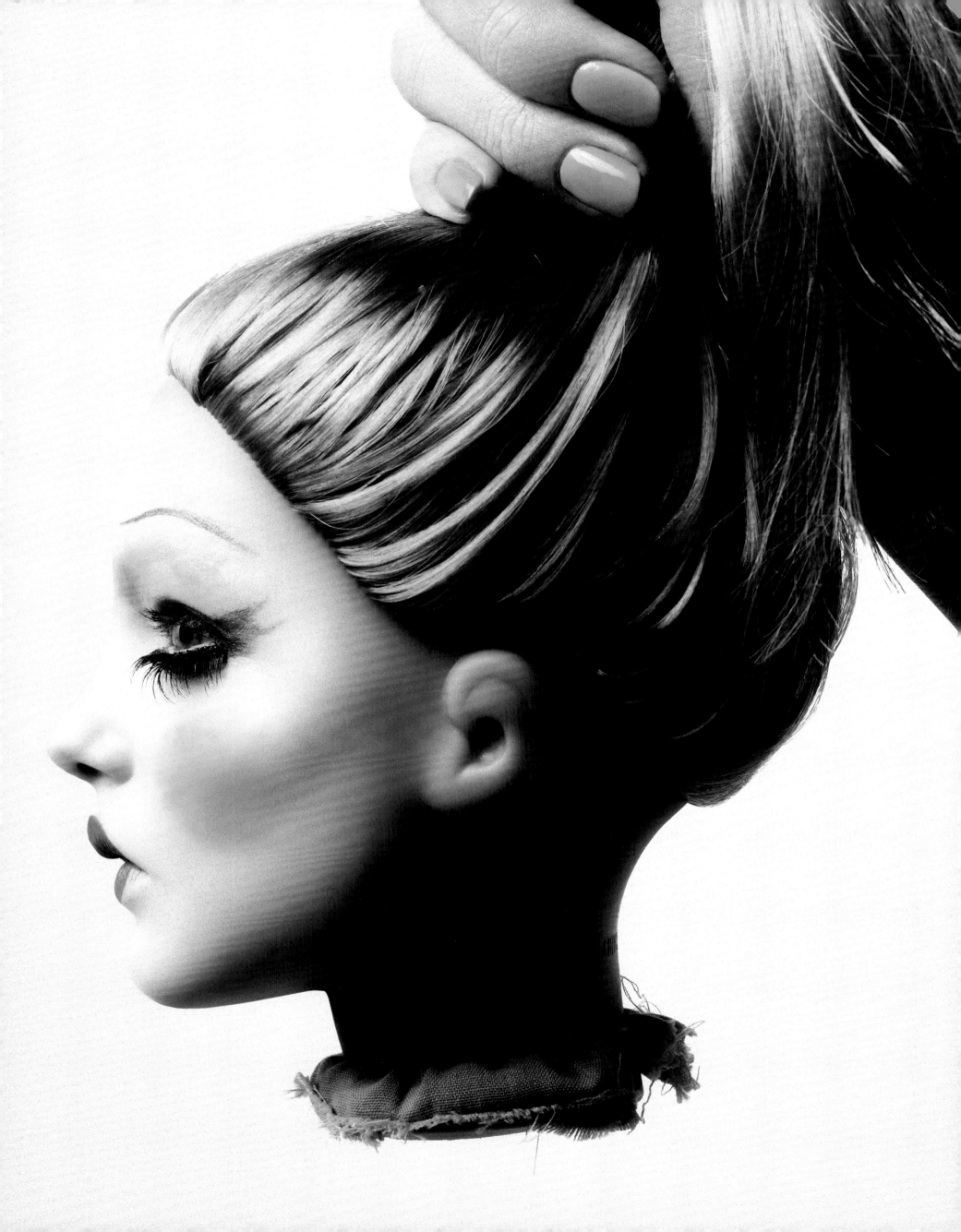

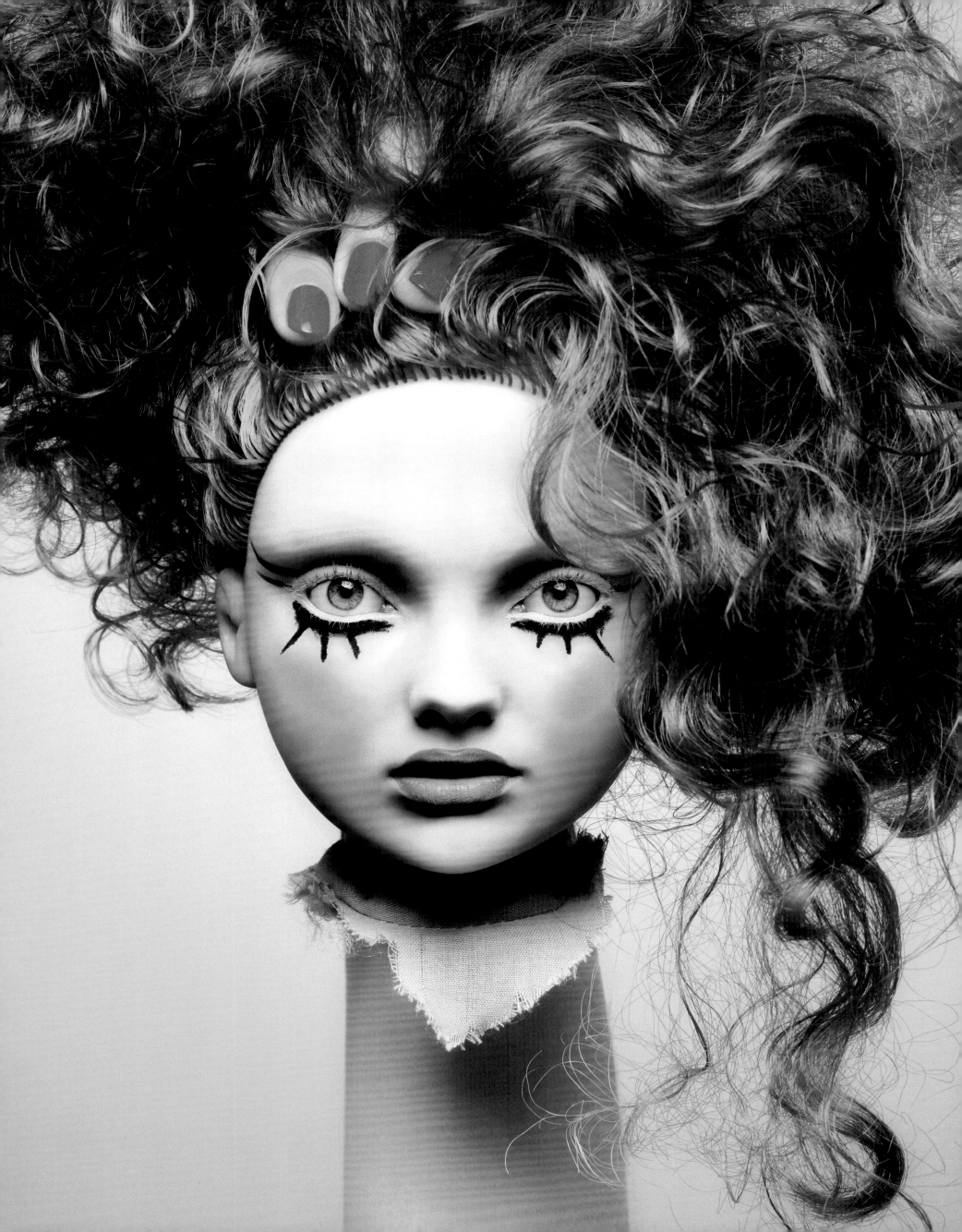

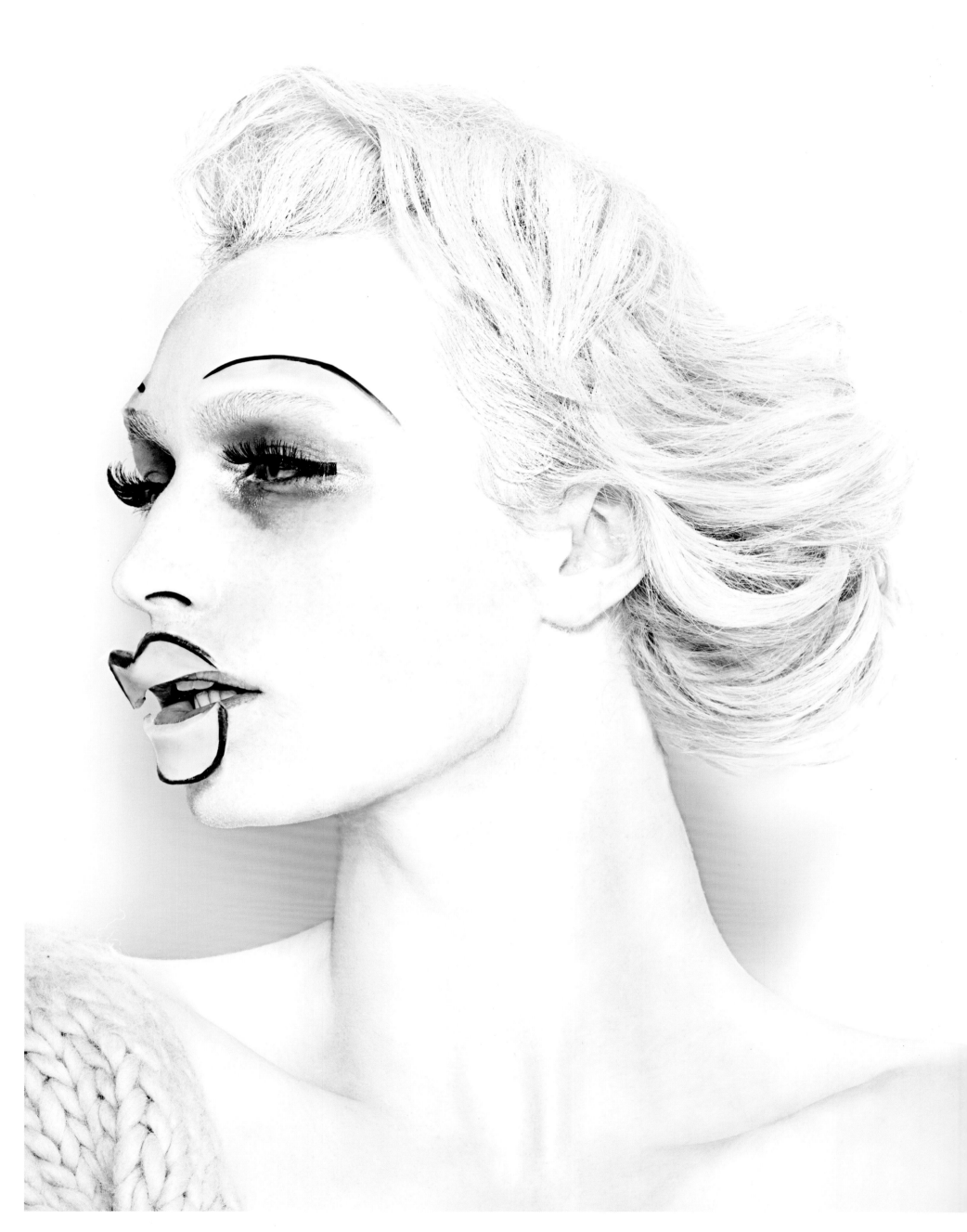

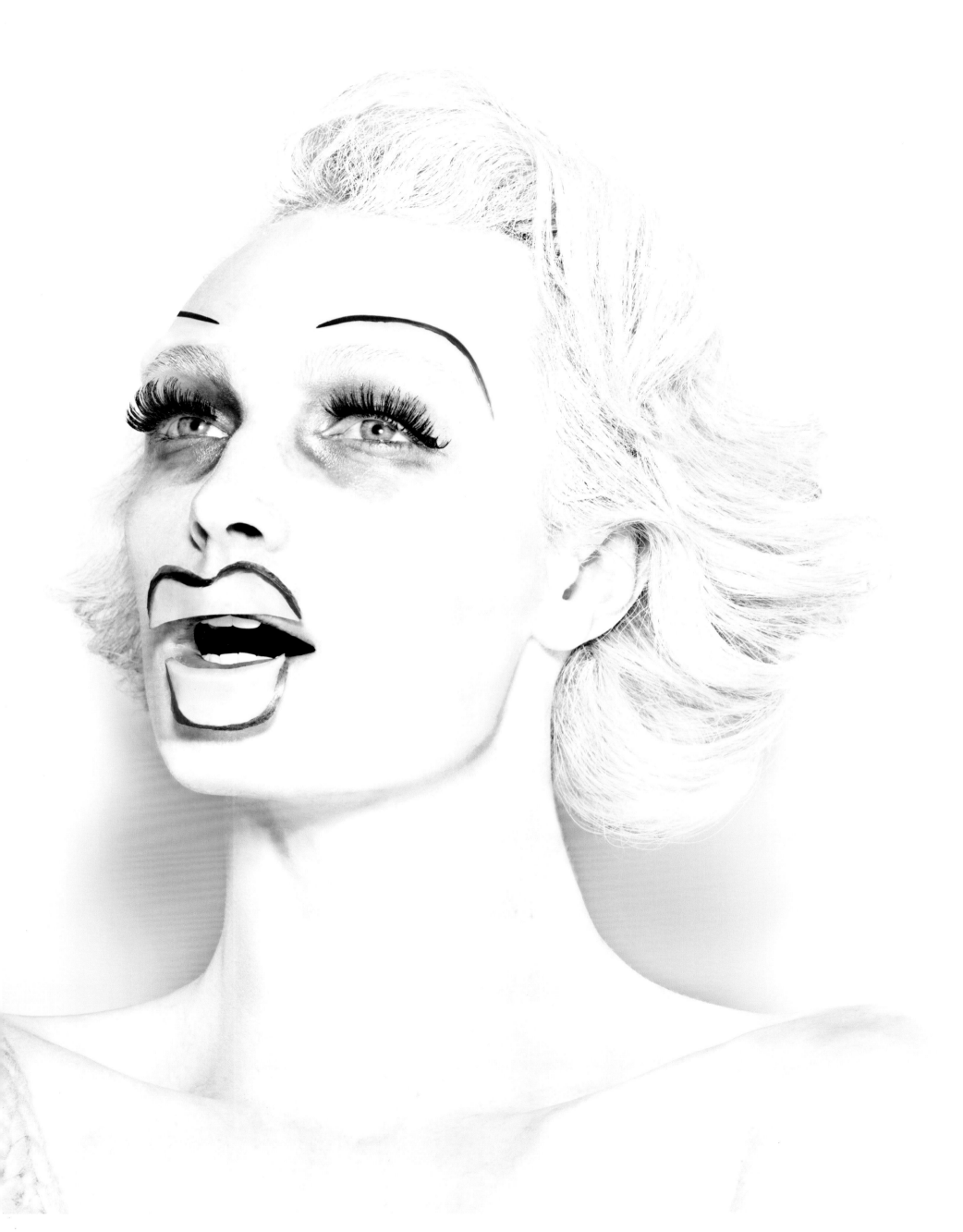

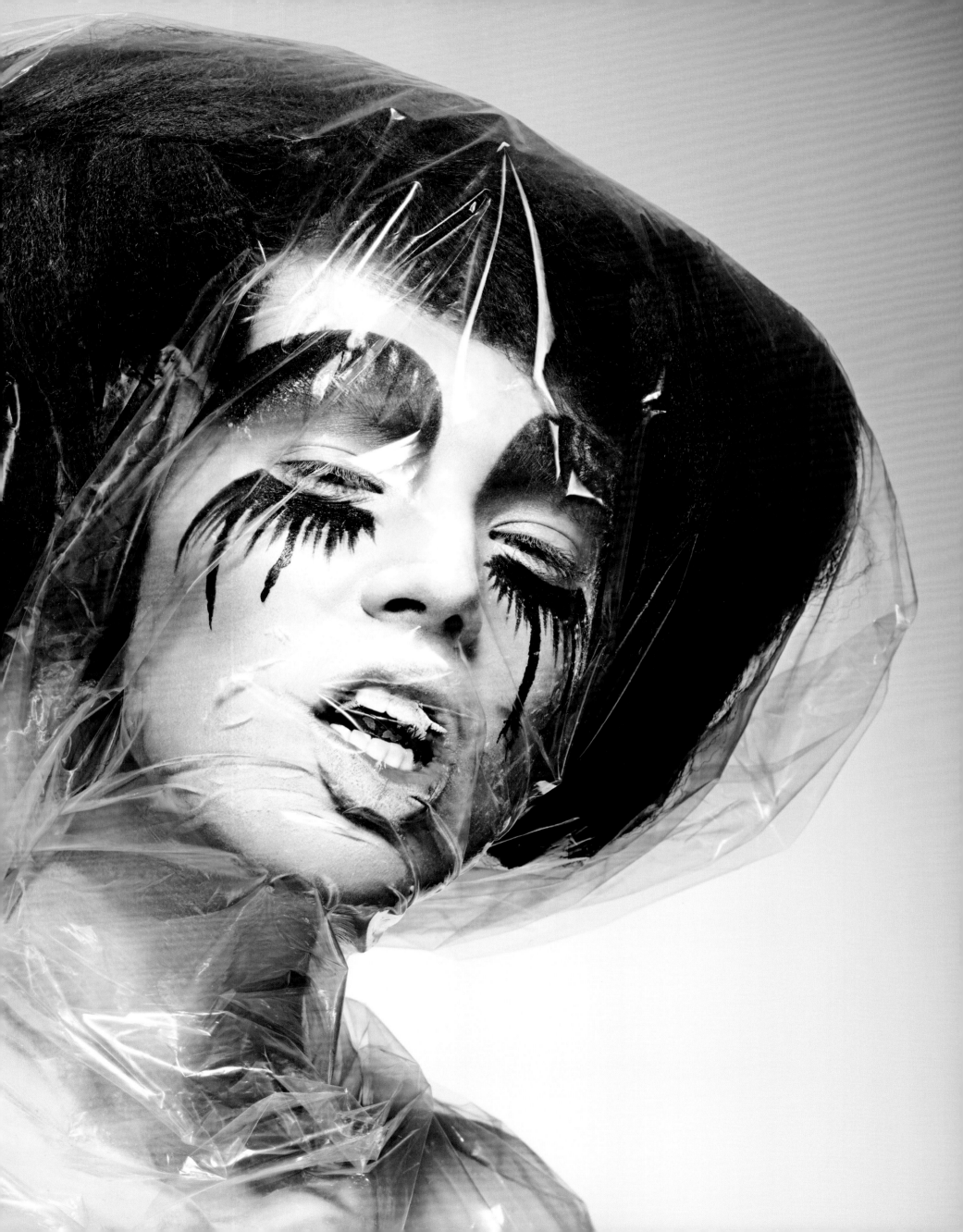

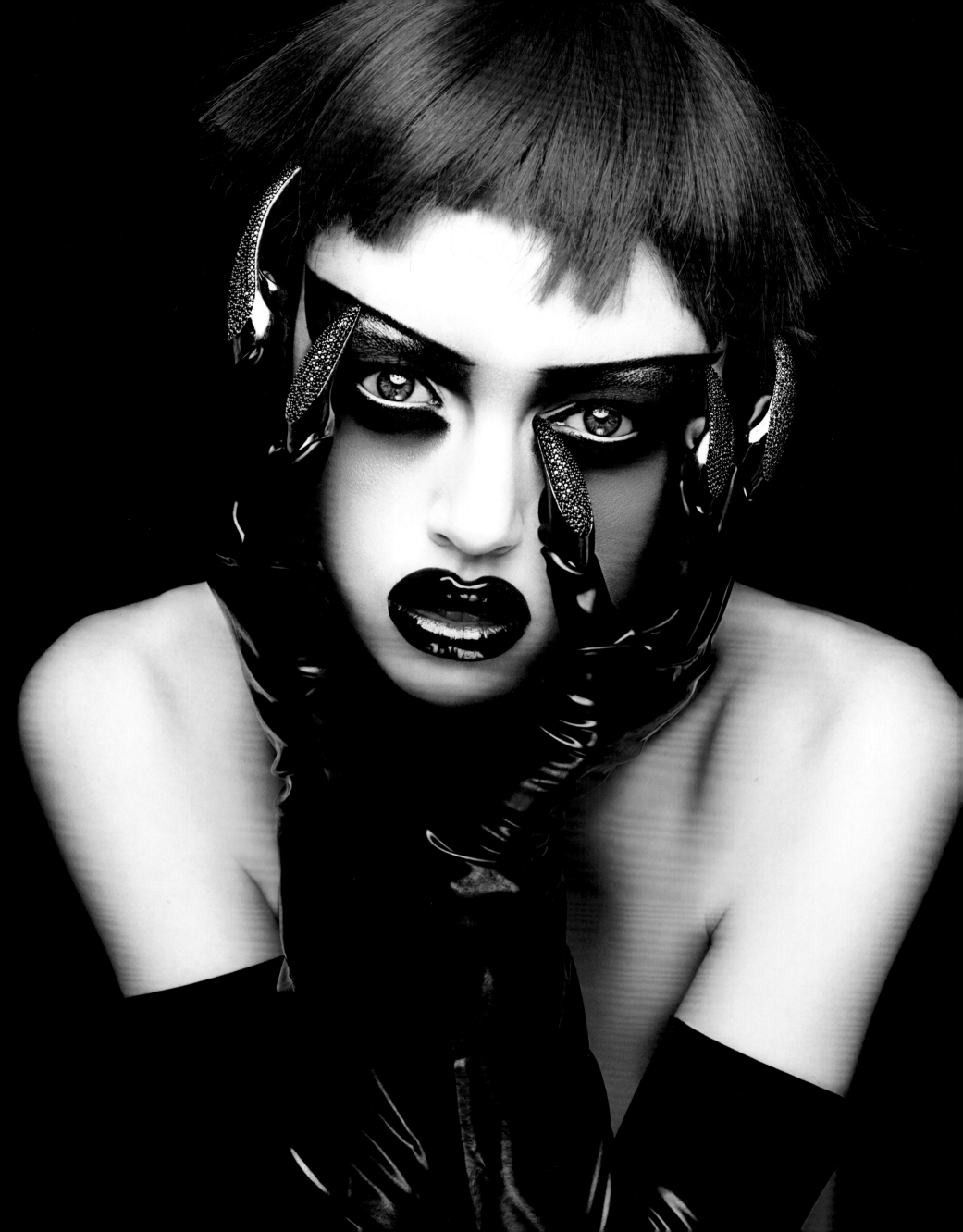

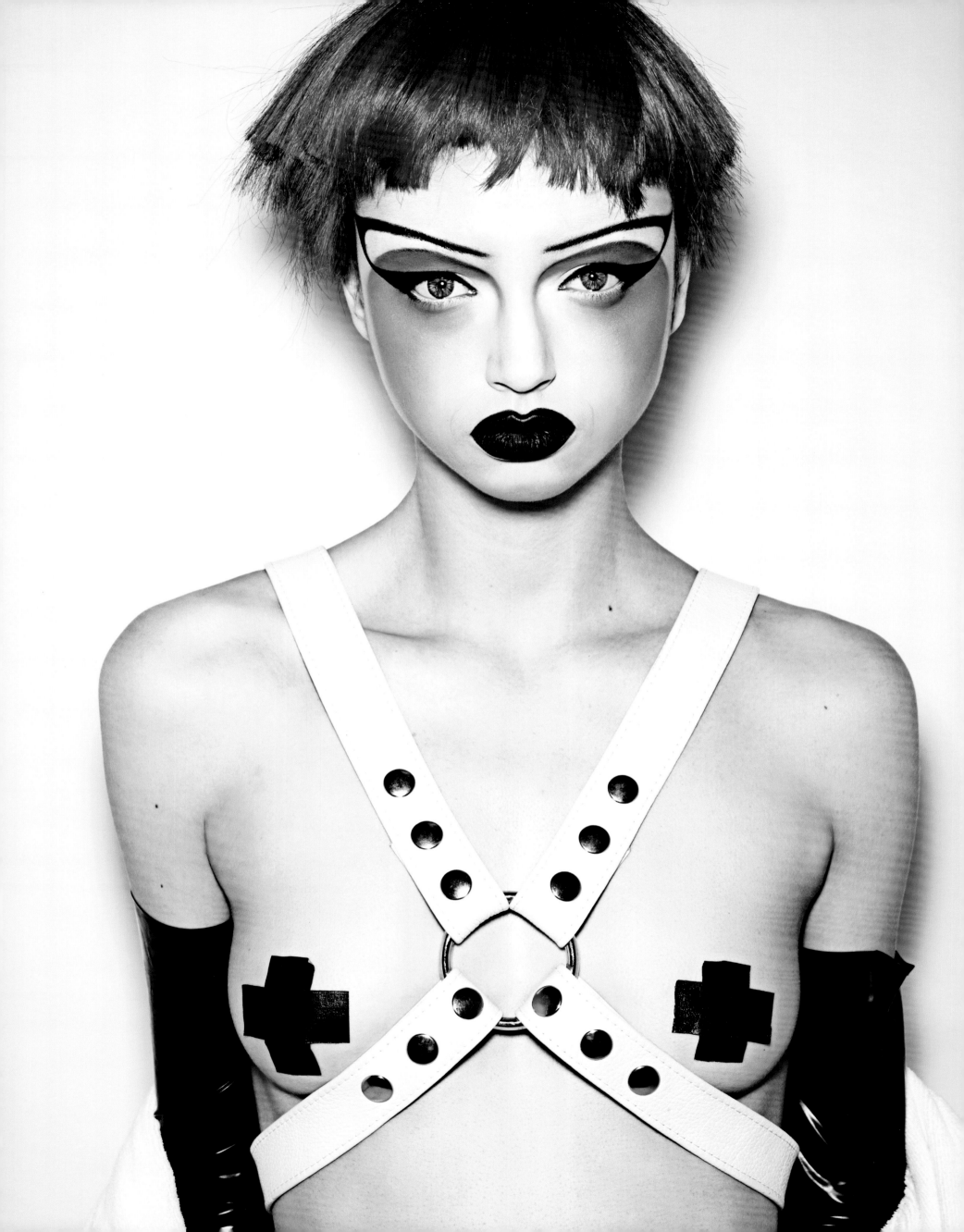

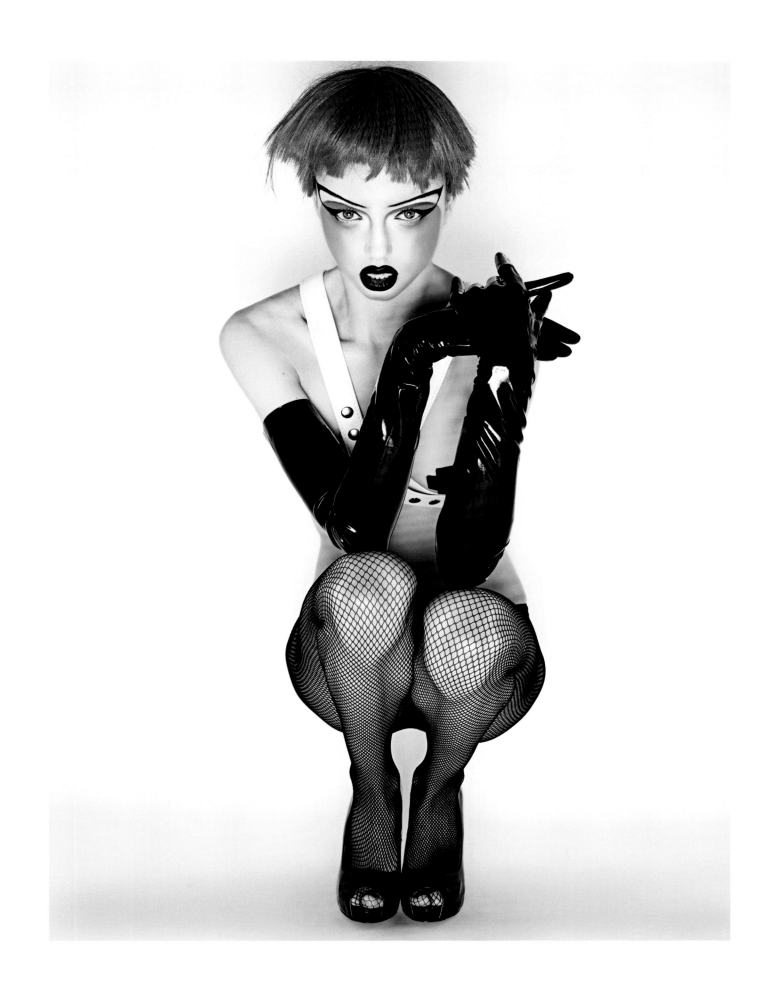

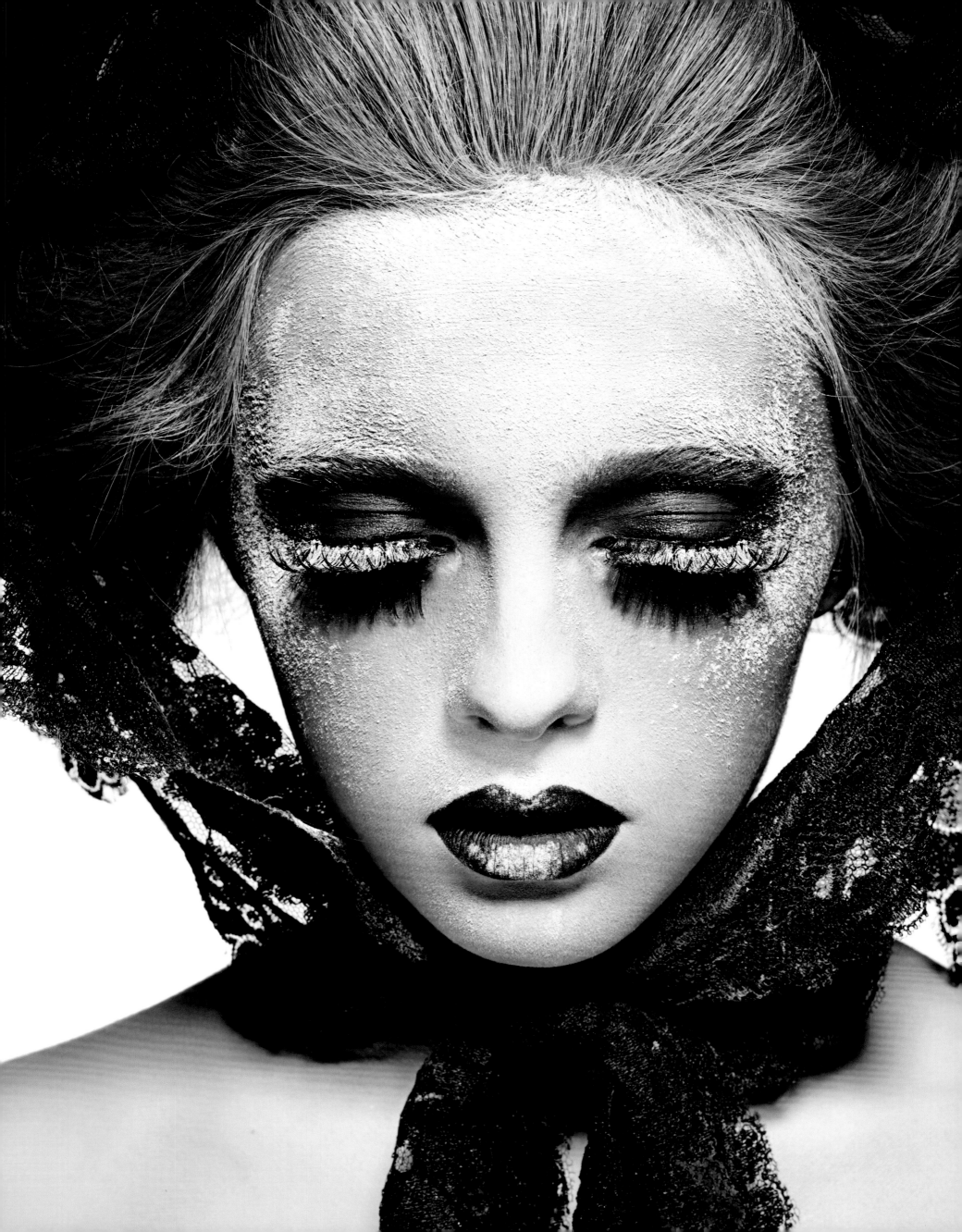

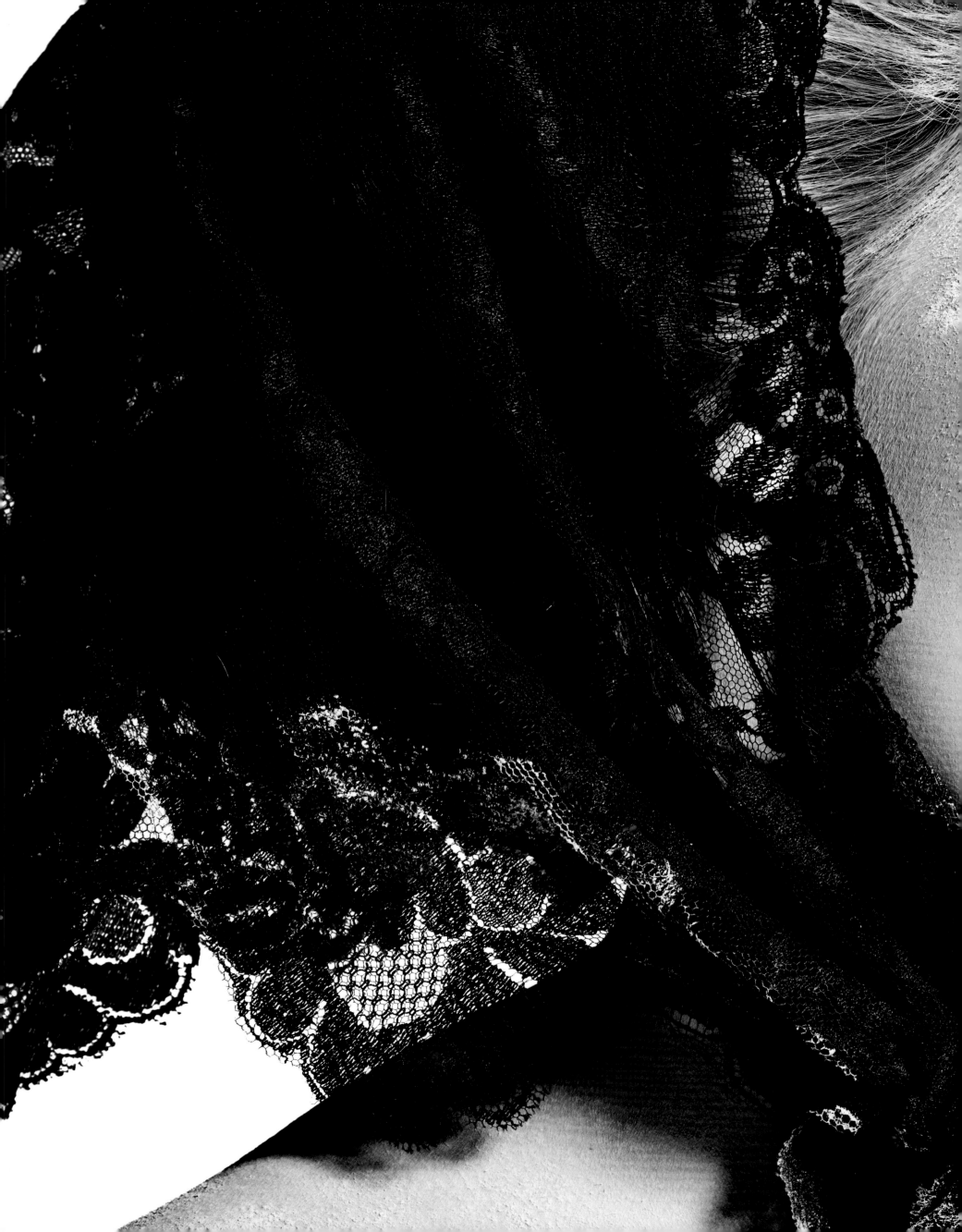

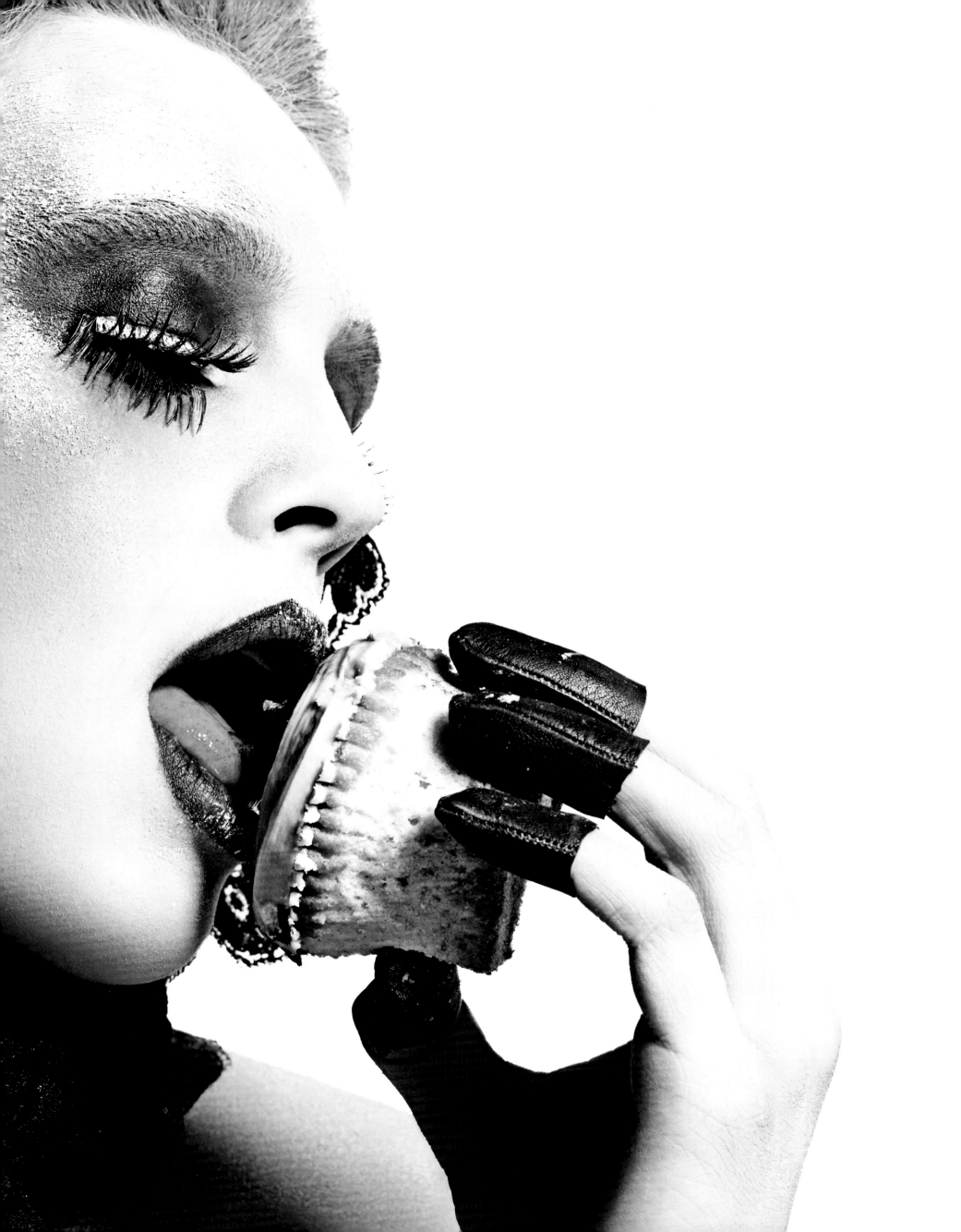

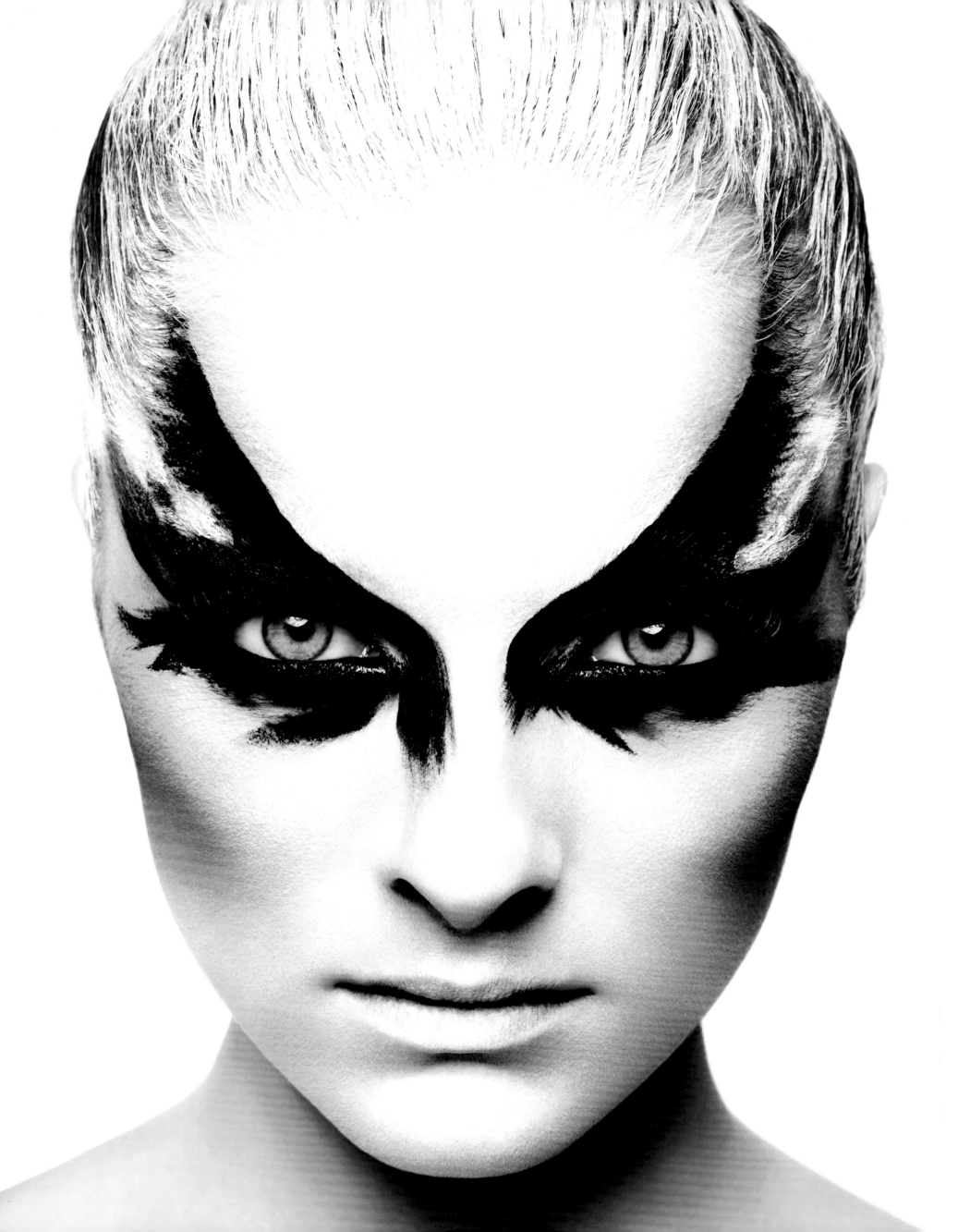

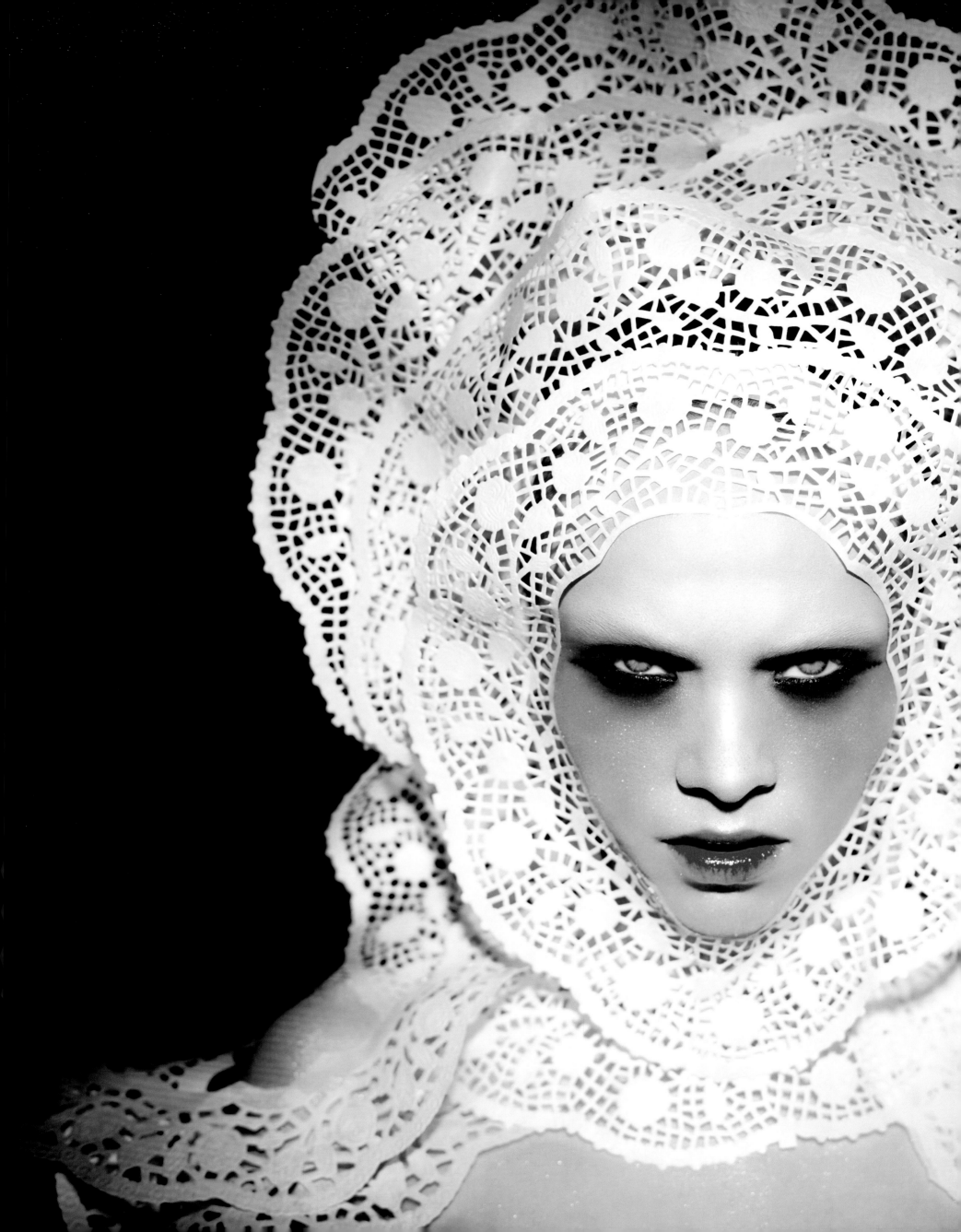

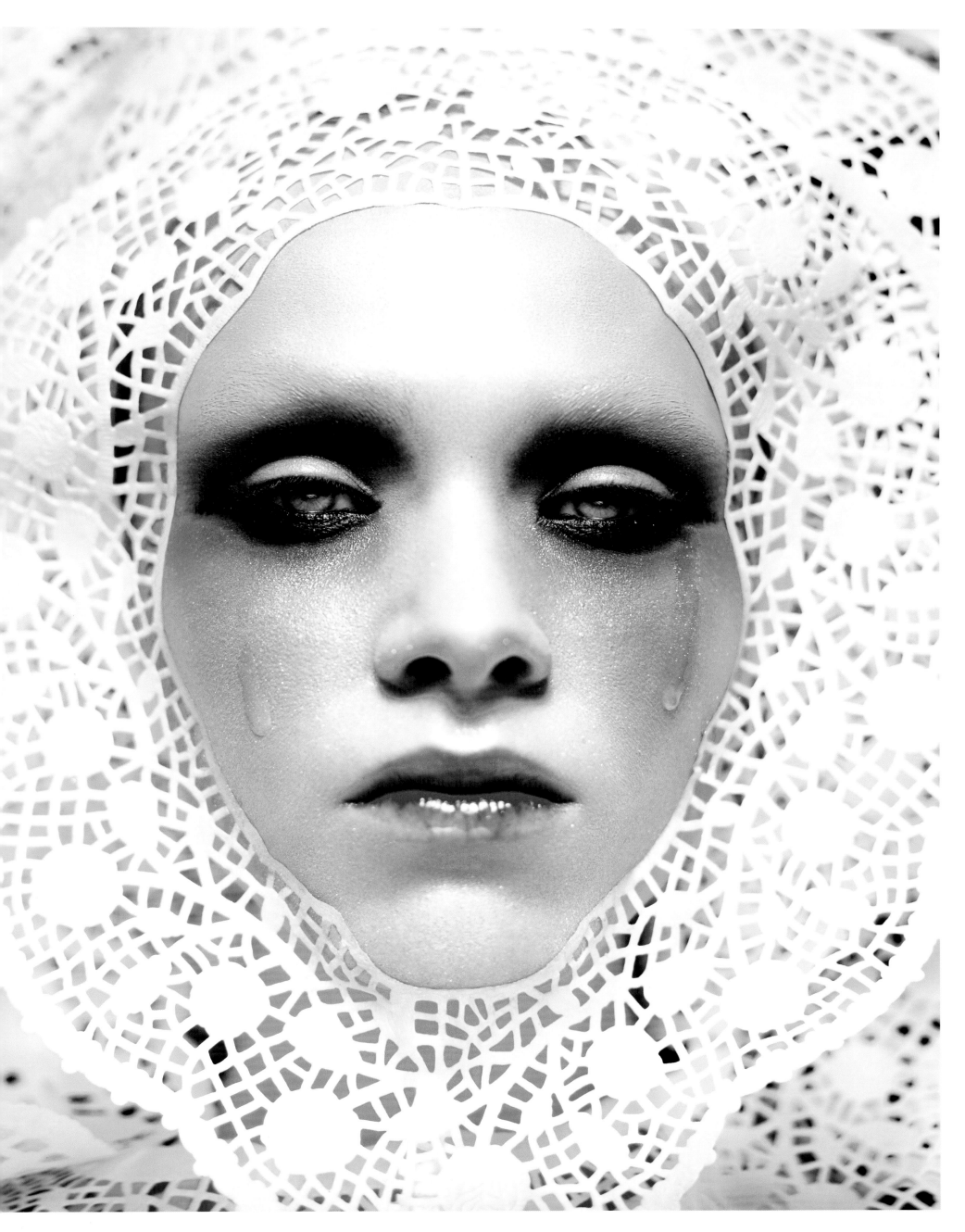

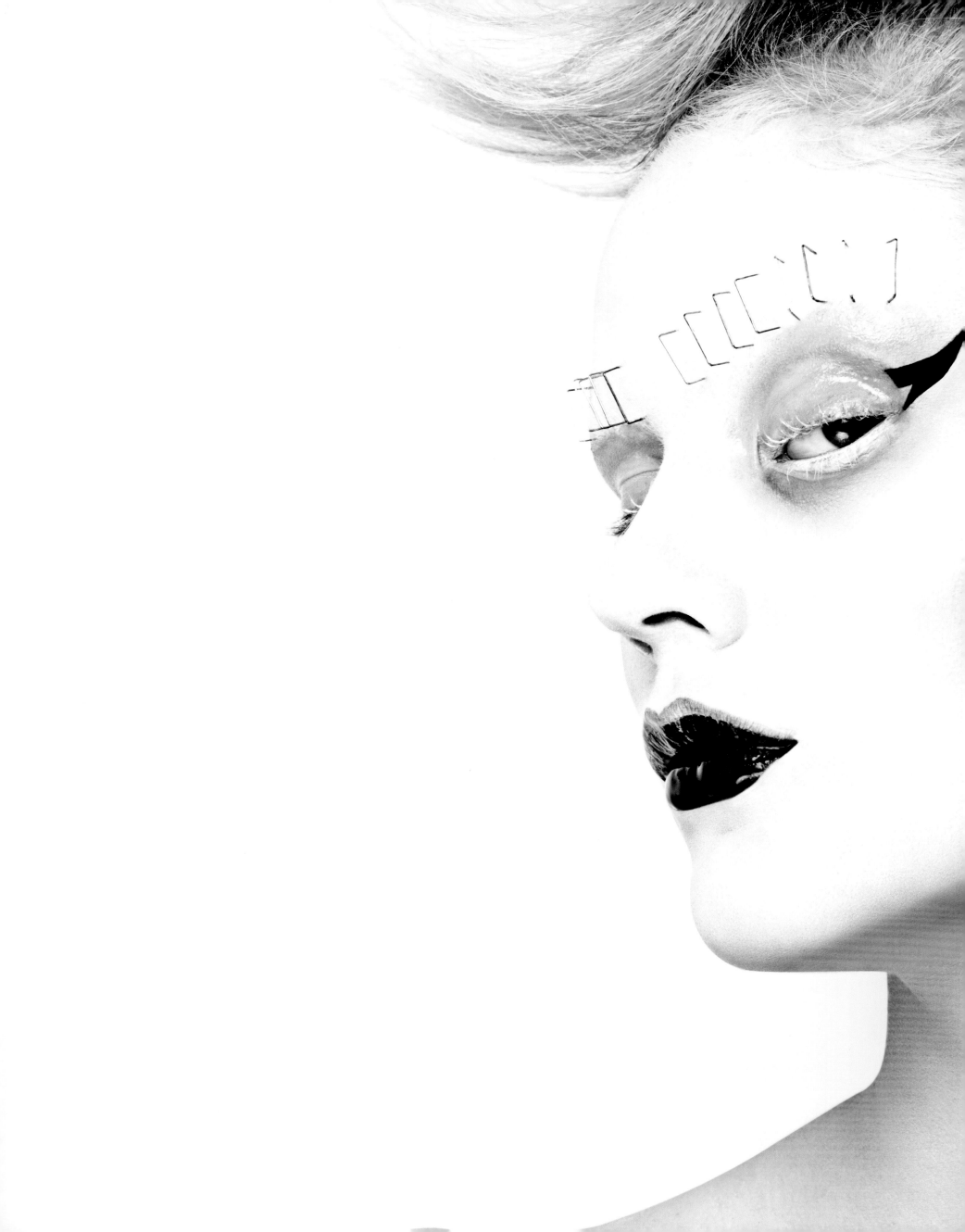

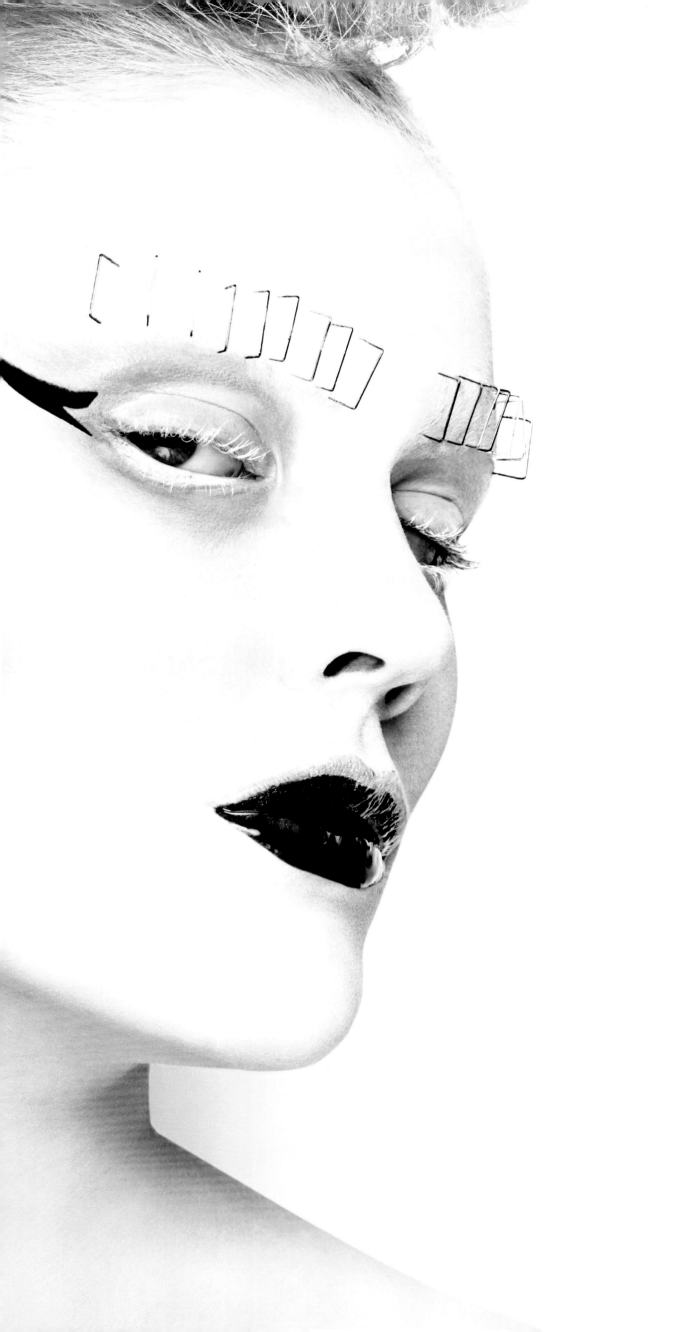

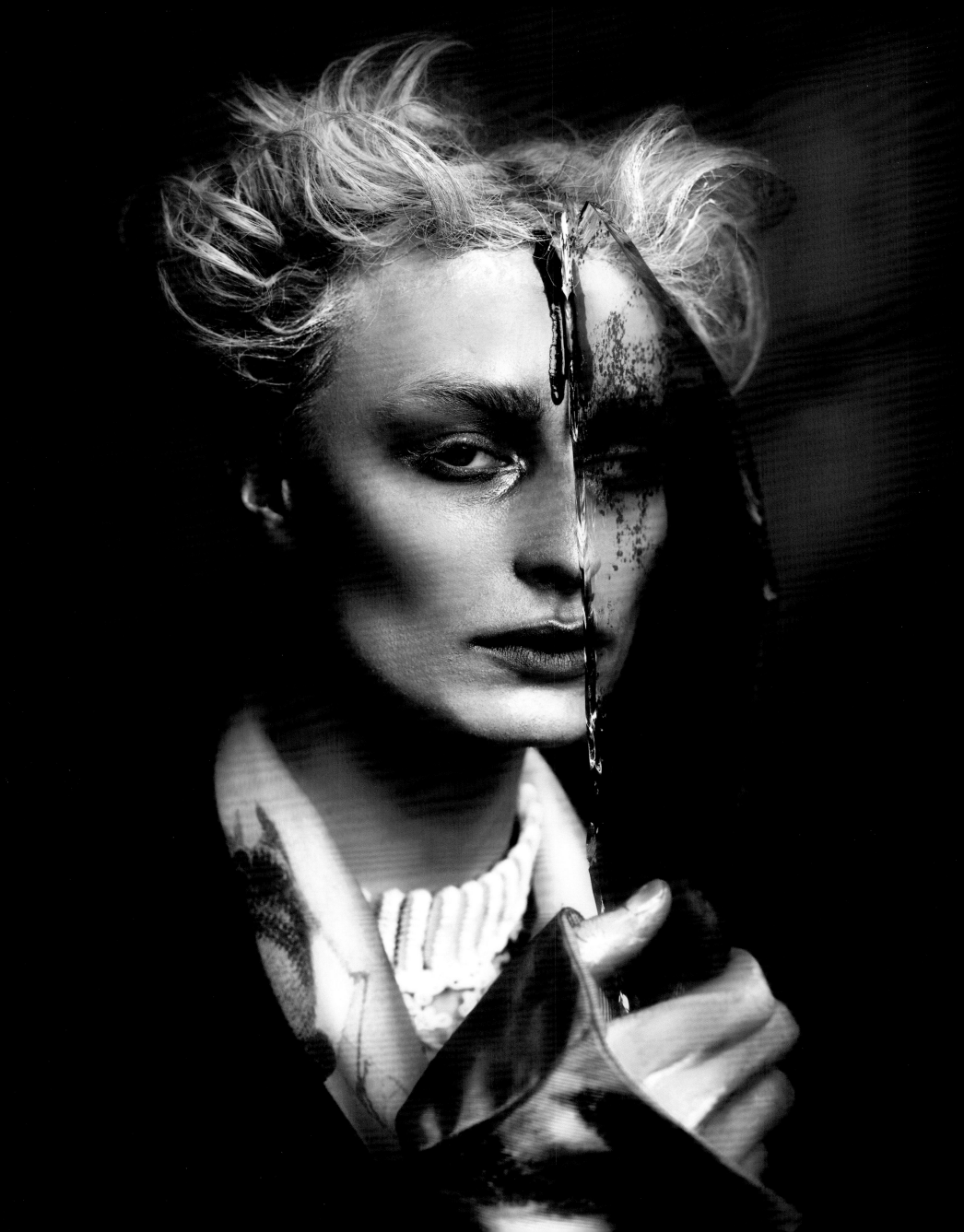

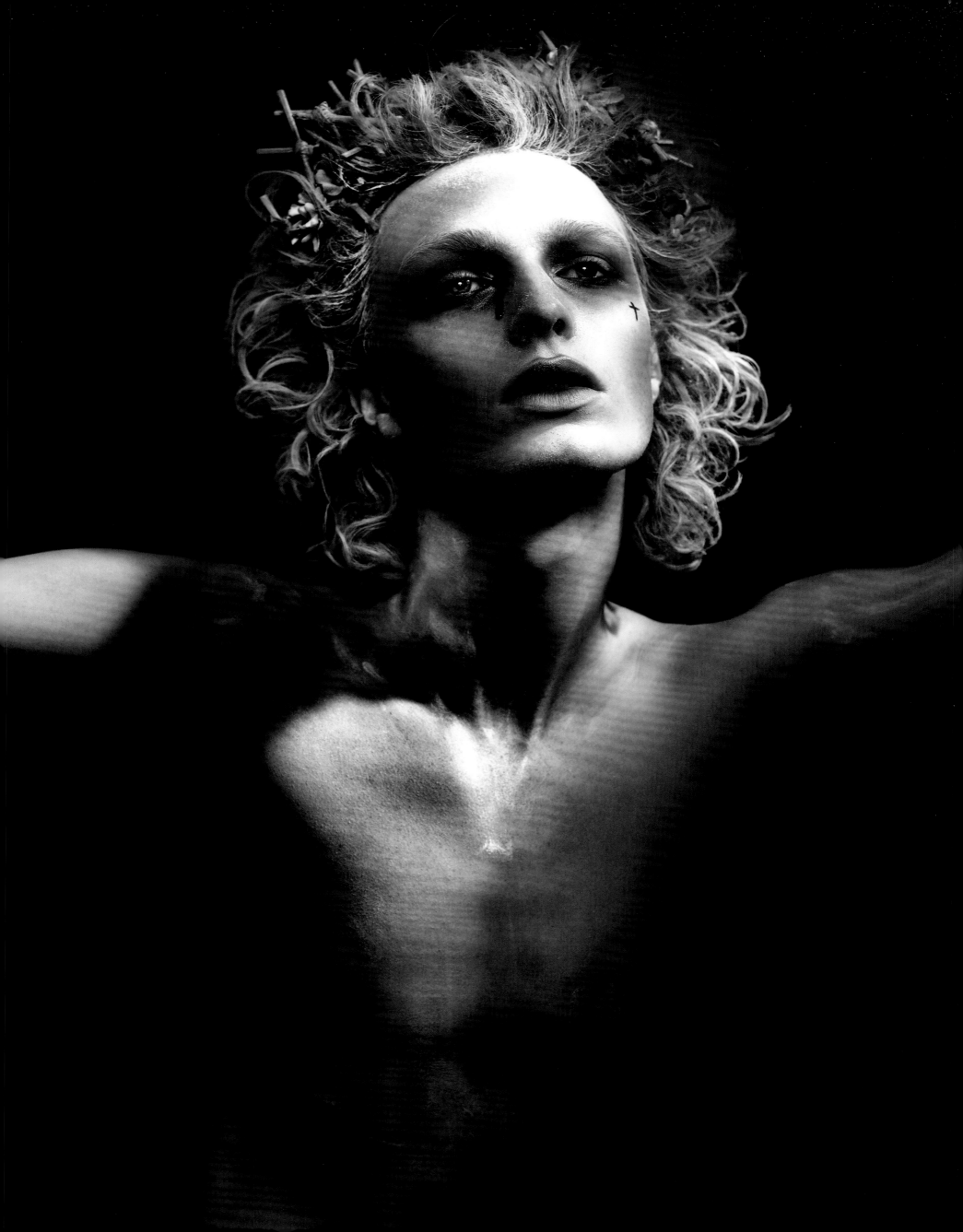

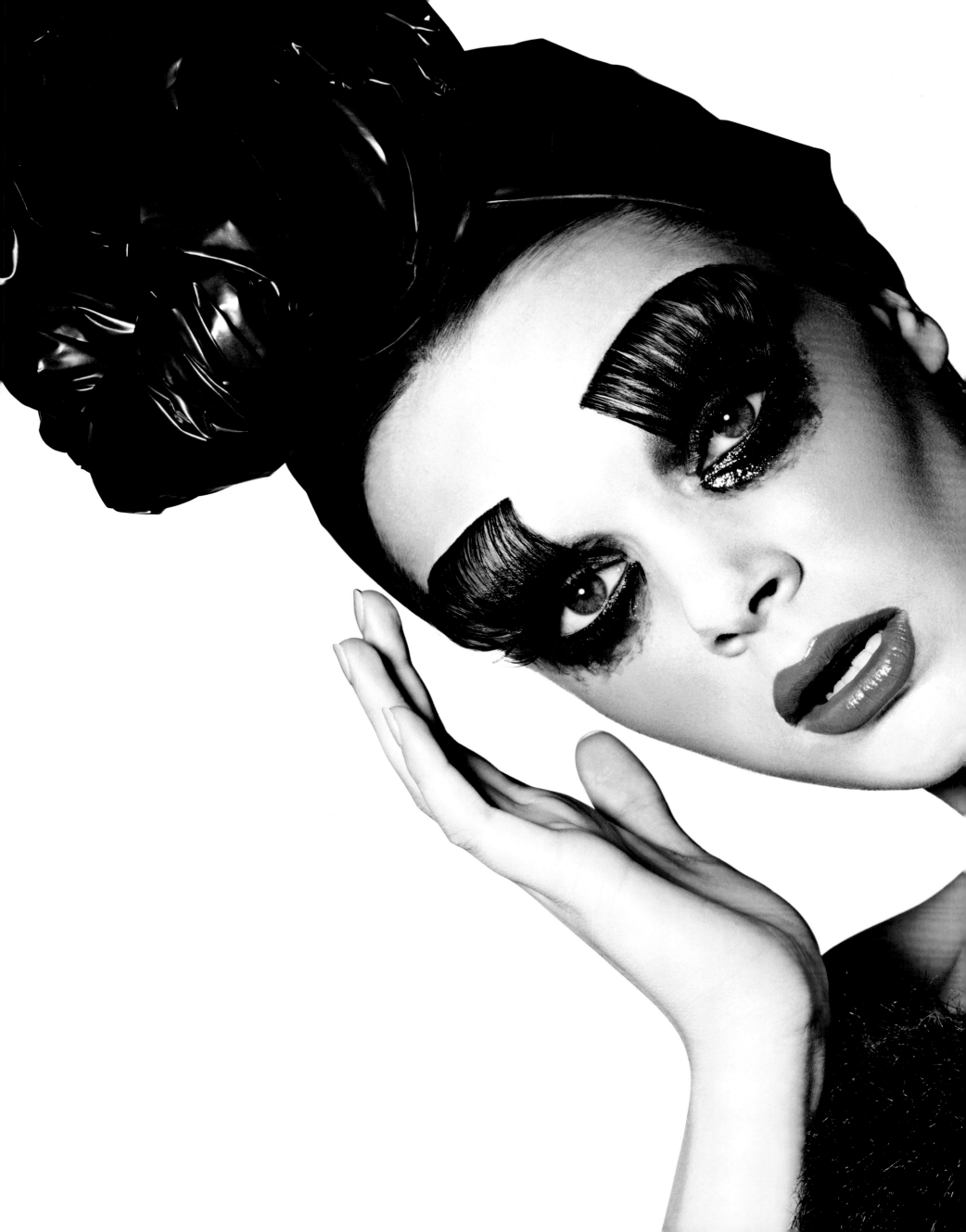

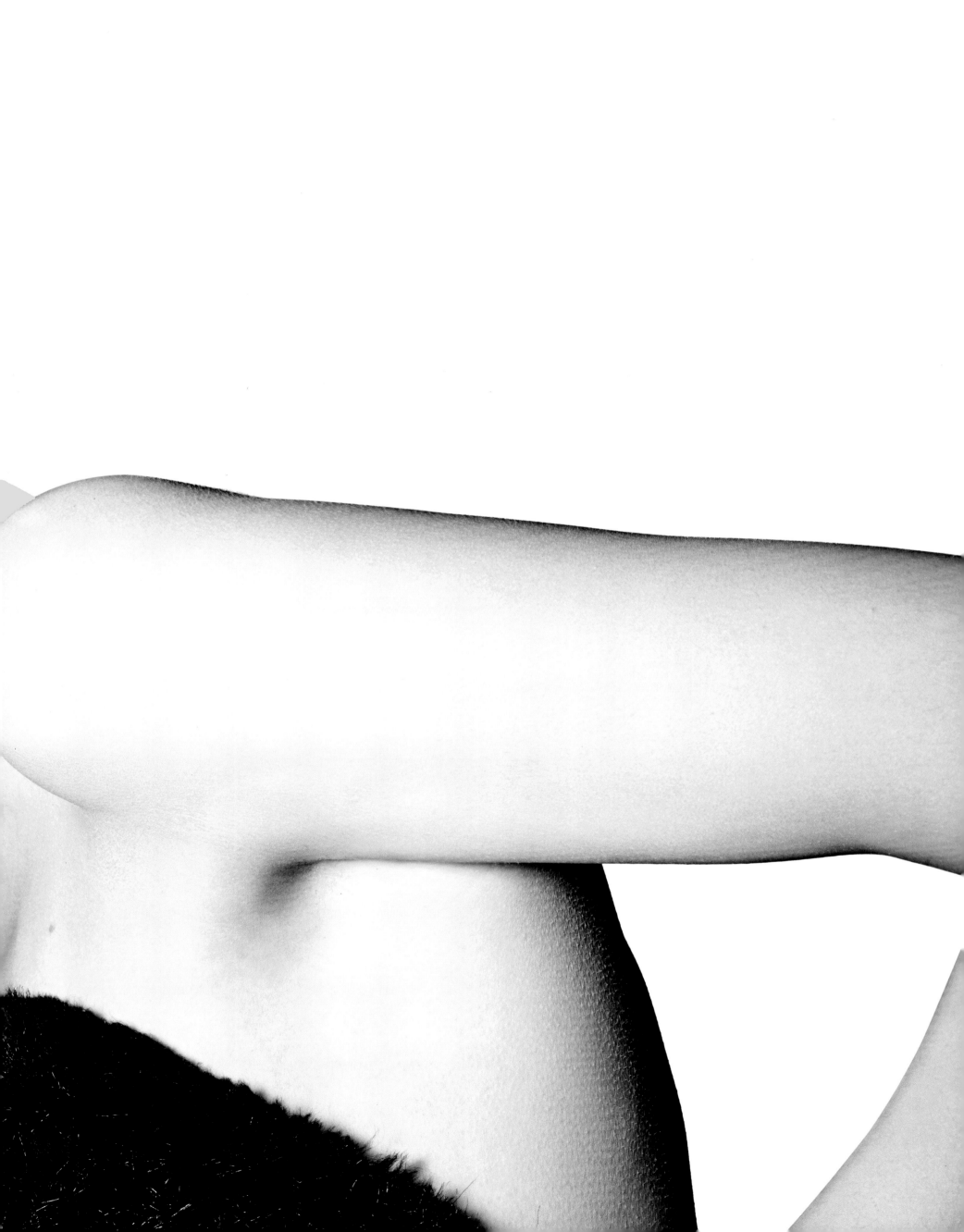

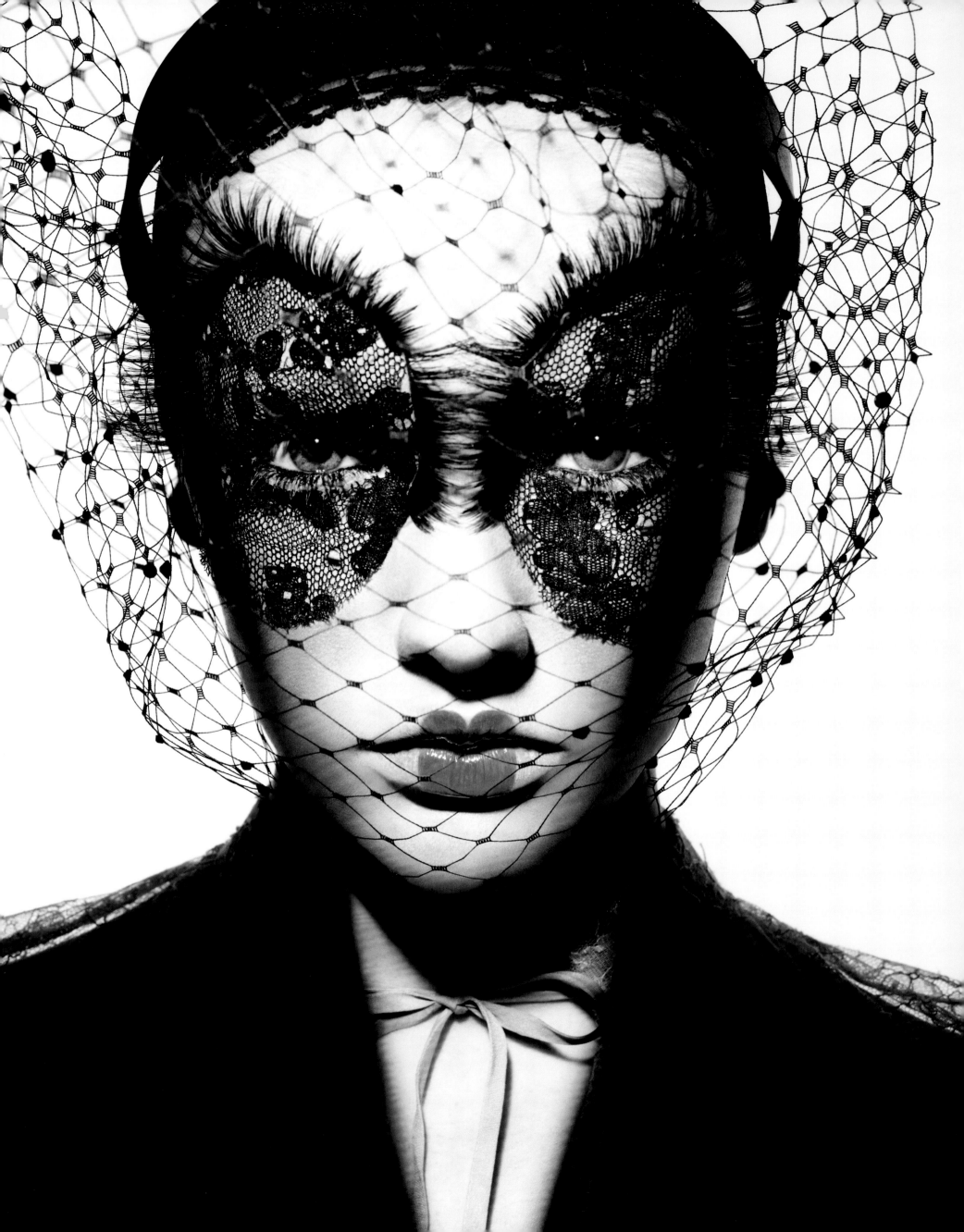

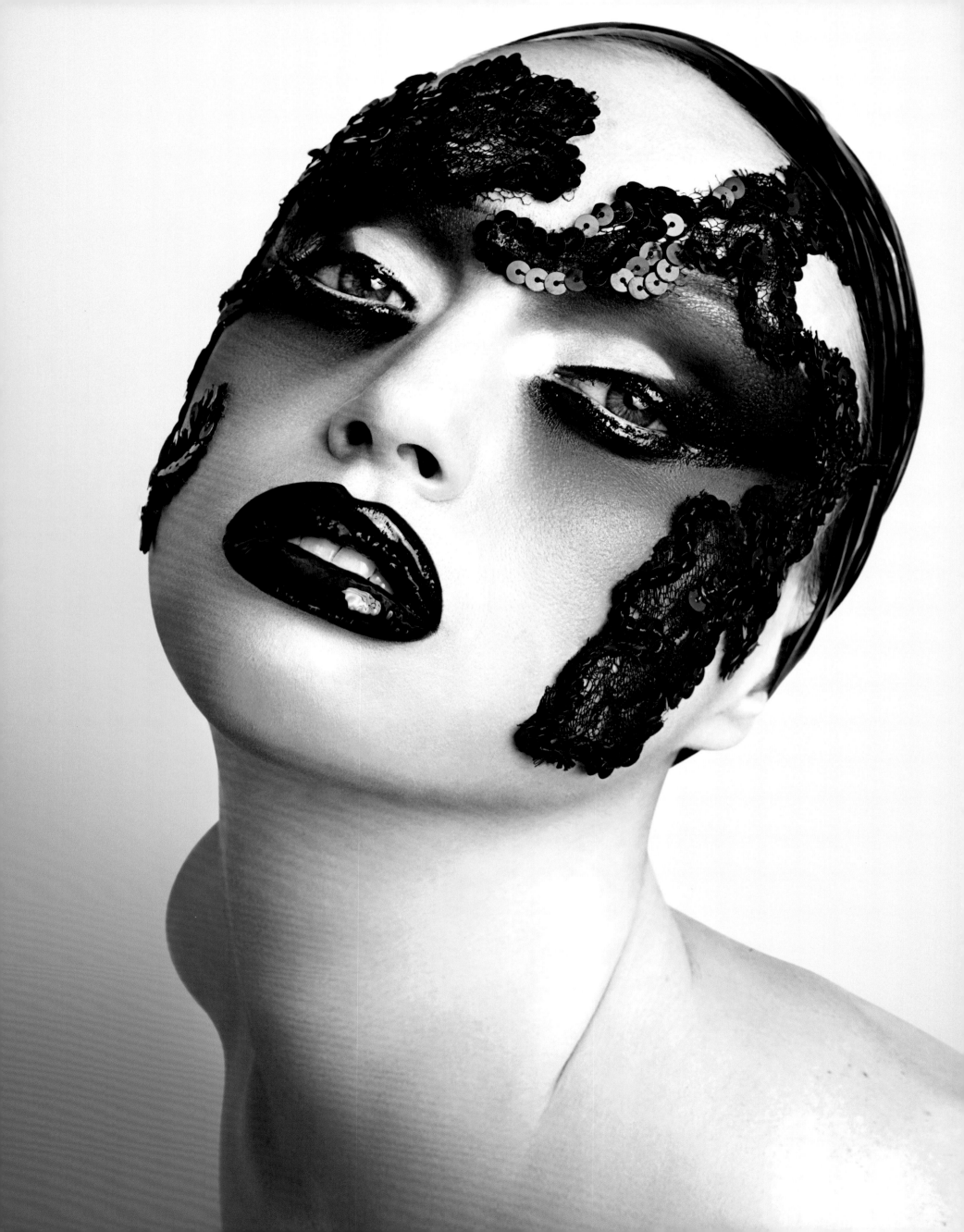

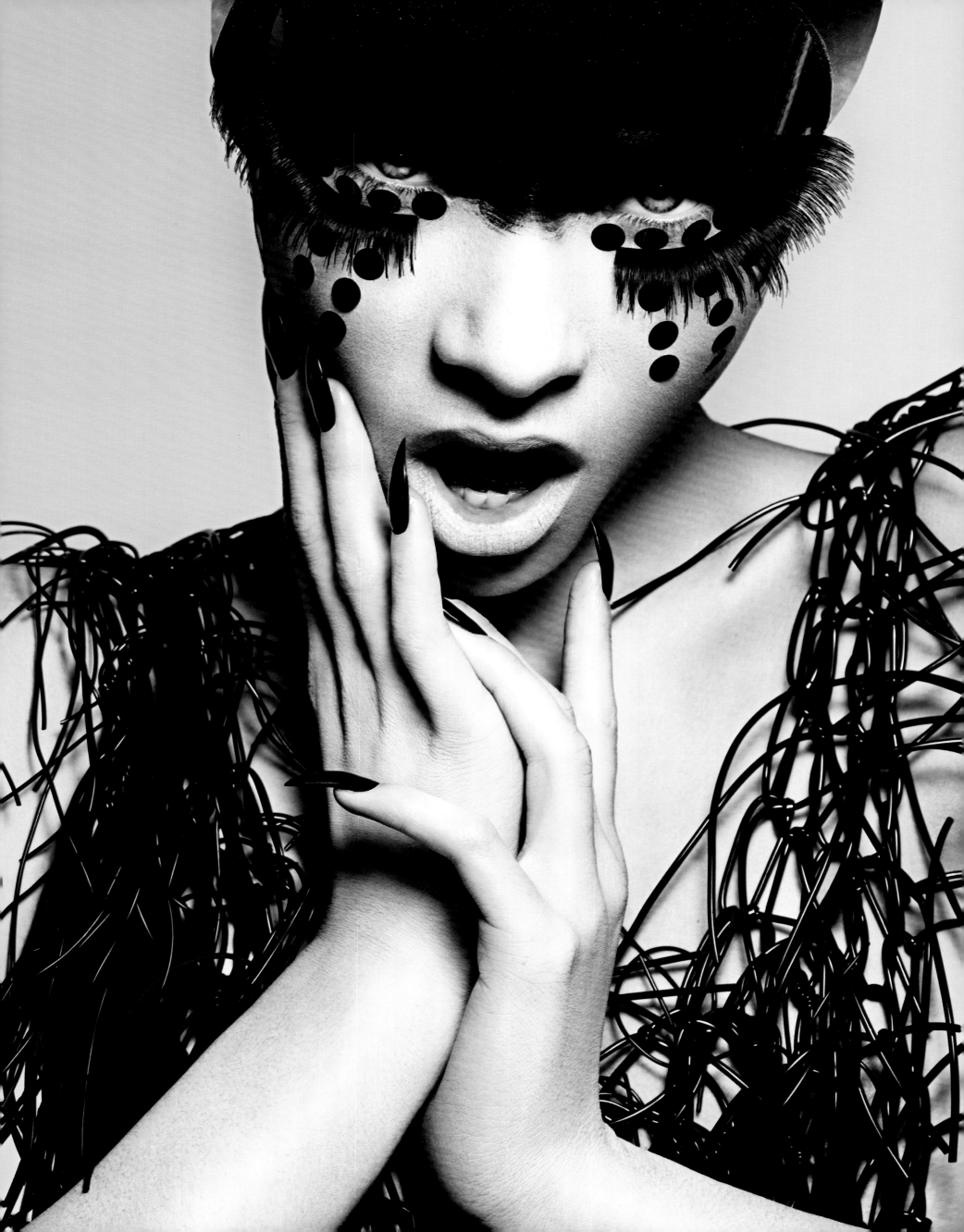

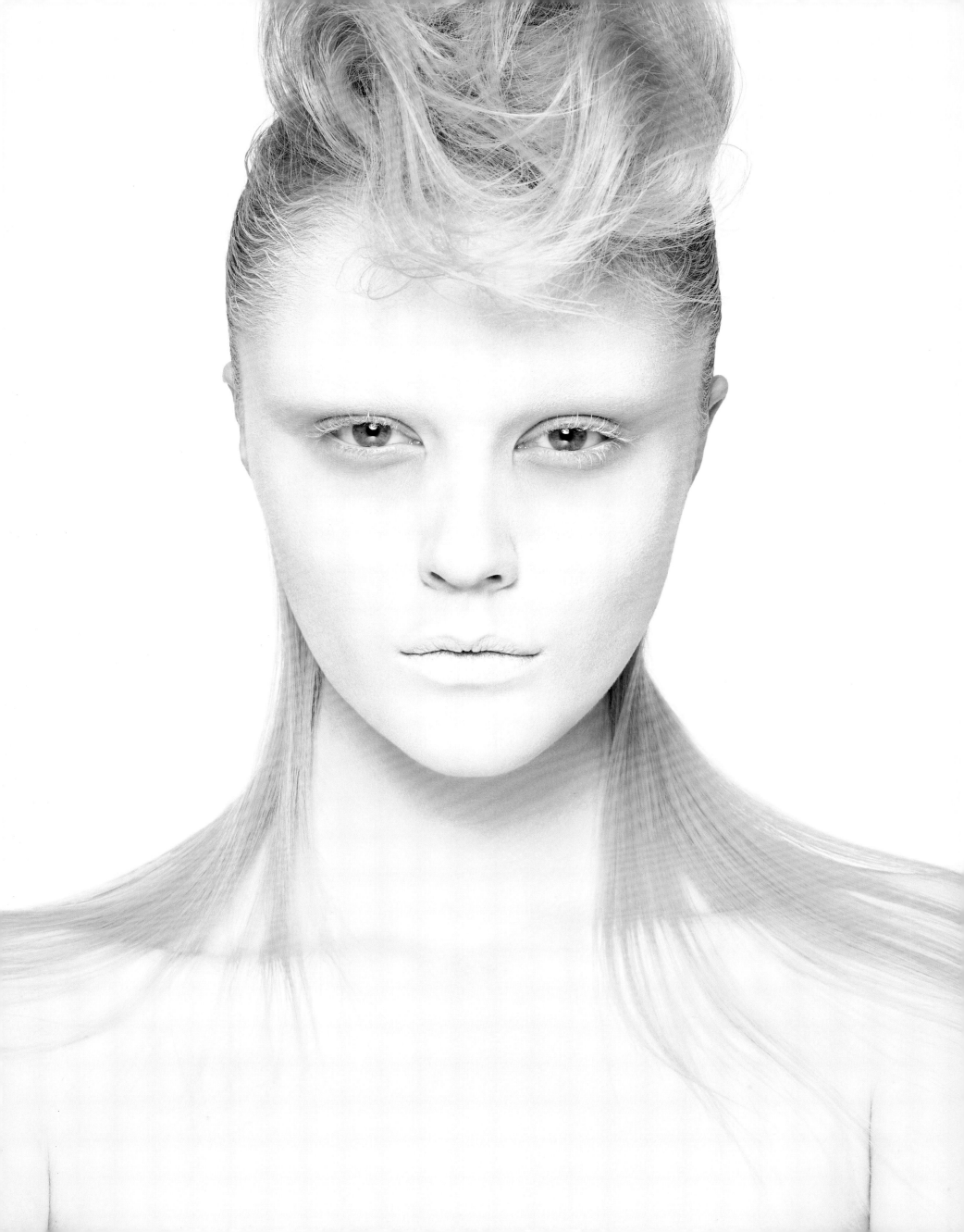

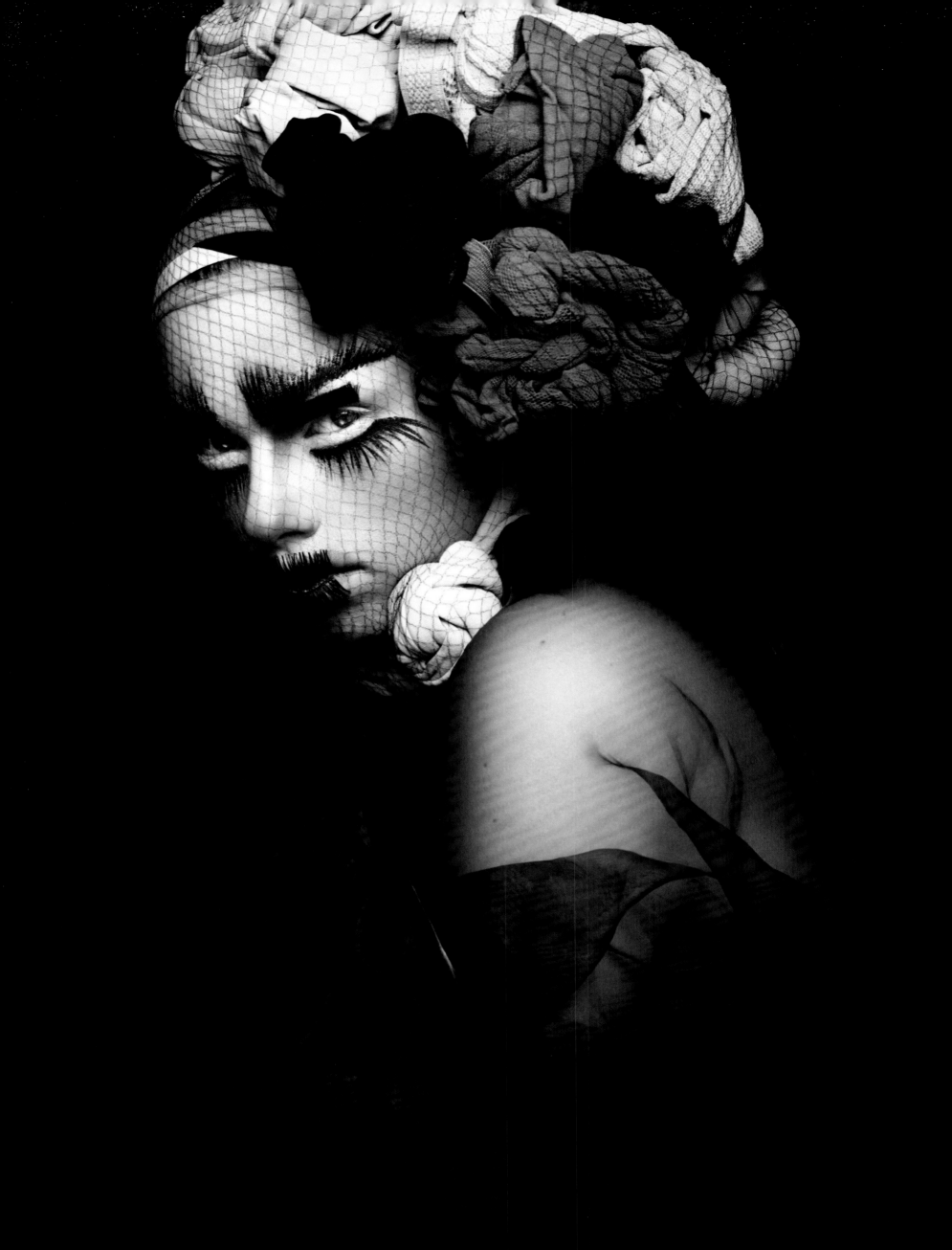

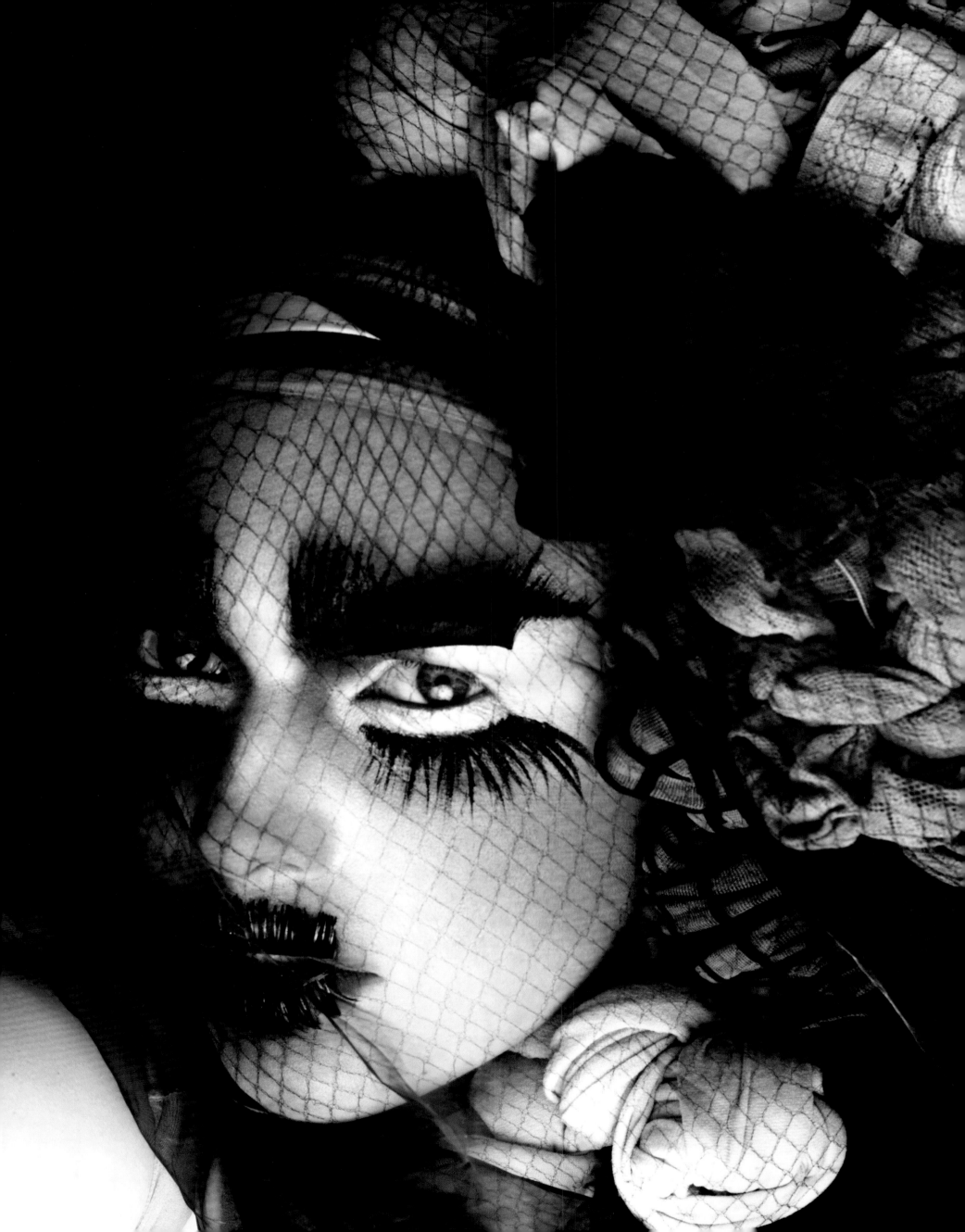

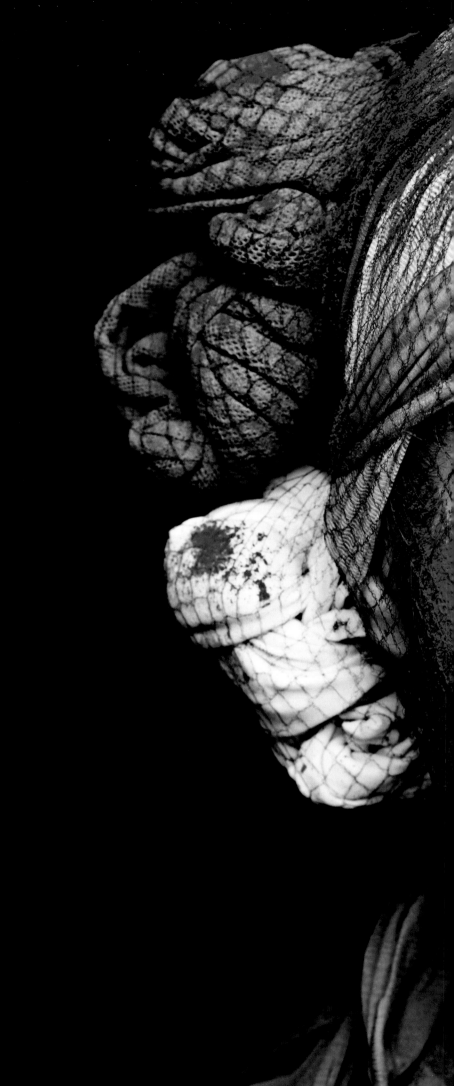

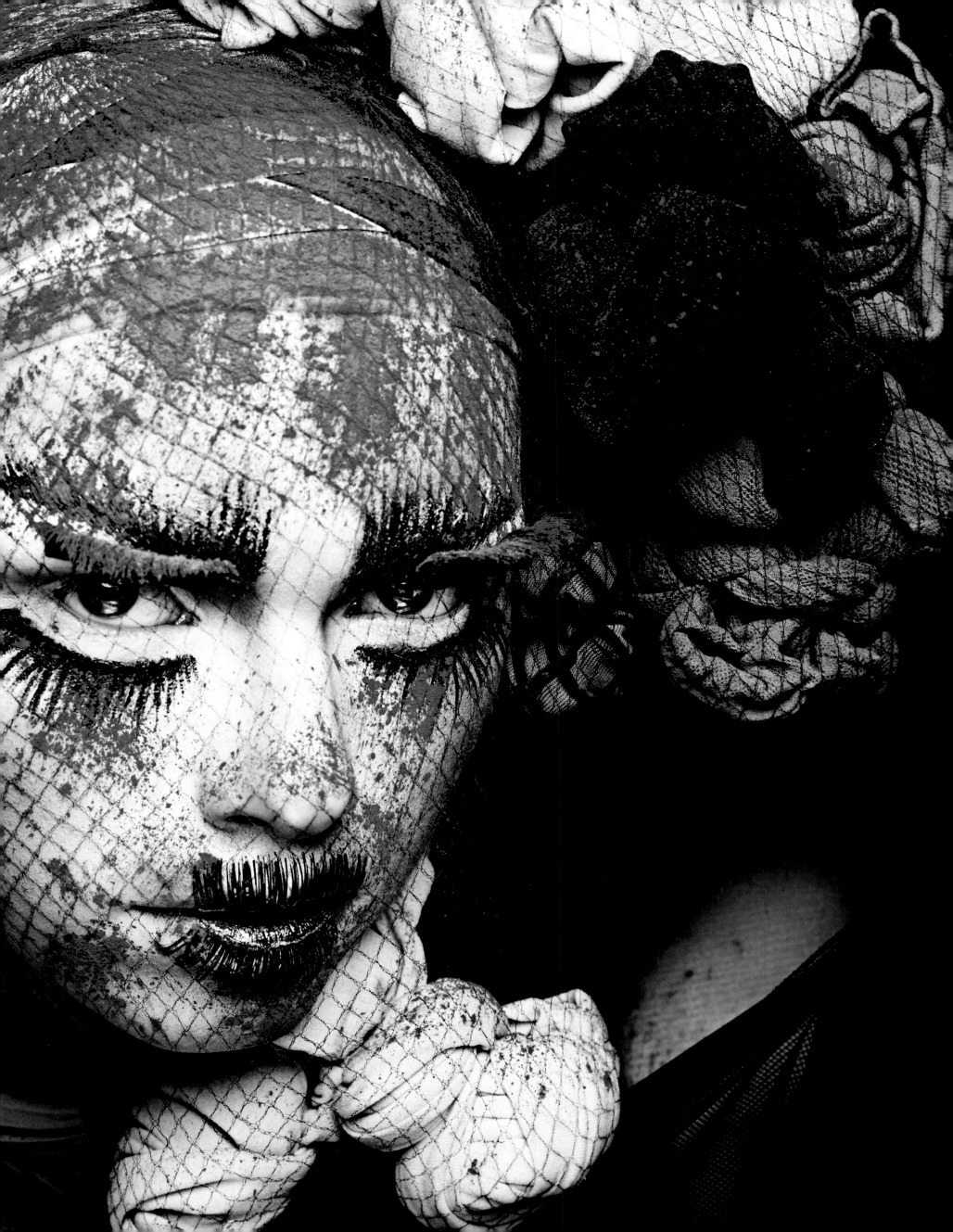

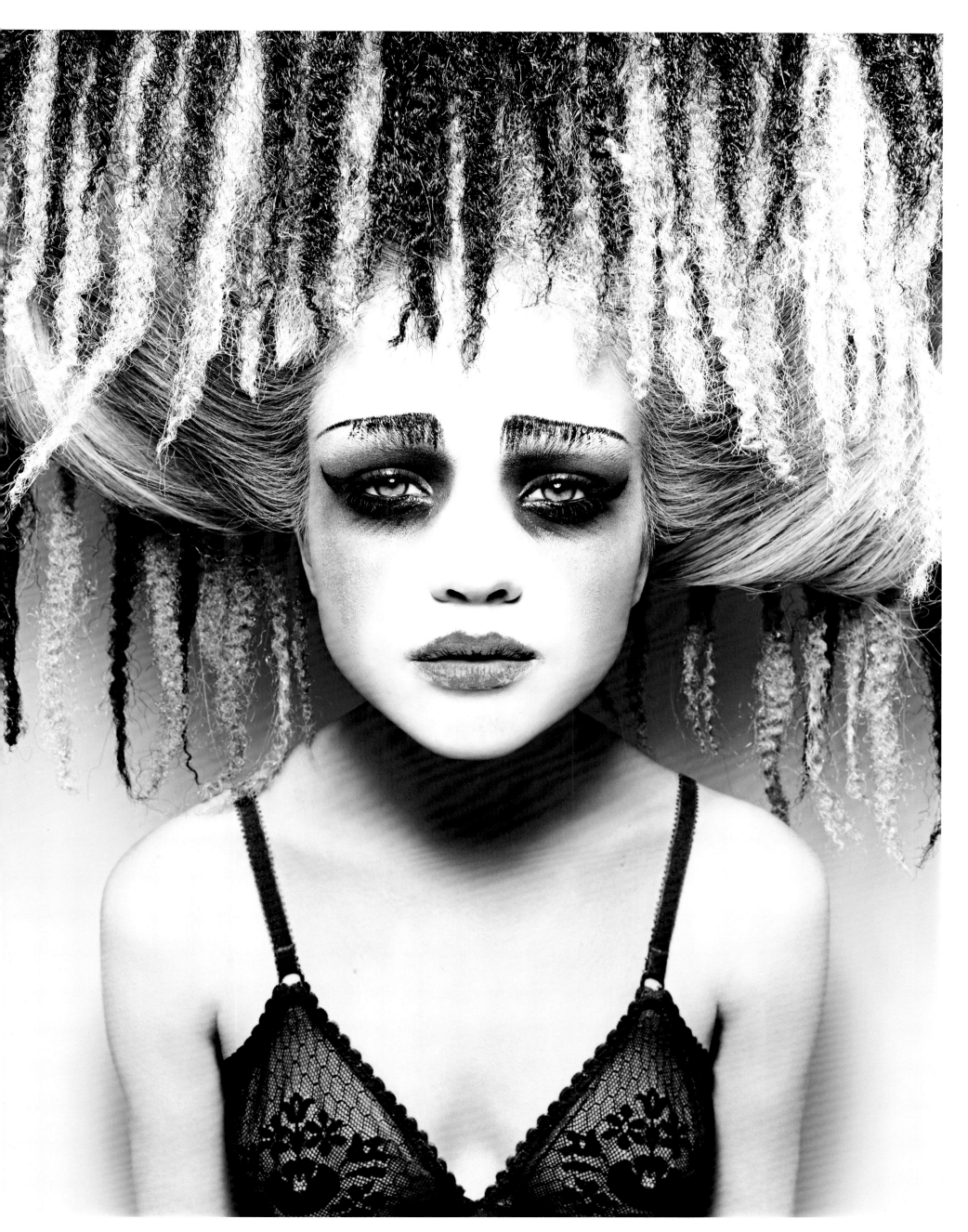

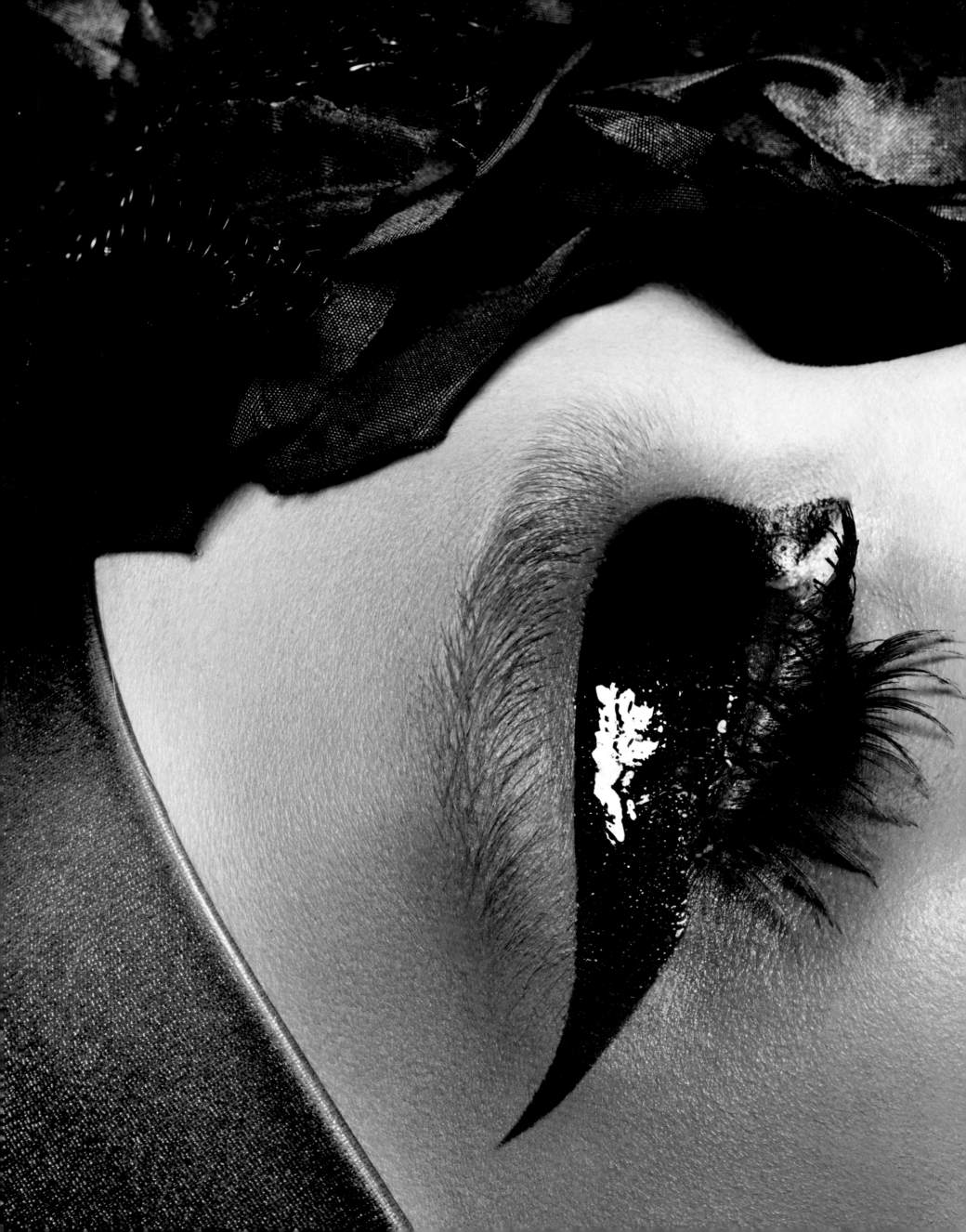

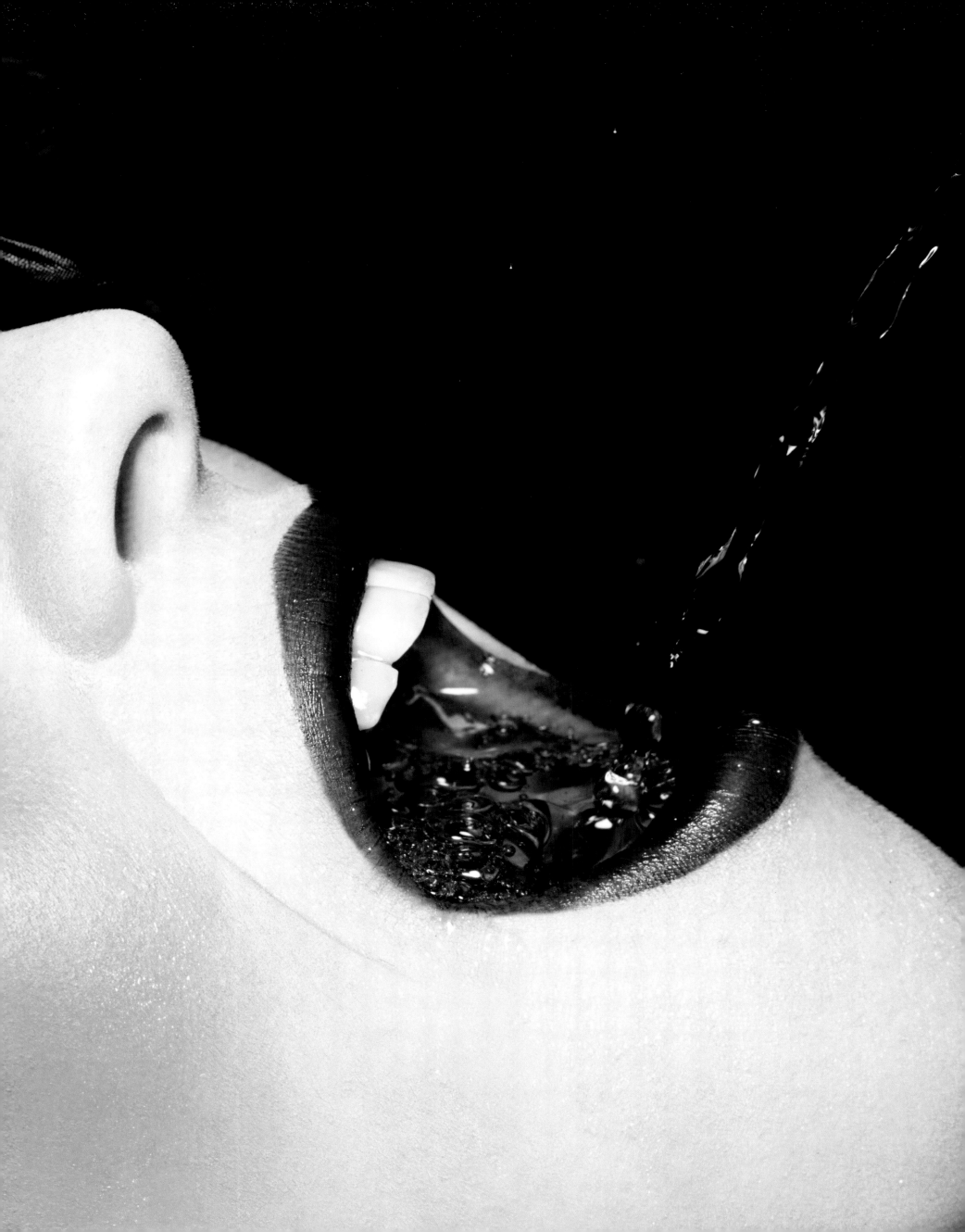

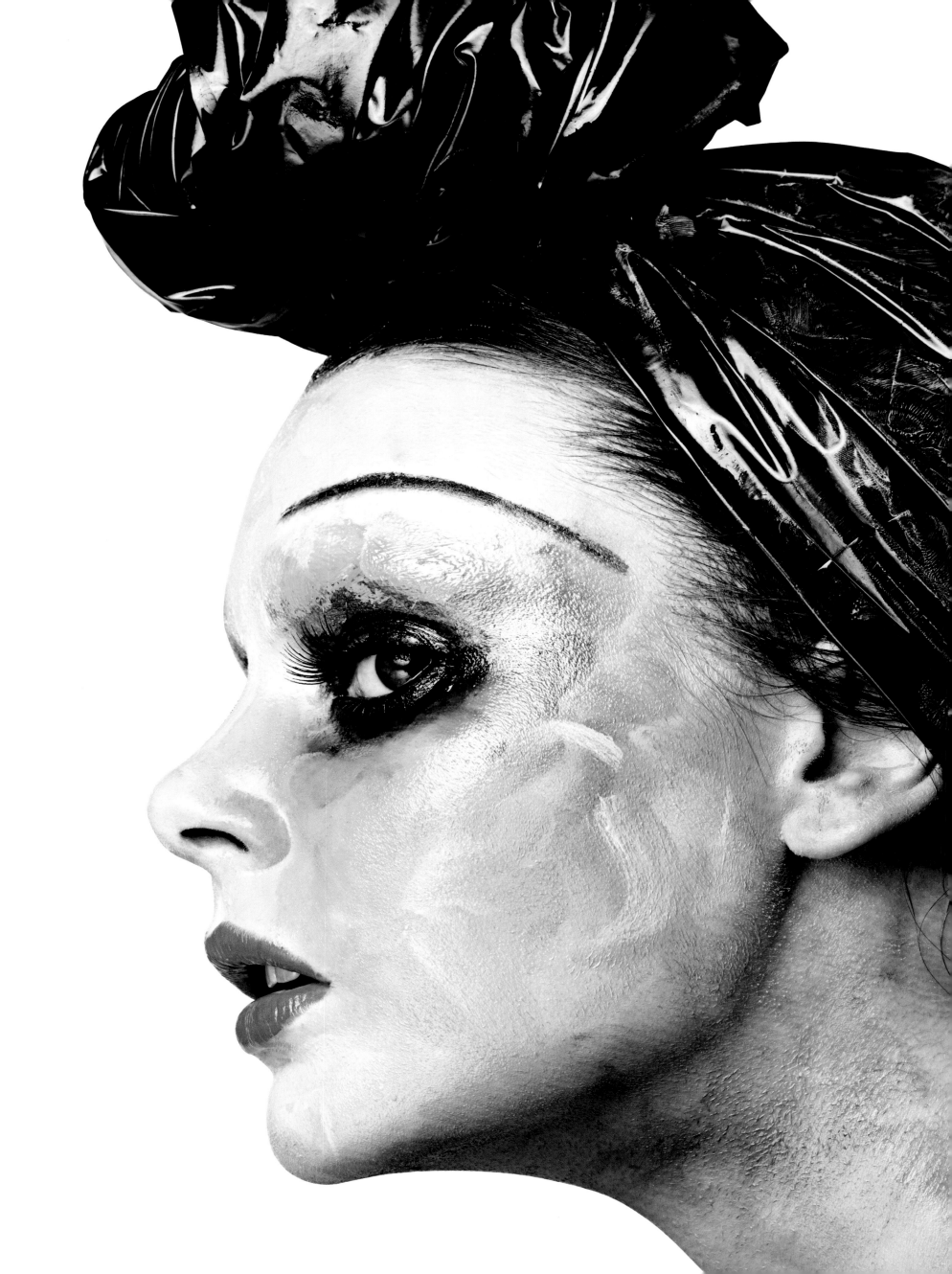

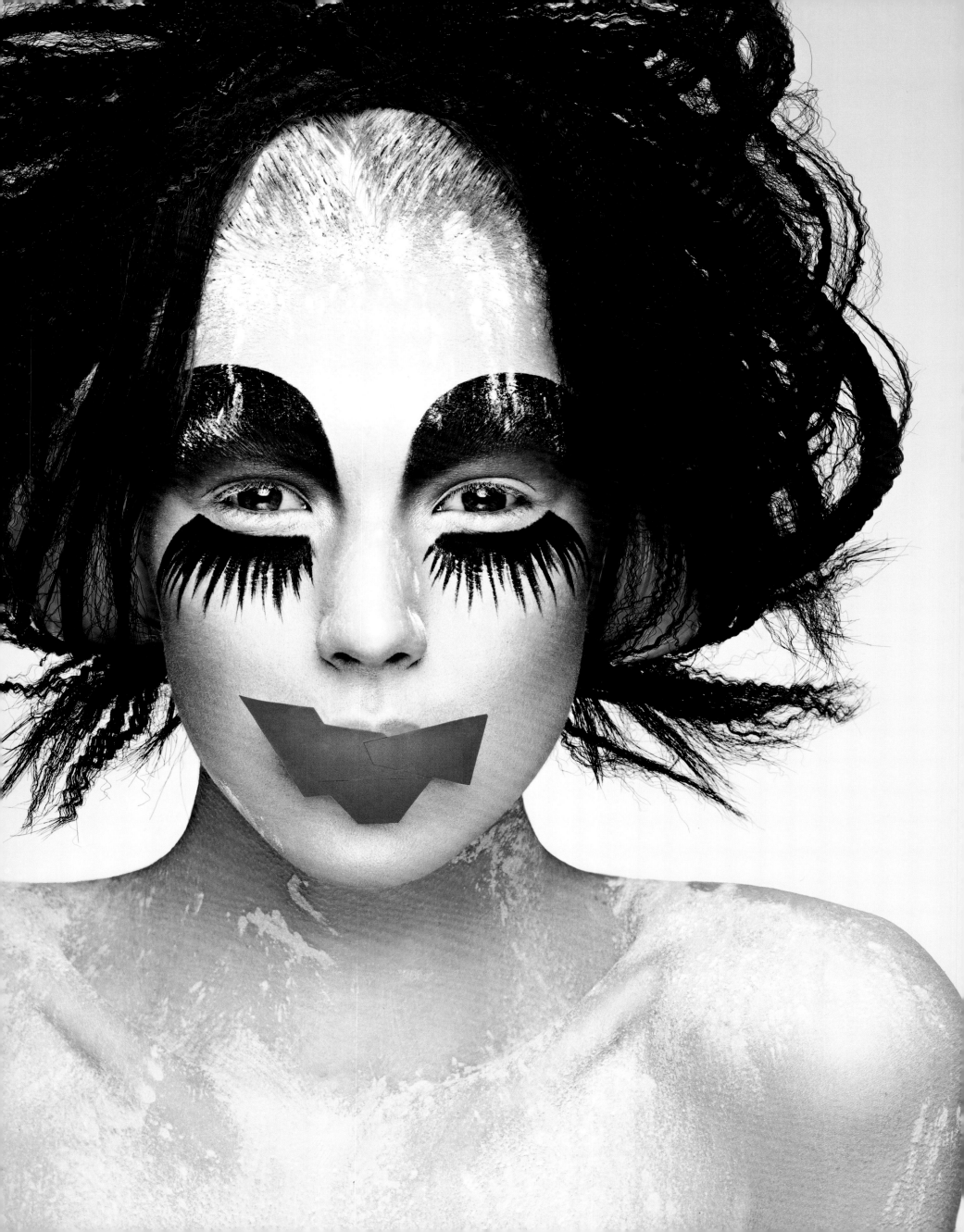

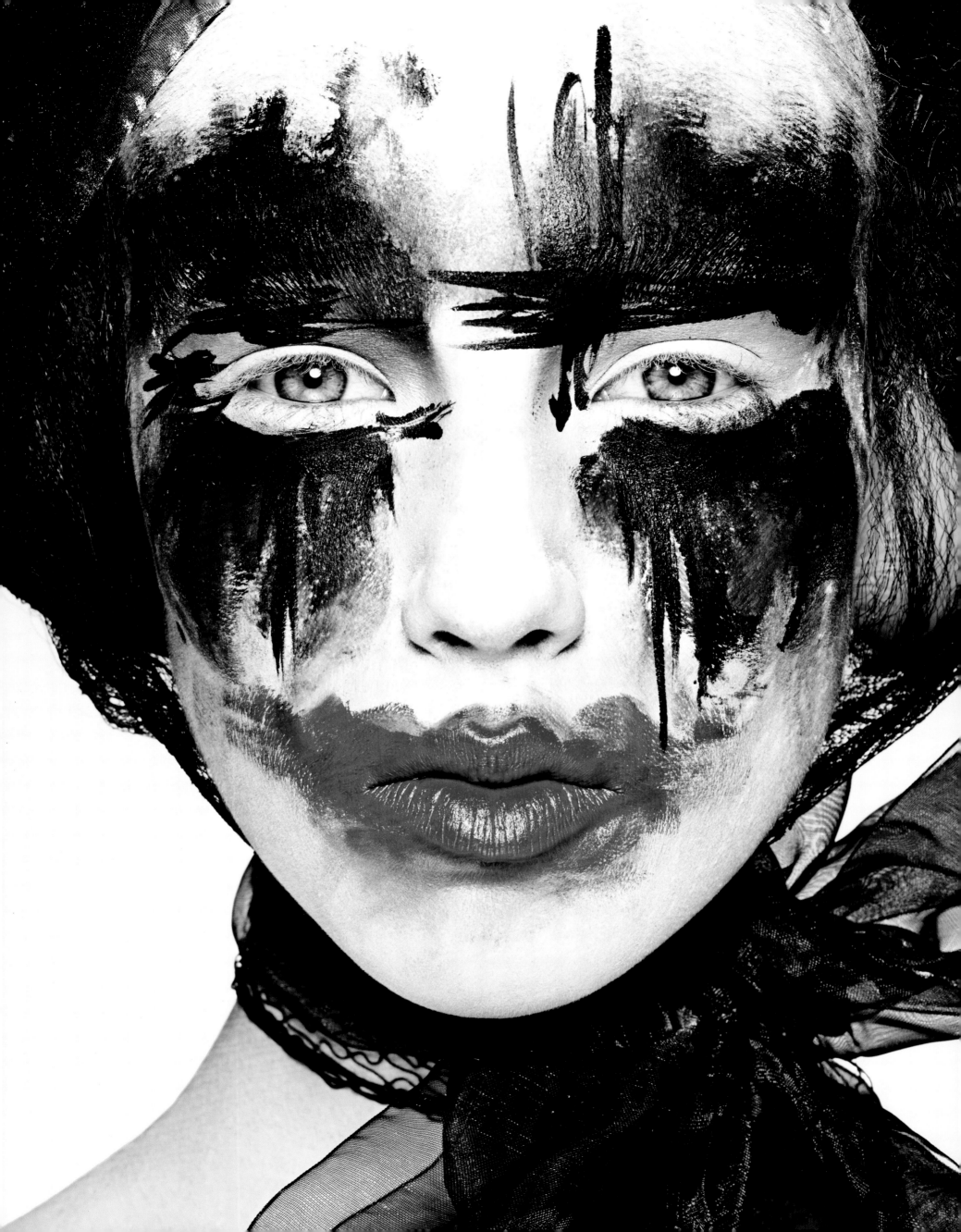

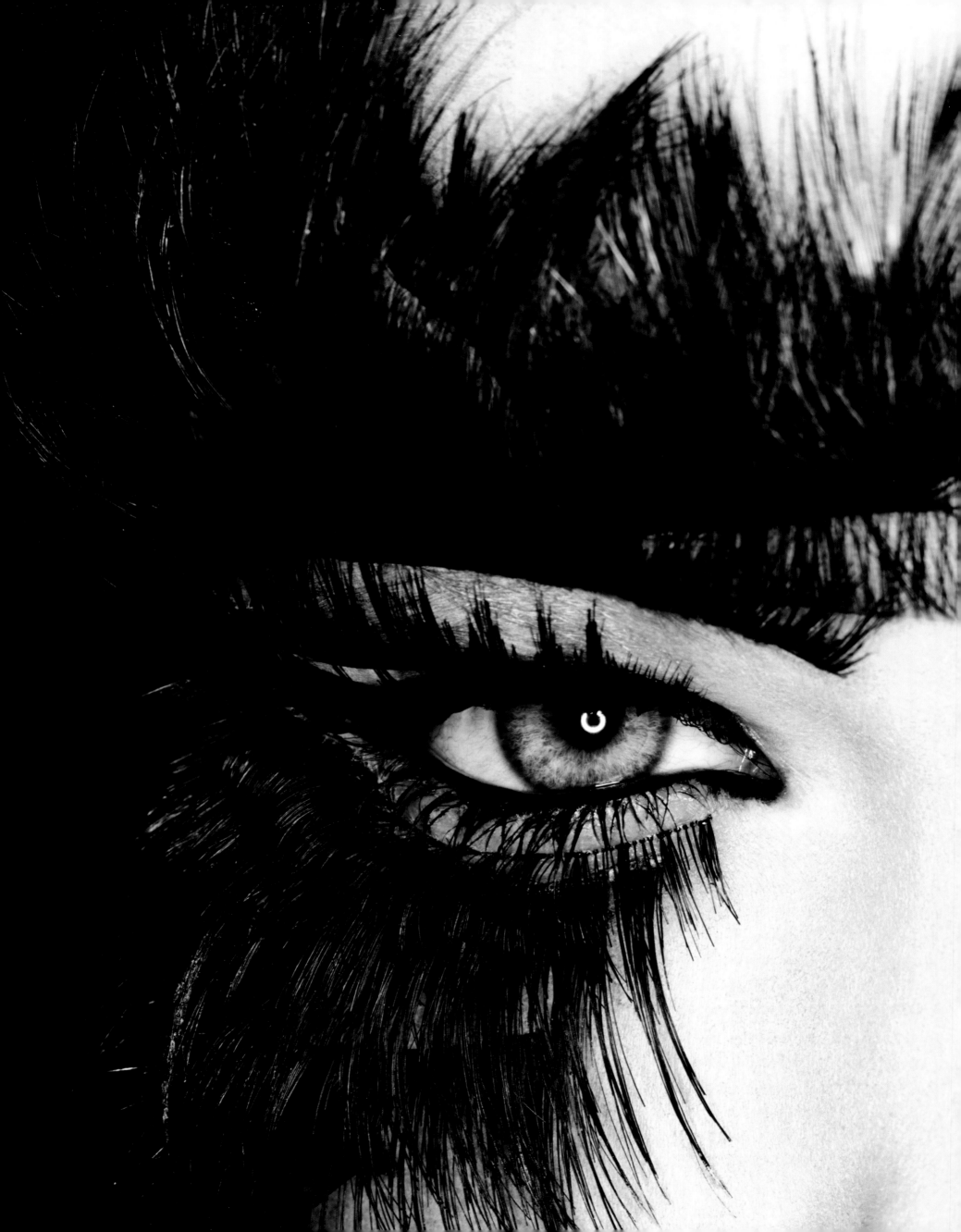

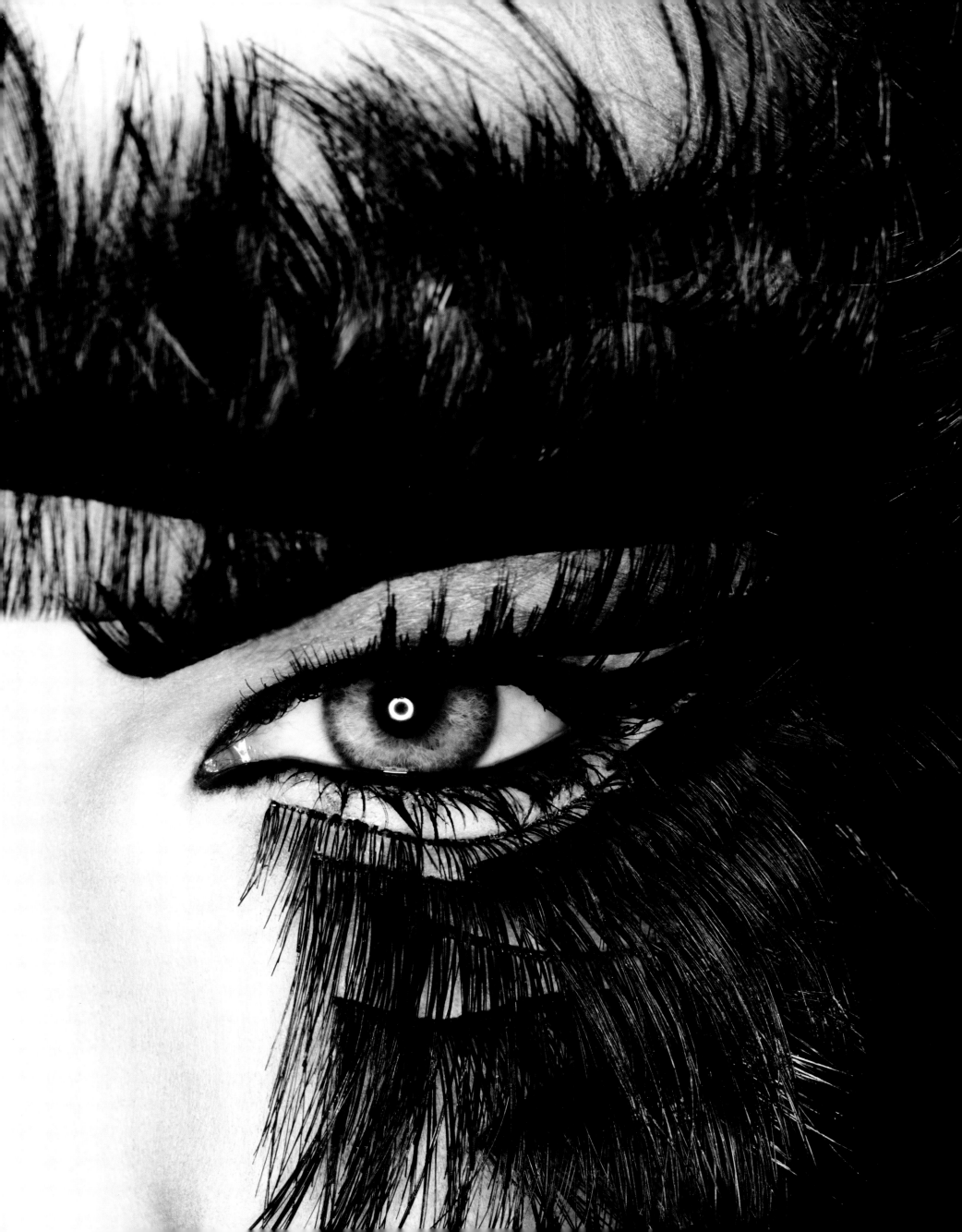

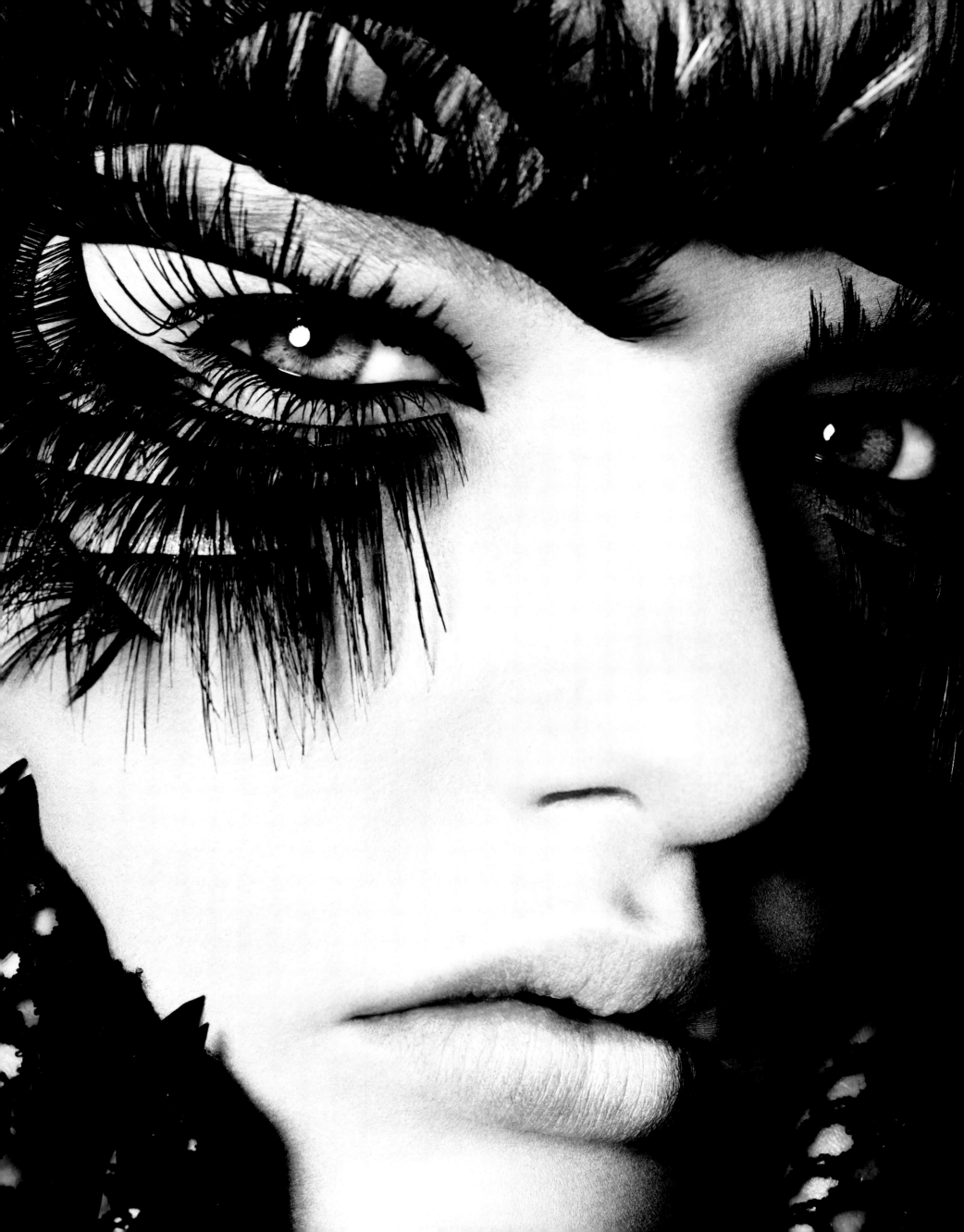

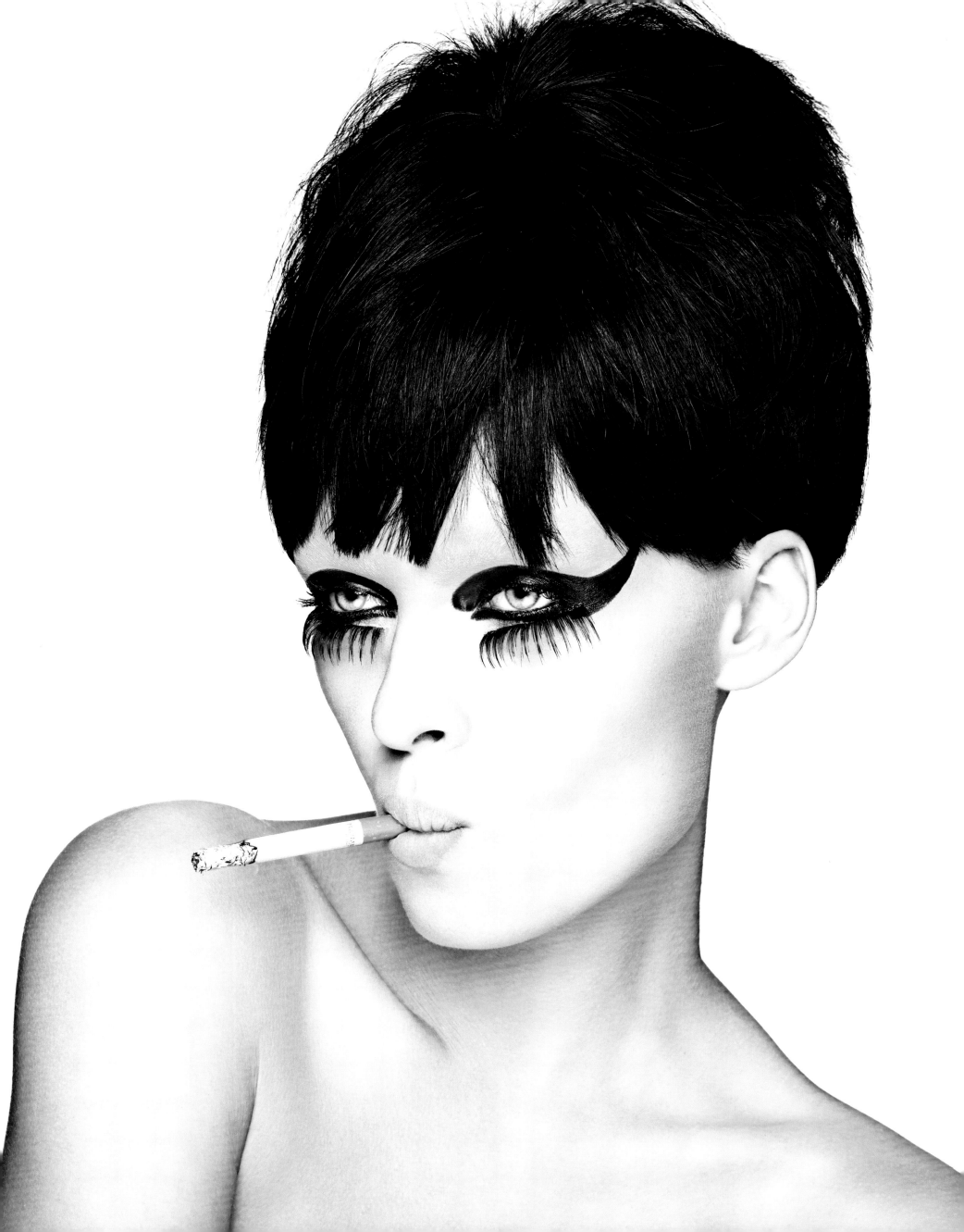

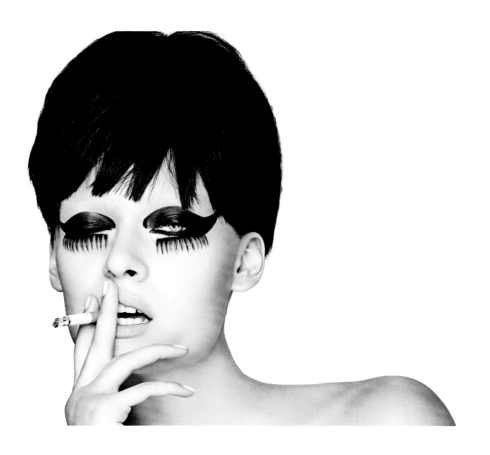
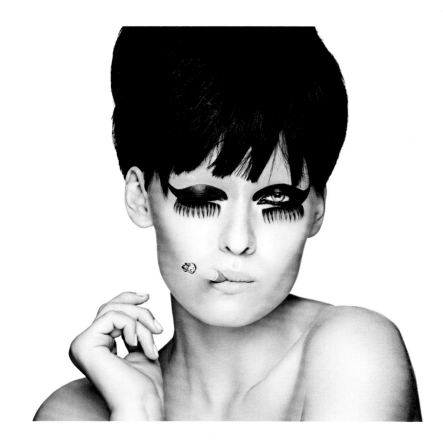
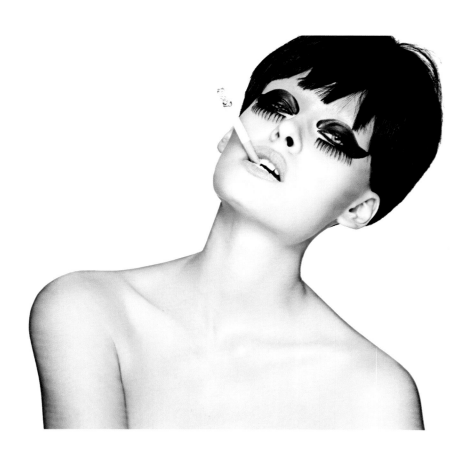
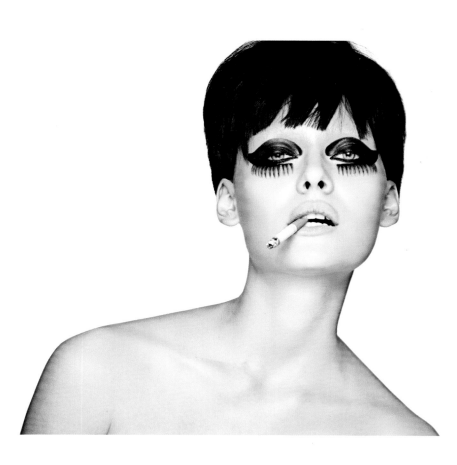

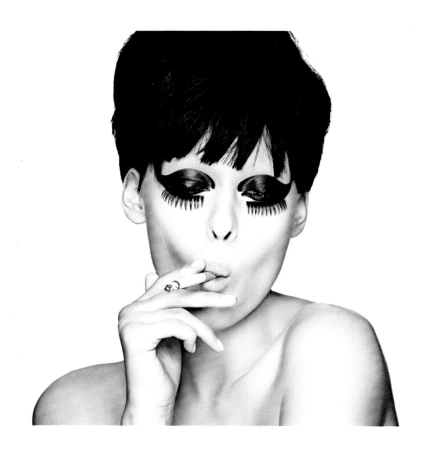
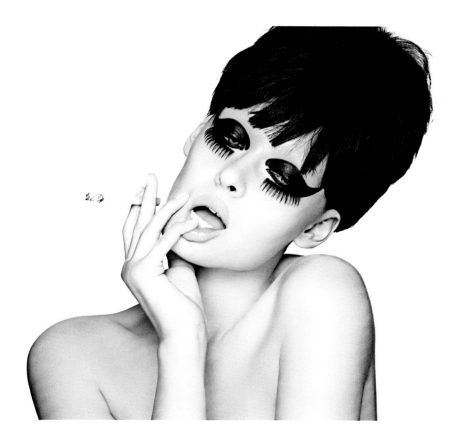
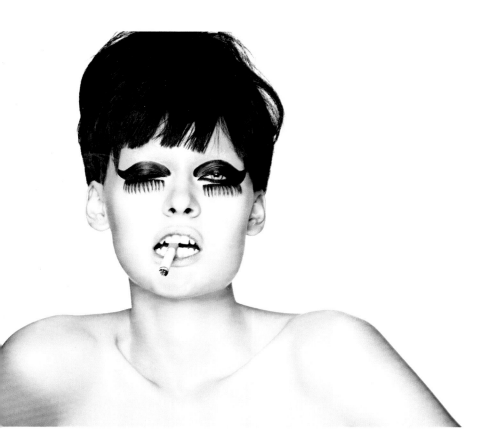
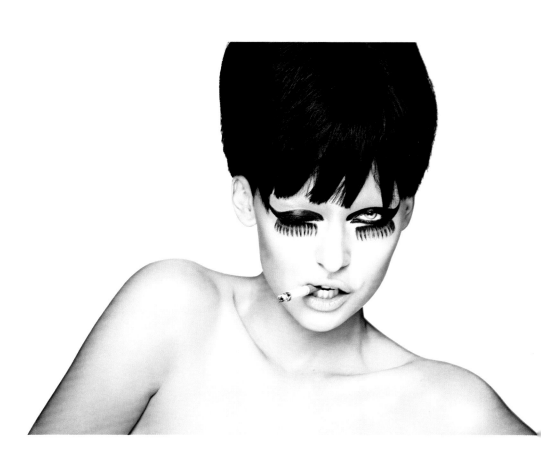

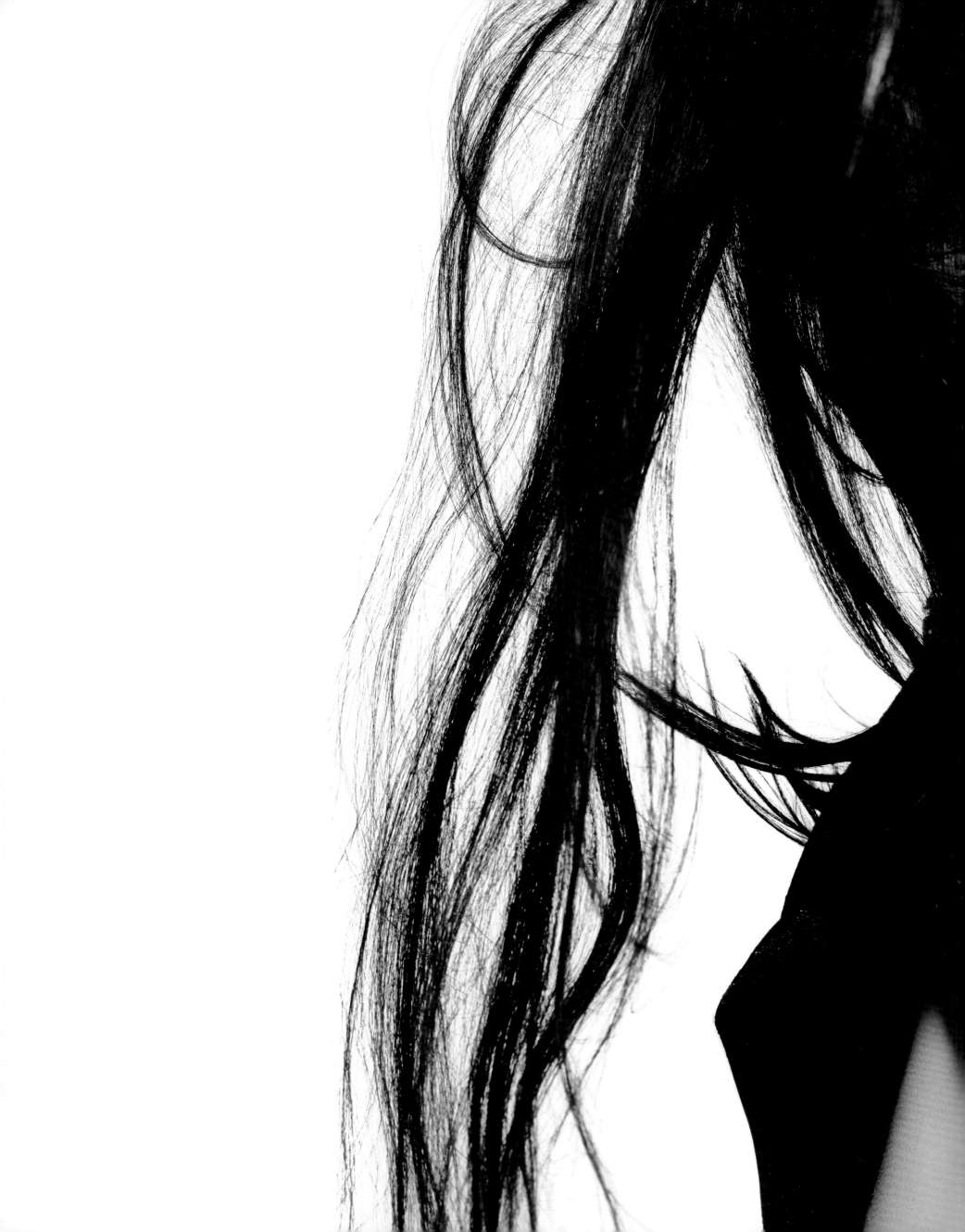

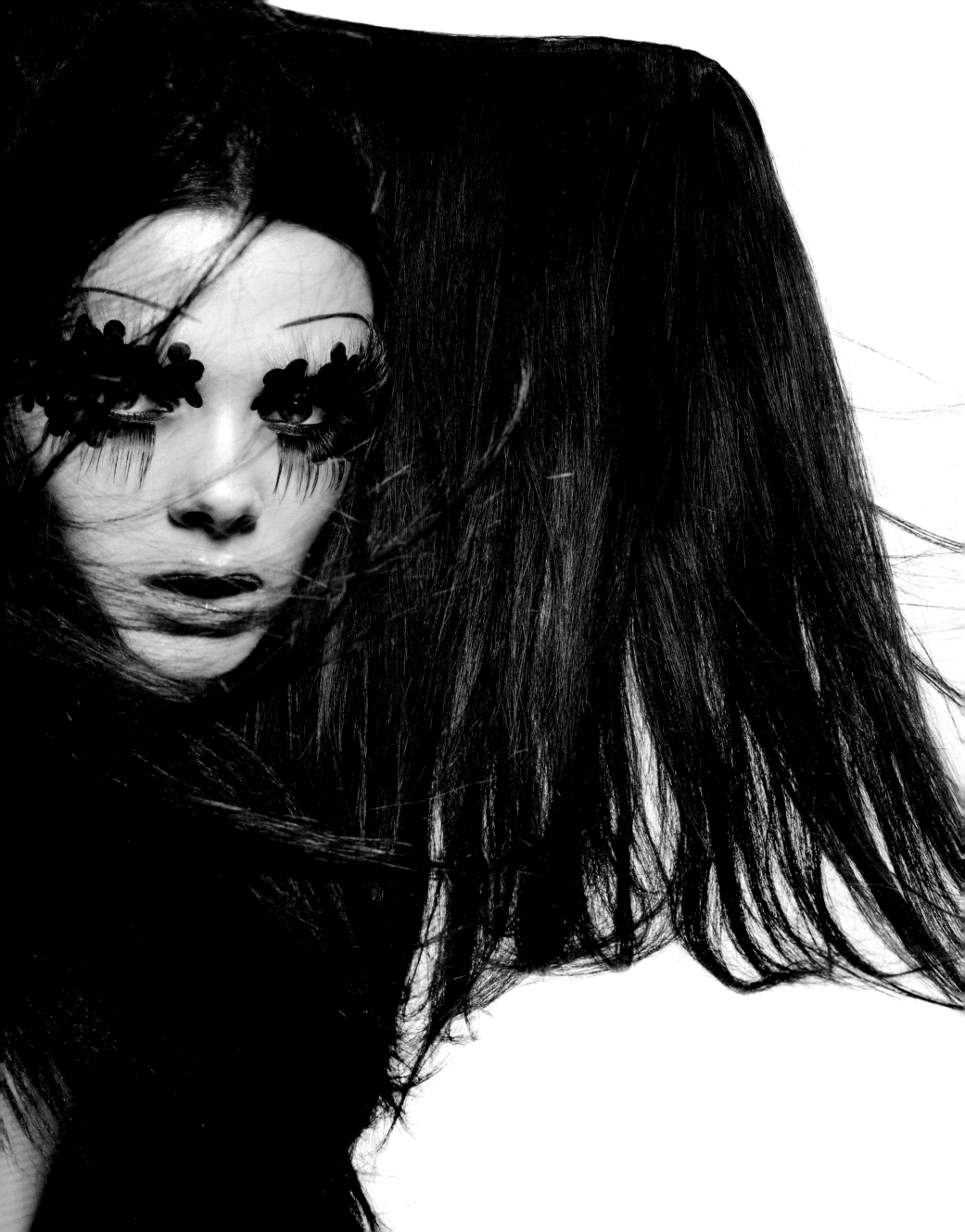

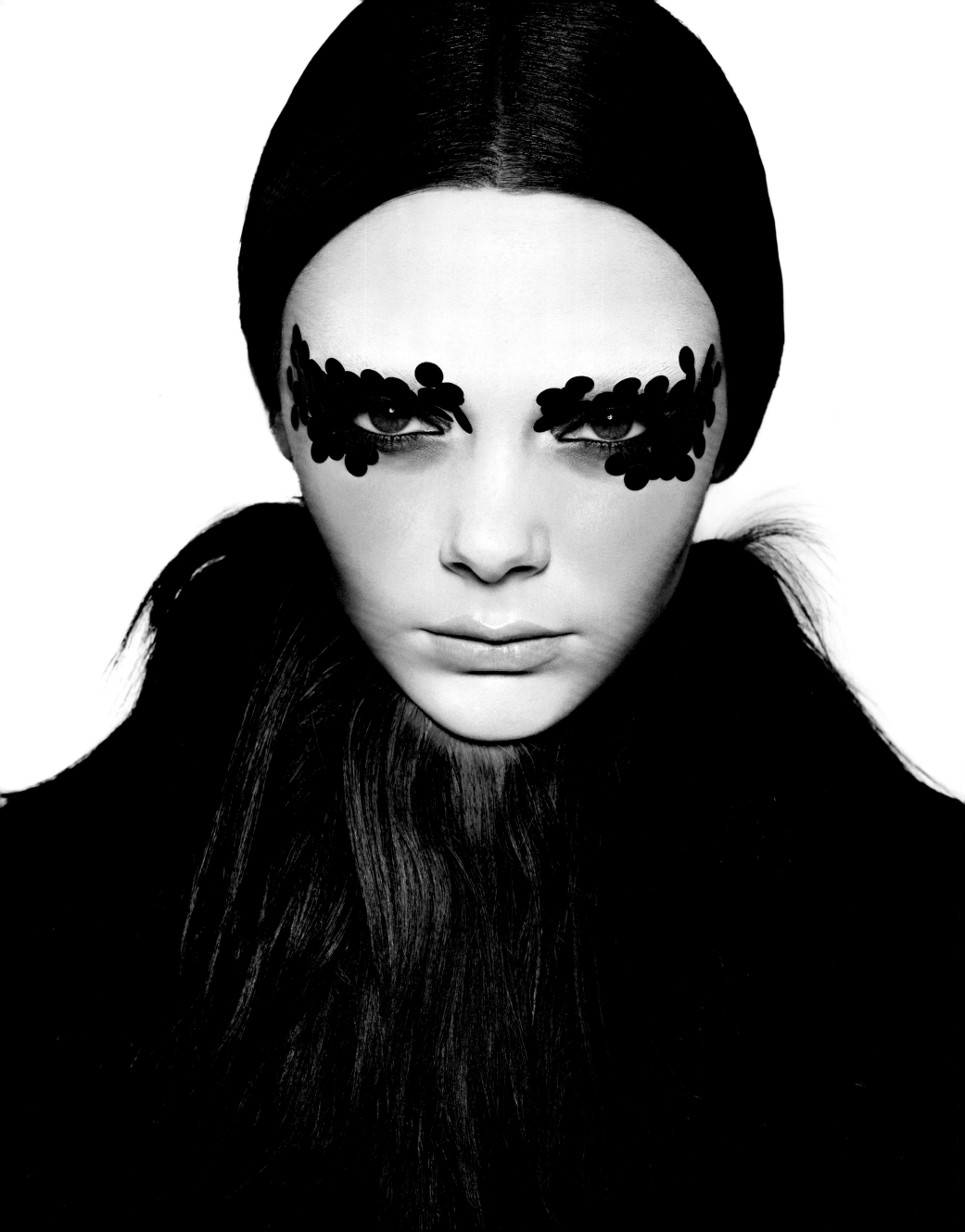

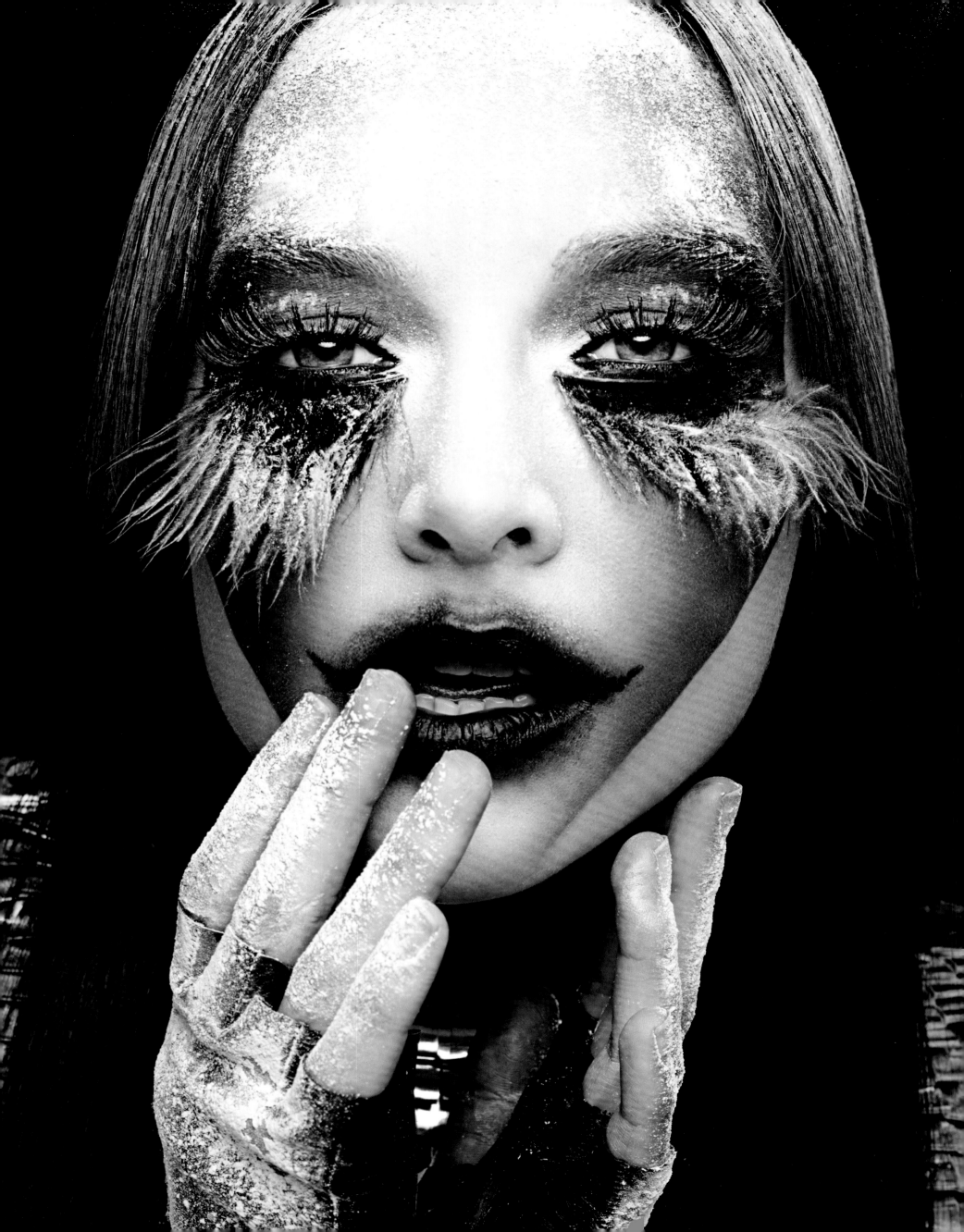

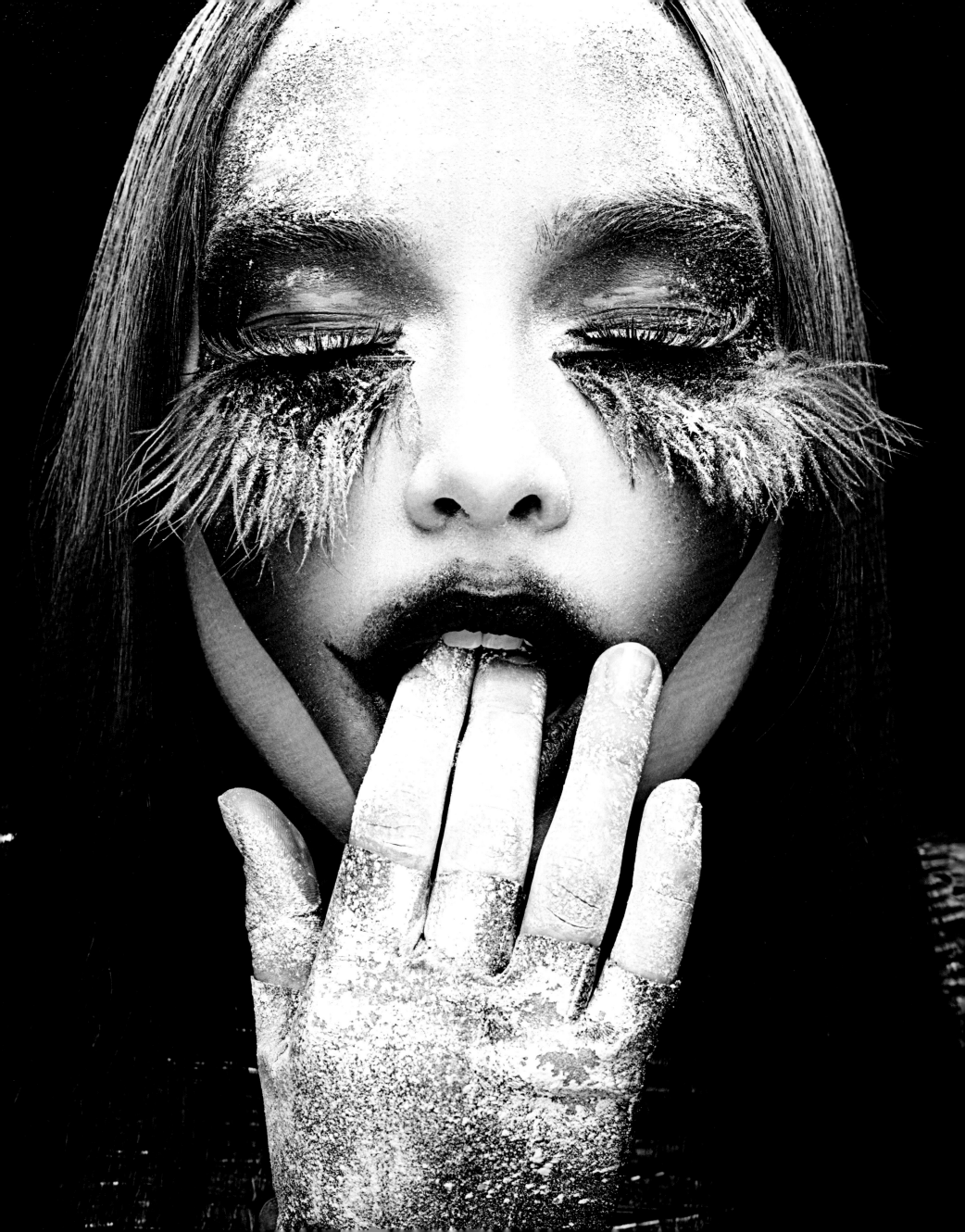

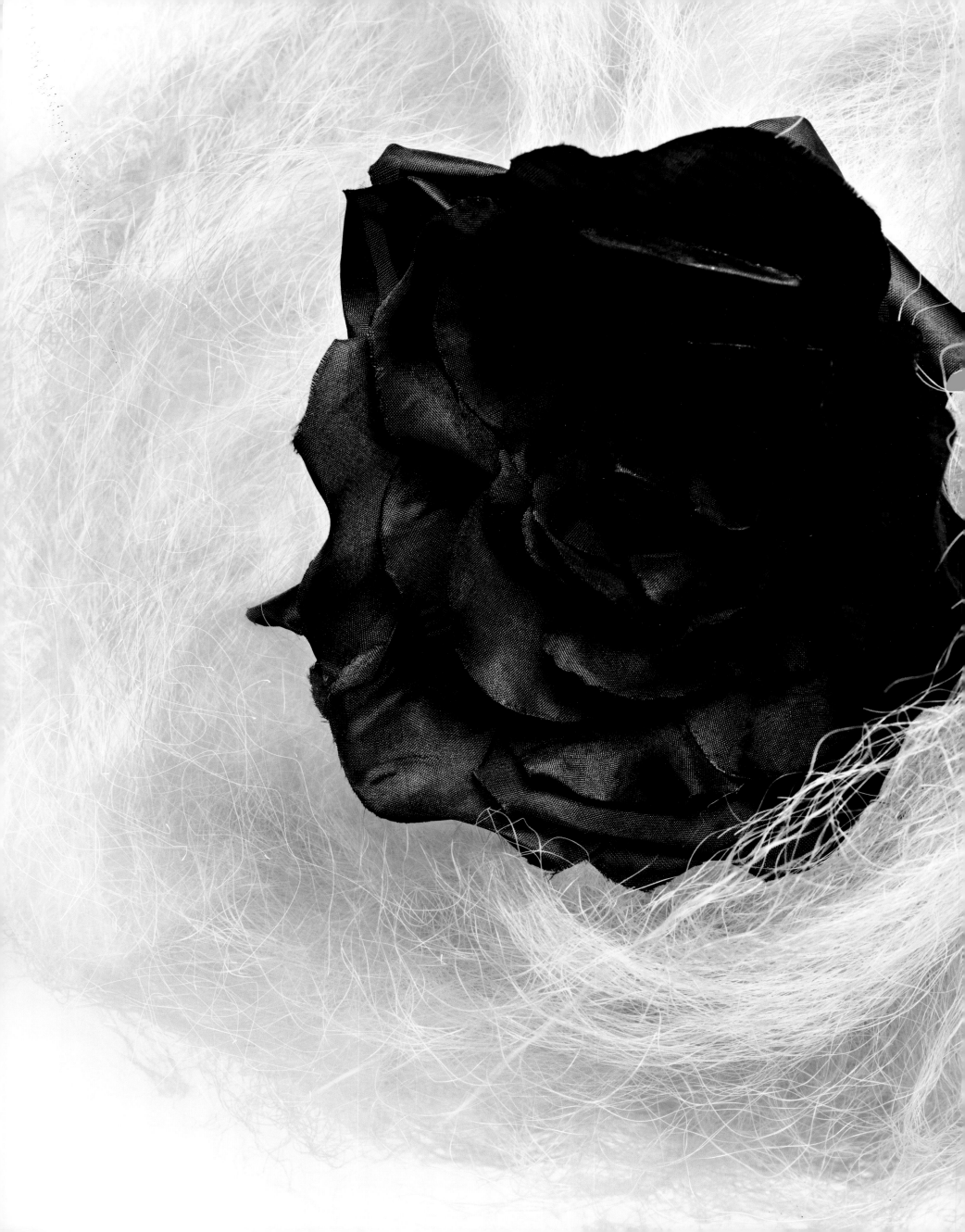

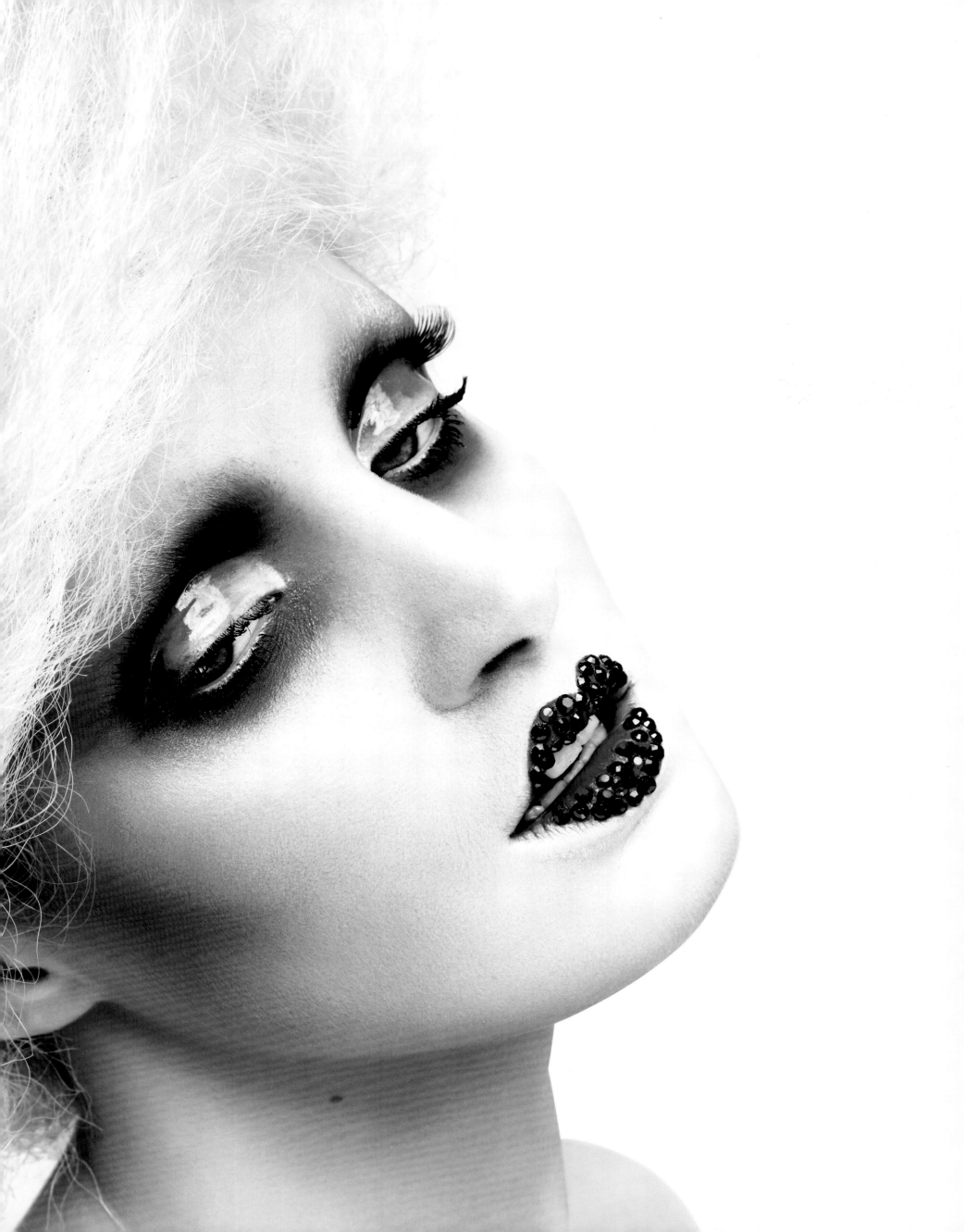

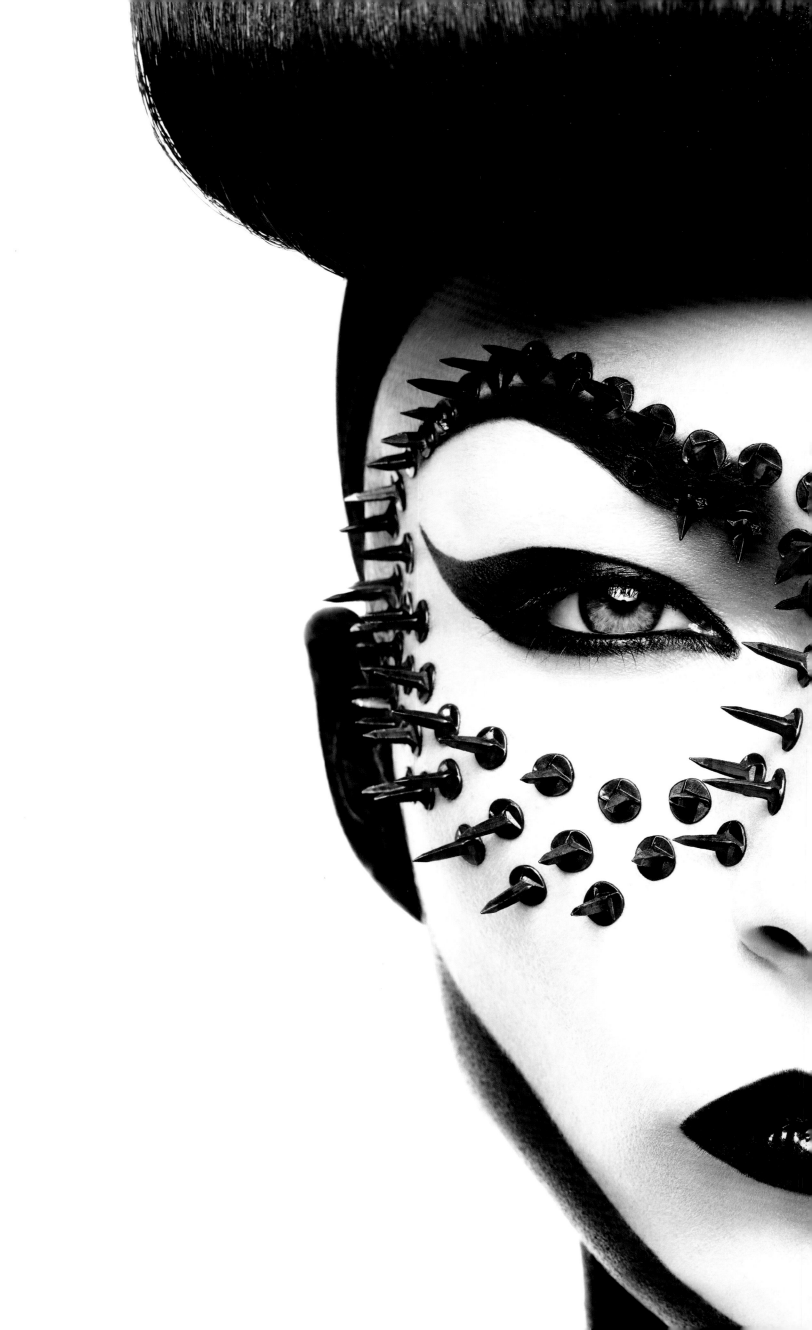

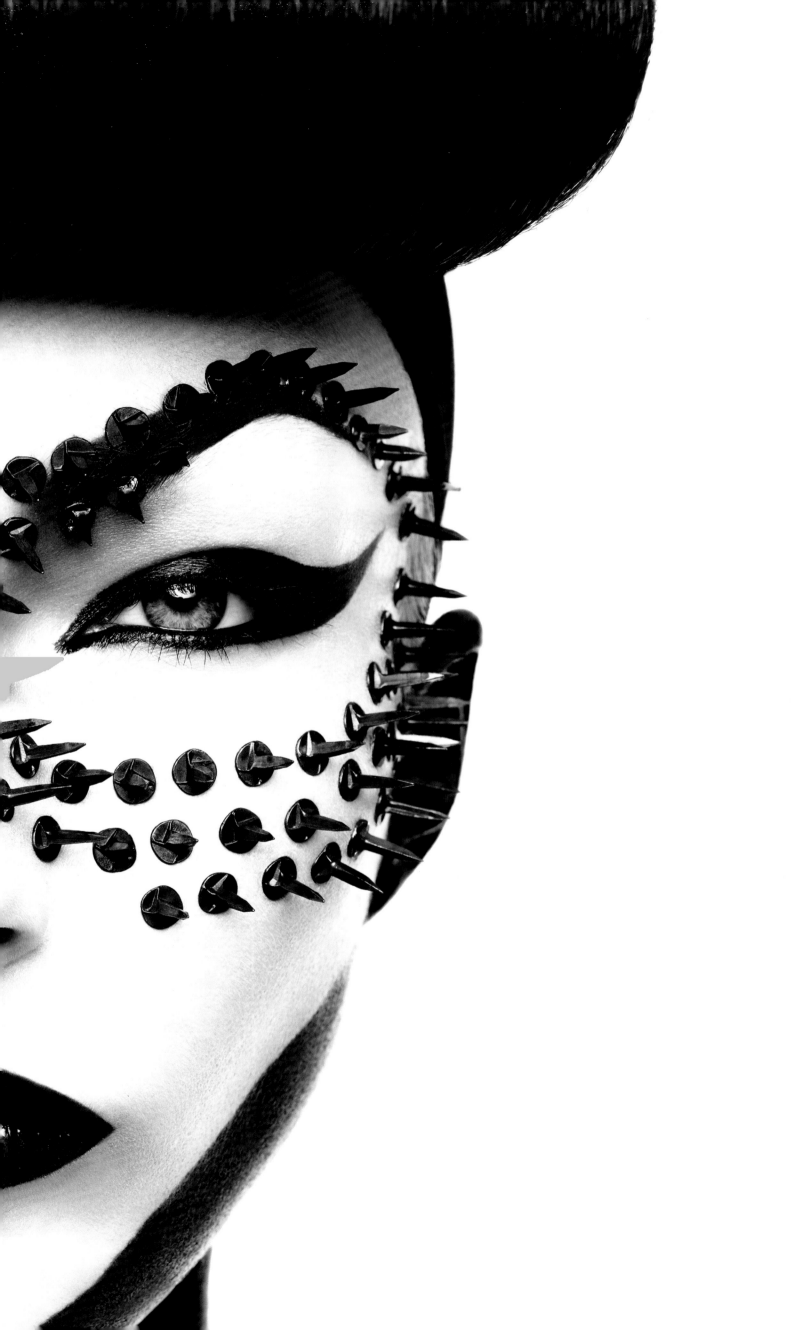

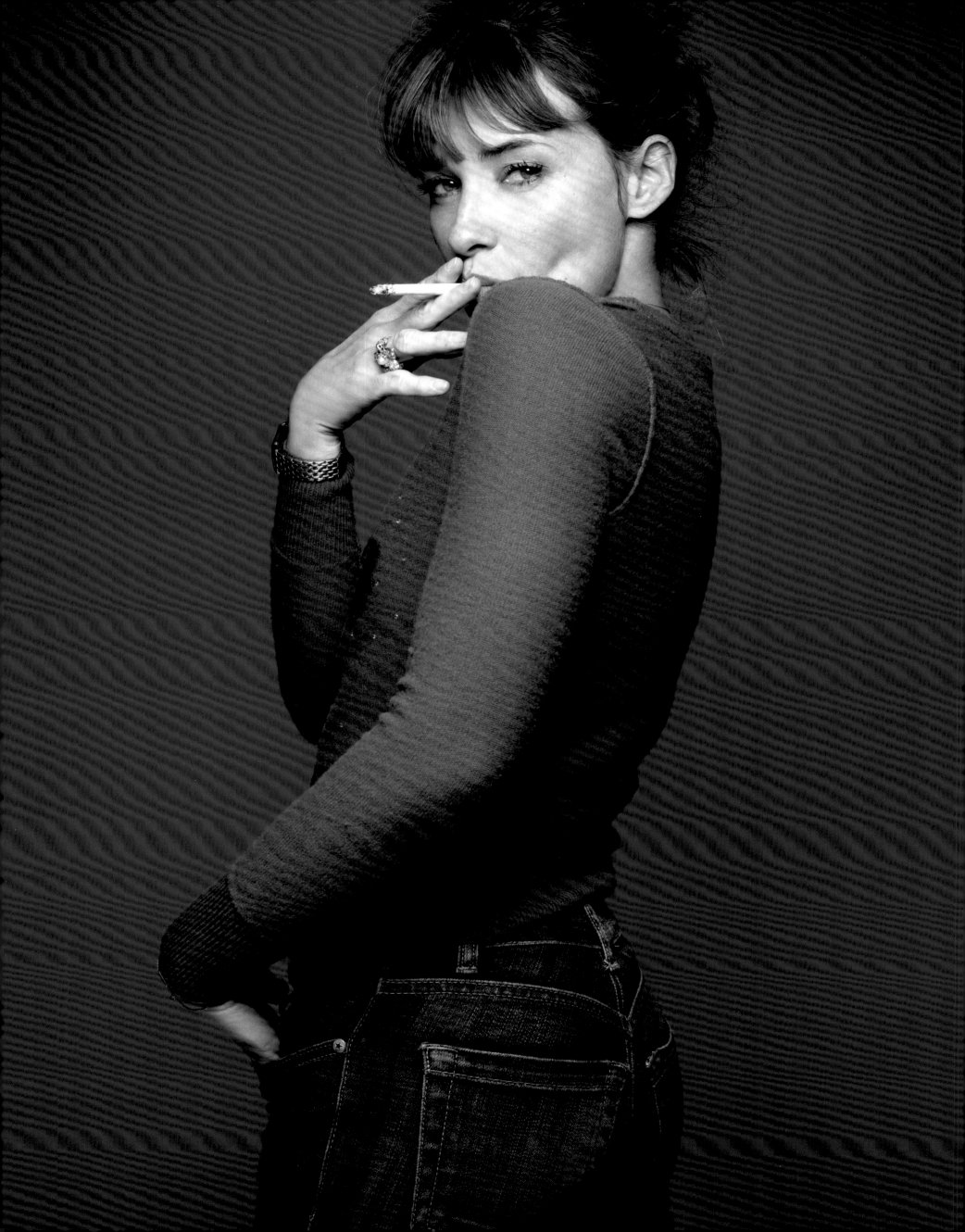

Was fashion an industry that you always wanted to work in? No! When I was young, I didn't think about fashion. I wanted to work in something artistic, but I was more attracted by American movies like *Alien,* and its special effects. But fashion was never very far from me – my mother was a beautiful woman, a total fashion addict. And I loved the women's magazines – the aesthetics of fashion photography made me dream. When I was 14 or 15, it started to become clear that fashion was what I wanted to be a part of. It took me a long time to find myself and then to assert myself in this job. I know today that it was not a mistake.

And what is your style? What have clients come to expect of you? I love the atemporal, the classicism that goes through trends and never becomes obsolete. And I love the exuberance, the strangeness as well. I like that a face bothers me by its ambiguity. Normality bores me; something in me compels me to break it, to confuse the issue. The continuous search for this balance between classic and off-beat, prevents me from reaching a deadlock in my work. I love telling stories and creating characters through my makeup. I think my clients are reassured by my perfect command and my sense of the off-beat.

Which aspects of your personality come across in your makeup? My chameleon side. I am a small woman with a sweet-little-girl air – but I also have an overbearing and crazy side in me. My angel and devil sides are readable in my makeup.

When you have a model in front of you, how do you decide what direction to go in? There are beauties that speak to you through their unusual personalities. You feel an emotion that emerges but cannot be explained. For me, these faces are very inspiring and guide me in my interpretation. Large eyes, a strong nose or an irregularity in the face can be a starting point to highlight a character. Perfect beauty is a little bland for my taste.

What about working with celebrities? I imagine that requires a different approach. With models, you can play, you don't have any limits. With celebrities, you are representing and expressing rather than changing. It's their personality, which is an interesting challenge. It takes diplomacy, responsiveness and speed. When I work on famous faces, I work more for them. When I do makeup on models, I'm the boss: I work for me.

Have you ever wanted to be an artist or a painter? The thought has never even crossed my mind. My creativity comes from my hard work. I'm obsessed by my doubts and anxieties. Research, work and development allow me to calm my fears and put them in perspective. I know the value of my work, but this does not prevent me from constantly questioning it.

Is it important to get on with the people that you work with? As it is teamwork, the dialogue is essential. Sometimes obstacles are encountered because some people's egos do not always facilitate this dialogue. You must be diplomatic and not try to impose ideas systematically, but rather adapt yourself to the atmosphere, to others. I am fortunate enough to work with photographers who love makeup and like my look; we are often on the same wavelength. It's easy when I work with Rankin. He loves makeup and hair, clothes, everything about fashion. He loves women, personality, rock'n'roll, sex and sensuality. For me, it's exactly the same!

What is your favourite feature to focus on? Eyes and skin, undeniably. The skin because it is a blank canvas for me where I bring the brightness, the freshness. Eyes because they provide a lot of opportunities for change. This is the part of the face that can radically change it; make it attractive, strange, disturbing.

You mentioned using a lot of colour and texture. What is it about texture? I like materials such as gloss, glitter, pigments. But what interests me when I work with materials other than makeup is working in another dimension. The relief of lace or fishnet plays on perspective like a 3D image. The clay that cracks on the skin, glued staples or nails… these materials are very interesting forms for modelling a face. I could work with grass or oil or chocolate… anything. You can't control these materials like classical makeup, as you don't know how they will work with skin or with light. It involves a lot more work, but in the end the result is amazing!

What's your creative process? When I started, I was inspired by the work of makeup artists I admired. Then I realised that I needed to stimulate this inspiration, to cultivate my own creativity. I became interested in art in different forms, to fuel my imagination and to understand how an idea is formed and what constitutes it. Painting, cinema, theatre, dance and photography, of course – all of this serves as a support to my creativity. The emotion in front of an artwork inspires me. I pay attention to the light, to the atmosphere it brings to a place, how it sculpts a face, how colours vibrate according to its intensity. For me, the light has an absolutely magical power. I keep my mind open, all the time. I photograph all these moments in my head and I try to translate them in my makeup.

What products do you use on a daily basis? Some mascara, blush and a lip balm, that's it. In the evening I highlight my eyes with a khaki kohl pencil to play with the transparency and depth of my green eyes.

Which products would you most recommend? Without doubt, mascara… for sexy and sparkling eyes. And blush to look well.

What is the biggest mistake that people can make? The biggest mistake, in my opinion, is to try to reproduce the makeup of the catwalks. Recreating makeup originally created for a very young and very beautiful model does not always produce the expected result.

What was it like working on a book with Rankin? It took six to eight months between the proposition and the first shoot because I was so afraid. But as soon as we started it become so easy. I was really free and Rankin was like a child in a candy store! I was surprised when Rankin proposed this book to me. It was such a generous proposition. This book will be with me my whole life! It is about something inside me. It is just about Rankin and I, that's it.

CONTRIBUTORS

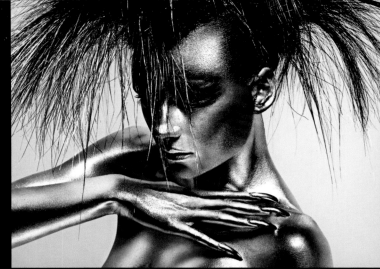

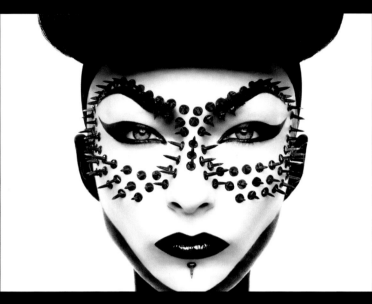

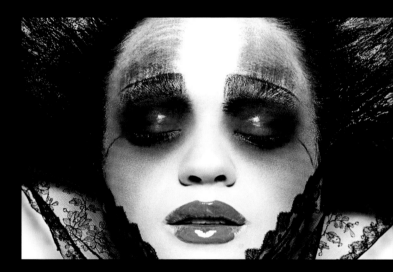

Model
Lilah Parsons at Profile
Hair Stylist
Mark Daniel Bailey
at Artlist New York
Manicurist
Adam Slee at Streeters

Model
Felicity Gilbert at Storm
Hair Stylist
Kenna at Terrie Tanaka

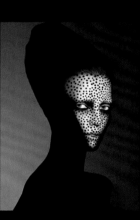

Model
Kasia Szwan at Storm
Hair Stylist
Kenna at Terrie Tanaka

Model
Rosie Tupper
at DNA Models
Hair Stylist
Enrico Mariotti
at See Management

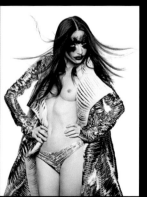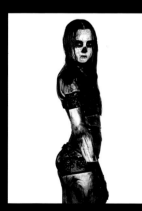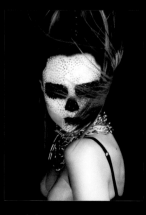

Model
Fanny Francois
 at One Management
Hair Stylist
Enrico Mariotti
at See Management

Model
Clea Martin at Storm
Hair Stylist
Mark Daniel Bailey
at Artlist New York
Stylist
Scott Robert Clark

Model
Hanna Mallette
at Wilhelmina
Hair Stylist
Enrico Mariotti
at See Management
Stylist
Michael Kozak

Model
Hanna Mallette
at Wilhelmina
Hair Stylist
Enrico Mariotti
at See Management
Stylist
Michael Kozak

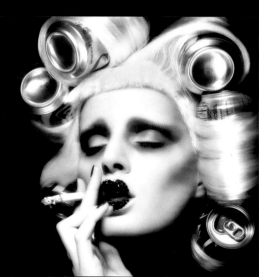

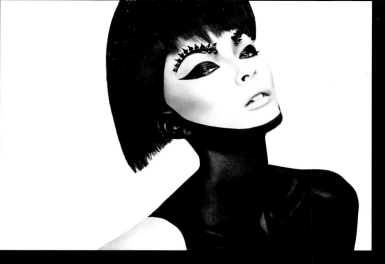

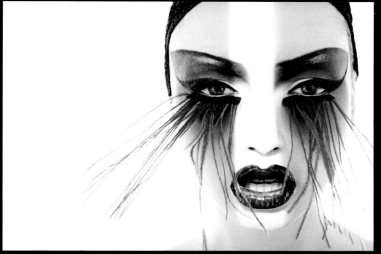

Model
Felicity Gilbert at Storm
Hair Stylist
Kenna at Terrie Tanaka

Model
Aysche Tiefenbrunner
at DNA Models

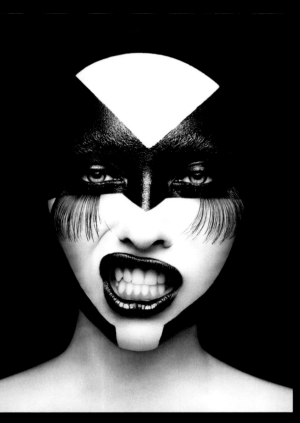

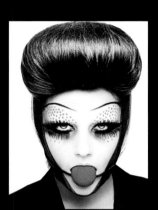

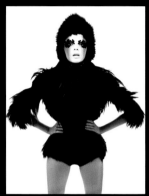

Model
Kara Campbell
at FM Agency
Hair Stylist
Alain Pichon
at Streeters

Model
Nikole Ivanova
at FM Agency
Hair Stylist
Deborah Brider
at DW Management
Stylist
Scott Robert Clark

Model
Victoria Zuban at Profile

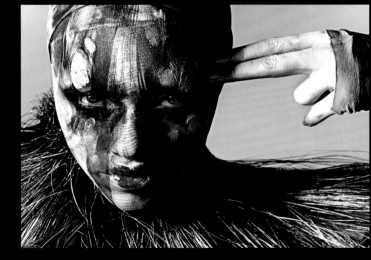

Model
Kajsa M at FM Agency

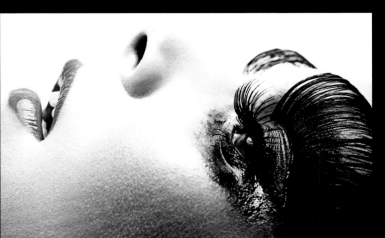

Model
Nikole Ivanova
at FM Agency

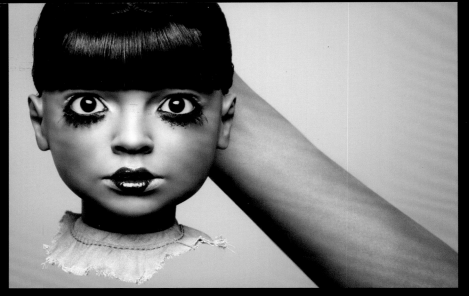

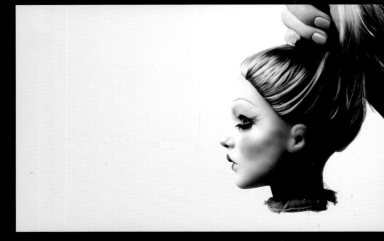

Model
Esther Crichton at Select
Hand Model
Soneya at Body London
Hair Stylist
Kevin Ford
at DW Management
Manicurist
Amanda at Body London

Model
Rosie Tupper
at DNA Models
Hand Model
Krystle at Body London
Hair Stylist
Kevin Ford
at DW Management
Manicurist
Amanda at Body London

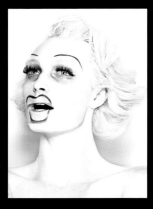
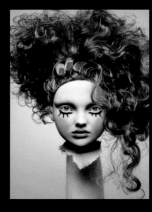
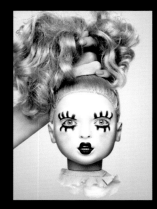

Model
Cooper Thompson
at Chic Management
Hair Stylist
Jonathan Dadoun
at Ann Ramirez Agency
Stylist
Anna Hughes-Chamberlain

Model
Georgie Hobday at Profile
Hand Model
Antonia at Body London
Hair Stylist
Kevin Ford
at DW Management
Manicurist
Amanda at Body London

Model
Louise at Select
Hand Model
Eva-Marie at Body London
Hair Stylist
Kevin Ford
at DW Management
Manicurist
Amanda at Body London

Model
Aysche Tiefenbrunner
at DNA Models
Hair Stylist
Kozmo at Bryan Bantry

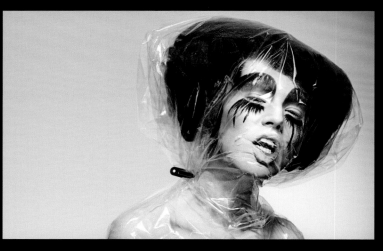

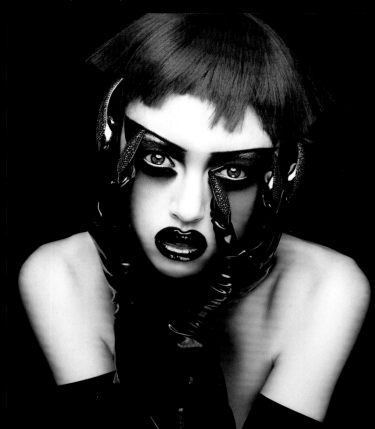

Model
Kara Campbell
at FM Agency
Hair Stylist
Alain Pichon
at Streeters

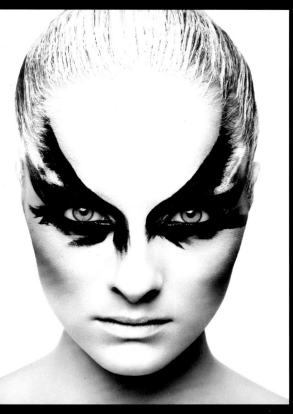

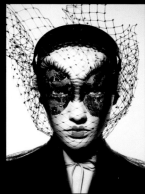

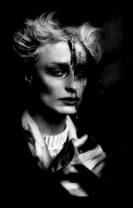

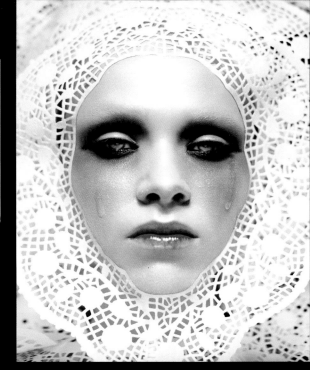

Model
Cooper Thompson
at Chic Management
Hair Stylist
Jonathan Dadoun
at Ann Ramirez Agency
Stylist
Anna Hughes-Chamberlain

Model
Gabi at Premier
Model Management
Hair Stylist
Jonathan Dadoun
at Ann Ramirez Agency

Model
Gabi at Premier
Model Management
Stylist
Caroline Saulnier

Model
Rachel Blais
at Premier Model
Management

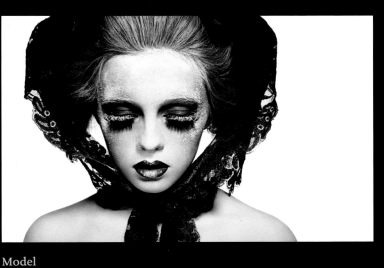

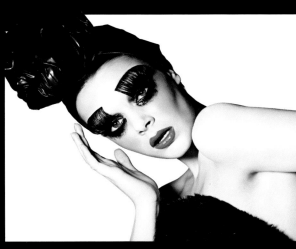

Model
Nikole Ivanova
at DW management
Hair Stylist
Deborah Brider
at See Management

Model
Ollie Henderson
at Next Models
Hair Stylist
Mark Daniel Bailey
at Artlist New York

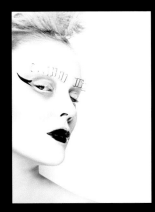

Model
Rosie Tupper
at DNA Models
Hair Stylist
Kozmo
at Bryan Bantry

Model
Agnes Donnelly
at Premier Model
Management
Hair Stylist
Jan Przemyk
at Naked Artists

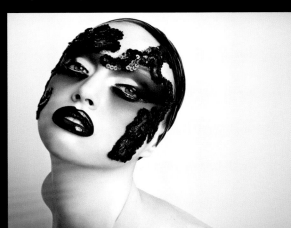

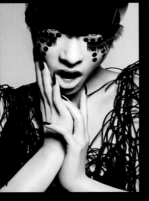
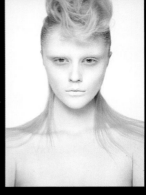
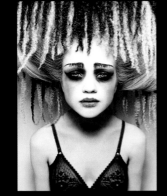

Model
Anna Michaux
at Select Models
Hair Stylist
Jonathan Dadoun
at Ann Ramirez Agency
Stylist
Anna Hughes-Chamberlain

Model
Agnes Donnelly
at Premier Model
Management
Hair Stylist
Jan Przemyk
at Naked Artists

Model
Rosie Tupper
at DNA Models
Hair Stylist
Enrico Mariotti
at See Management

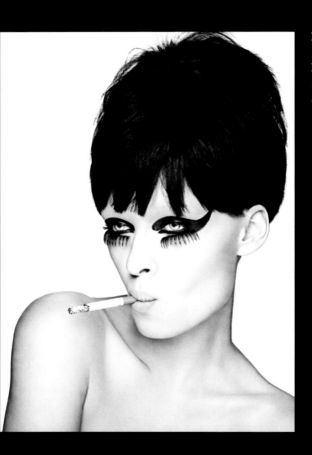

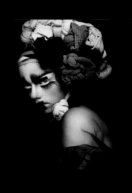

Model
Kasia Szwan at Storm
Hair Stylist
Mark Daniel Bailey
at Artlist New York

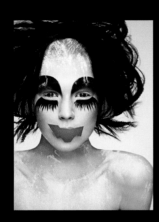
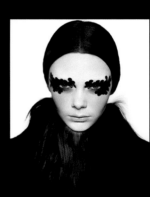

Model
Kajsa M at FM Agency
Hair Stylist
Mark Daniel Bailey
at Artlist New York

Model
Kara Campbell
at FM Agency
Hair Stylist
Alain Pichon
at Streeters

Model
Nikole Ivanova
at FM Agency
Hair Stylist
Deborah Brider
at DW Management
Stylist
Scott Robert Clark

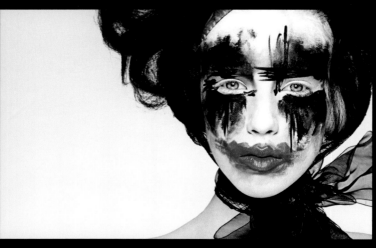
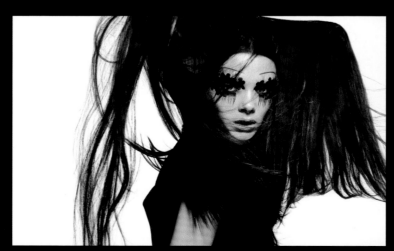

Model
Kara Campbell
at FM Agency
Hair Stylist

Model
Nikole Ivanova
at FM Agency
Hair Stylist

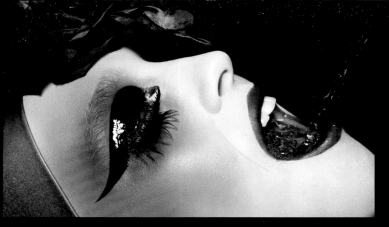

Model
Ollie Henderson
at Next Models

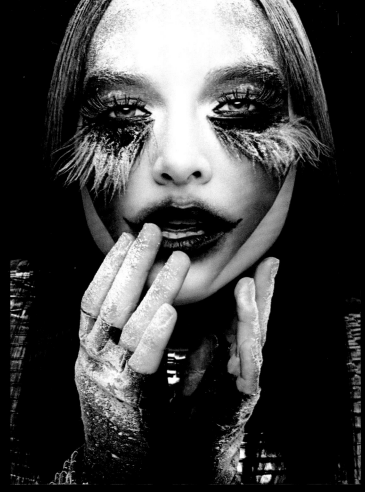

Model
Clea Martin at Storm
Hair Stylist
Mark Daniel Bailey
at Artlist New York

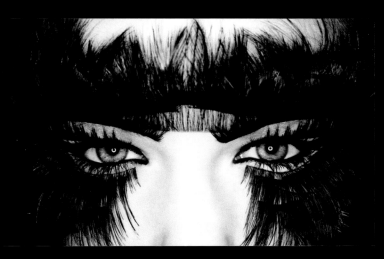

Model
Anna Michaux
at Select Models
Hair Stylist
Jonathan Dadoun
at Ann Ramirez Agency

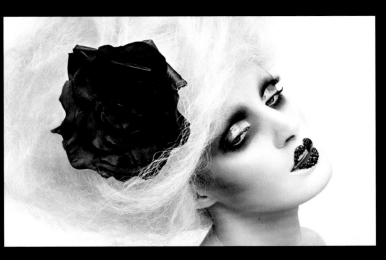

Model
Fanny Francois
at One Management
Hair Stylist
Enrico Mariotti
at See Management

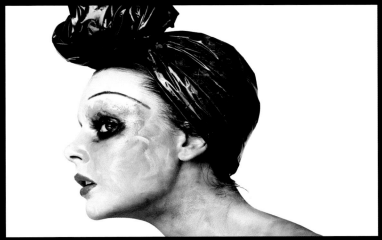

Model
Nikole Ivanova
at FM Agency
Hair Stylist
Deborah Brider
at DW Management
Stylist
Scott Robert Clark

CREDITS & THANK YOUS

Photography
Rankin

Make-up Artist & Creative Director
Caroline Saulnier

Editor
Liza Barber

Interviewer
Amelia Phillips

Sub editor
John McDonnell

Design
Ben Jeffery

Executive producer
Nina Rassaby-Lewis

Producers
Harriet Cauthery
Maria Domican
Virginia Hernando
Laura Oughton
Zoe Roberts

Production Assistant
Katie Bruce

Digital Operators
Michael Tinney
Matthew Thomas
Jimmy Donelan
Hiro Shiozaki

Photographic Assistants
Neil Dawson
Dominic Storer
Max Montgomery
Jack McGuire
Dominic Chinea
Darren Gwynn
Eva Pentel
Trisha Ward
Nico Terrano
David Adams
Rama Lee
Maria Dominika

Post Production
Lucy Daley
Laura Bungey

Archivist
Amy Poole

Digital Artists
Luke Freeman
Joel MacGregor
Peter Hart
Camilla Karlsen
Bryan Egan
Gabriel Lloret

Head of film
Vicky Lawton

Film Assistants
Matthew Oaten
Mark Glenister
Charlie Robins
Alex Simpson
Josh Cooper
Jack Sutcliffe

Printed by
Graphicom Italy

Published by
Rankin Photography Limited

All rights reserved. No part of this publication may be reproduced, stored in a retrieval system or transmitted in any form by any means electronic, mechanical, photocopied, recorded or otherwise, without prior written permission of the copyright owner. All the above activities shall be subject to English Law.

I would like to thank all of the models, hairstylists and stylists who supported me during this project, through their boundless enthusiasm and creativity.

Thank you to my agent, Ann Ramirez, for her astute eye and her unfailing presence. When doubts crept in, her help was invaluable.

I thank my parents for their love and unwavering support for all my projects. A huge thank you to all of Rankin's photographic team: Max, Jimmy, Matt, Mike, Neil, Dom, Hiro, Jack, Eva, Rama...and all the others who I may have forgotten. Thanks for facilitating the shoots, for your sunny smiles, and your professionalism at all times.

Nina, Maria, Harriet, Laura, Lucy, Liza, Zoe... thanks for all the help, for the organisation, and the energy put in to making my shoots go smoothly.

Thanks to Vicky and her film team for their incredible talent in transforming stills into stunning moving image. Thank you Noel, the gourmet chef whose buffets are amongst the best that I've experienced in photographic studios anywhere.

Zazu Susa, thanks for the images from Second Life that inspired me.

And finally Rankin - the first photographer who has given me the opportunity to express myself freely and offer me the best of gifts: this book.

One thousand times, thank you!
Caroline